Britain at War

Twentieth Century in Pictures

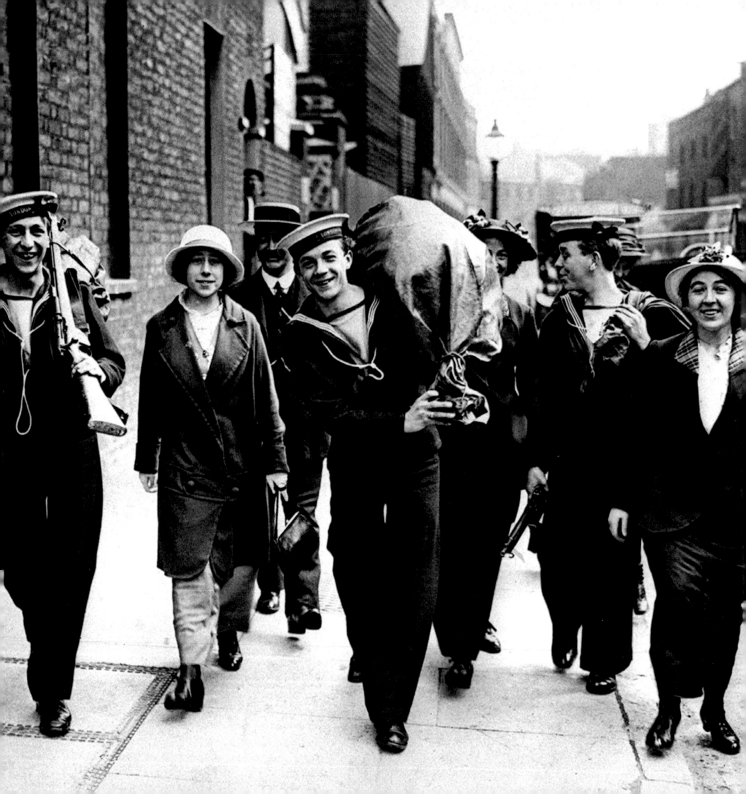

Britain at War

Twentieth Century in Pictures

AMMONITE PRESS

PRESS ASSOCIATION Images

First Published 2009 by
Ammonite Press
an imprint of AE Publications Ltd,
166 High Street, Lewes, East Sussex BN7 1XU

Text copyright Ammonite Press
Images copyright Press Association Images
Copyright in the work Ammonite Press

ISBN 978-1-906672-37-9

British Cataloguing in Publication Data. A catalogue
record of this book is available from the British Library.

Editor: John Thynne
Series Editor: Paul Richardson
Picture research: Press Association Images
Design: Gravemaker + Scott

Colour reproduction by GMC Reprographics
Printed by Kyodo Nation Printing Services Co., Ltd.

Page 2: Royal Navy
Volunteer Reservists are
called back to active service
at the outbreak of war with
Germany.
1st August, 1914

Page 5: Soldiers of the
British Army trudge through
a desolate winter landscape
as the Battle of the Somme
draws to a close. The Allies
advanced just 125 square
miles after five months of
fighting, losing in the region
of 420,000 British and
195,000 French soldiers.
1st November, 1916

Page 6: British troops from
the 2nd Battalion Light
Infantry carry out a patrol,
targeting oil smugglers at a
gas and oil separation plant
in Rauallah, Southern Iraq.
26th September, 2003

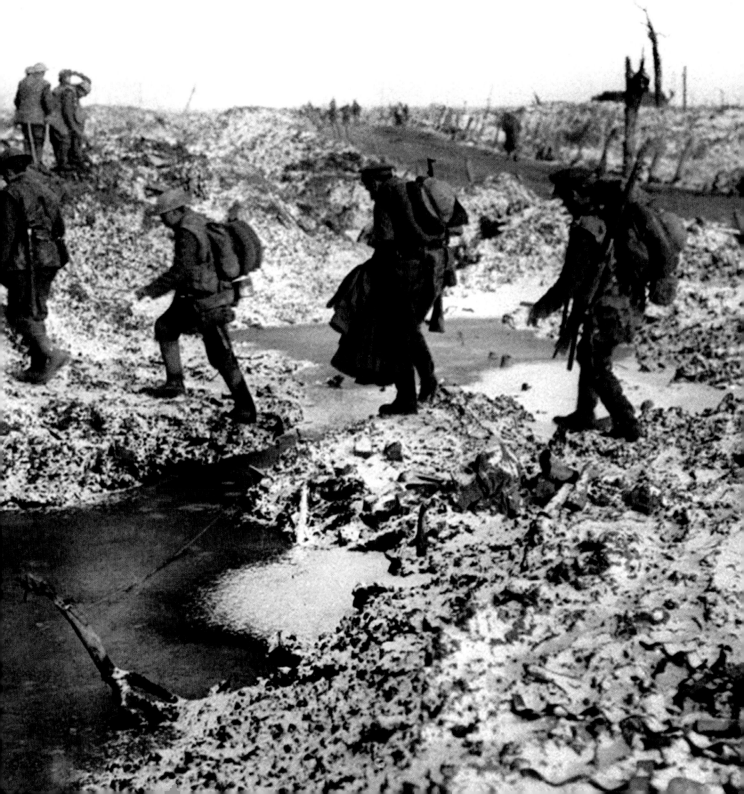

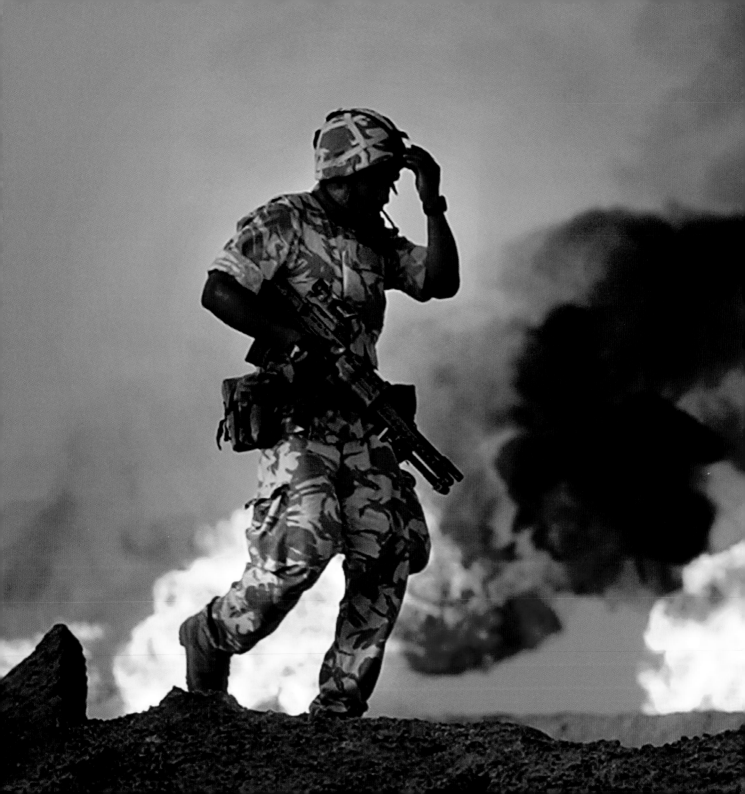

Introduction

During the 20th Century, Britain became embroiled in the two greatest wars in human history and was a major protagonist in a number of other international conflicts. This book celebrates not only the sacrifice of servicemen and women at home and abroad, but also the dogged determination of ordinary civilians, striving to continue their lives and support their families. Such conflict inevitably brings about social change and with large numbers of men absent on wartime military service, women were drawn into unfamiliar trades such as engineering, farming and munitions work. And in the 1940s, as rationing took hold and air raids became a daily affair, women and children bore the brunt of the hardship: these pages pay tribute to their particular brand of heroism.

From the mud and squalor of First World War trenches, tales of individual heroism such as that of HMS *Chester*'s 'Boy Jack', the joy displayed during Armistice Day celebrations, to the poignant laying to rest of the Unknown Warrior, the pages of this book weave a rich tapestry of a nation fighting for its freedom – and that of others – against the tyranny of the enemy. Away from Britain's shores the Korean War, the Suez Crisis, the Falklands Conflict and the Gulf Wars are represented too, stark reminders that the selfless duties performed by British service personnel continue to the present day.

Capturing these images were the unsung photographers of the Press Association, stationed outside recruitment centres to catalogue the fervor of enlistment, at airfields to witness the struggle for supremacy of the skies during the Battle of Britain, alongside troops overseas in the thick of the action on beachheads and battlefields, and setting up their cameras amid the rubble to witness the stoicism of Londoners whose city was devastated but undefeated during the Blitz. Through their work we glimpse too the most important commanders and tacticians in the history of 20th century warfare – Admiral John Rushworth Jellicoe, Field Marshal Montgomery and Guy Gibson of 'Dambusters' fame – as well as Prime Ministers David Lloyd George, Neville Chamberlain and of course Winston Churchill, whose words inspired a nation. Photographs of the Royal Family reveal how the nation's monarchs played a vital role in maintaining morale during times of war.

Hand-picked by PA Photos' own archivists, many of the 300 images in this book have not been seen since they were first used as news pictures in their day. They show not only the courage of Britons at war, but also that of the war-time photographer.

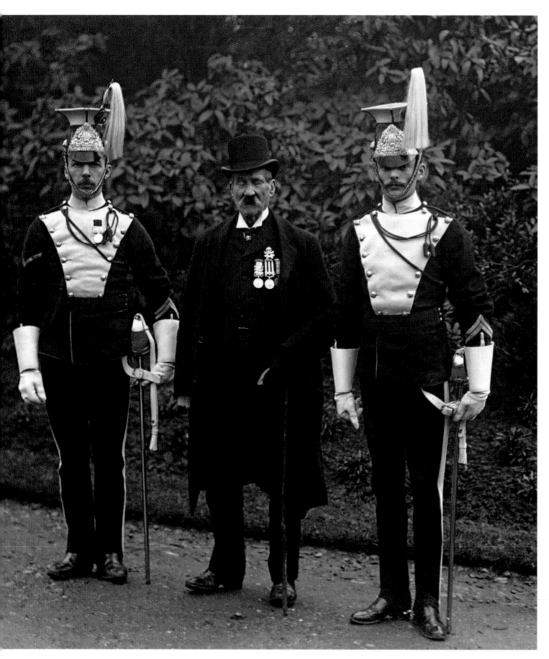

Facing page: 59 battleships and 17 seaplanes of the Royal Navy anchored at Spithead for a Mobilisation Review of the Fleet. The Fleet would next assemble off Southend in 1919 for the Victory Review.
July, 1914

Sergeant James Mustard, 80, the last survivor of the 17th Lancers, who took part in the charge of the Light Brigade at the Battle of Balaclava in 1854. He is flanked by two serving members of the regiment.
1912

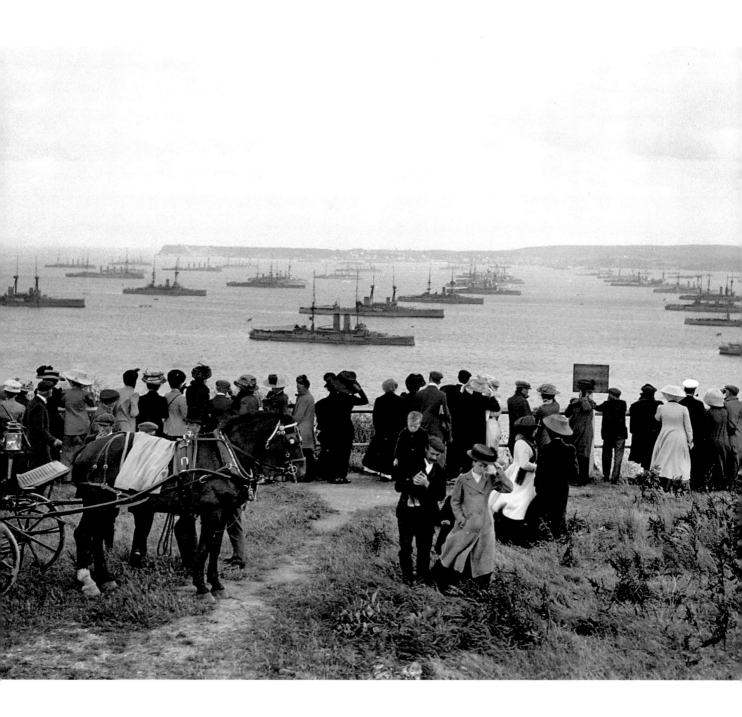

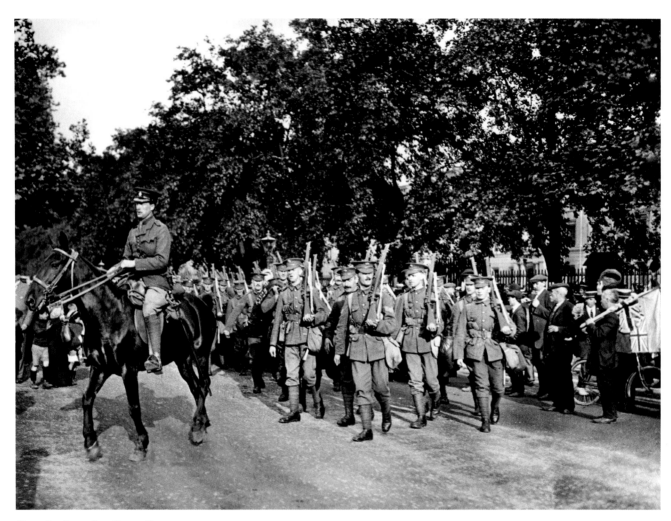

Crowds cheer the Grenadier
Guards as they leave their
London base at Wellington
Barracks for France at the
outset of the Great War.
4th August, 1914

Facing page: Female ticket
collectors at London Victoria
station check a British
soldier's ticket, a sign of
things to come as more
women took on traditional
male roles.
4th September, 1914

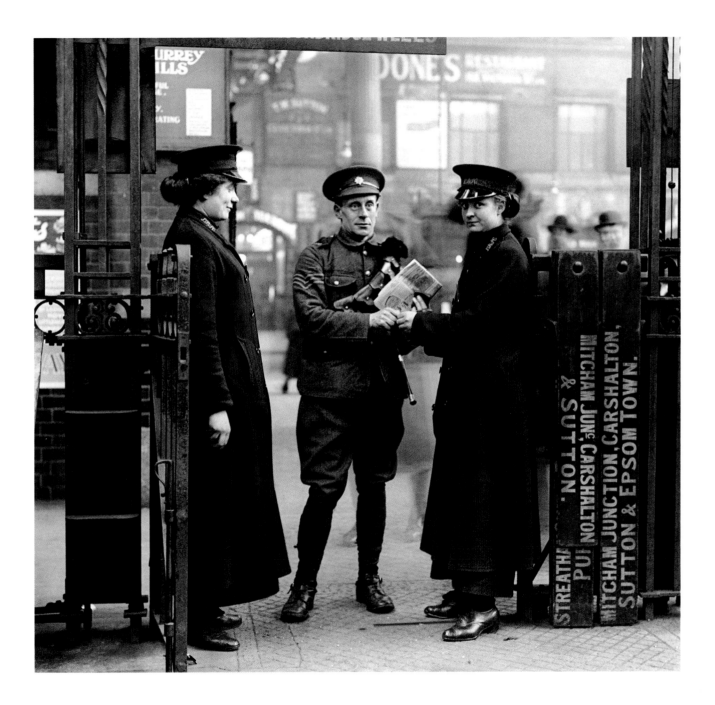

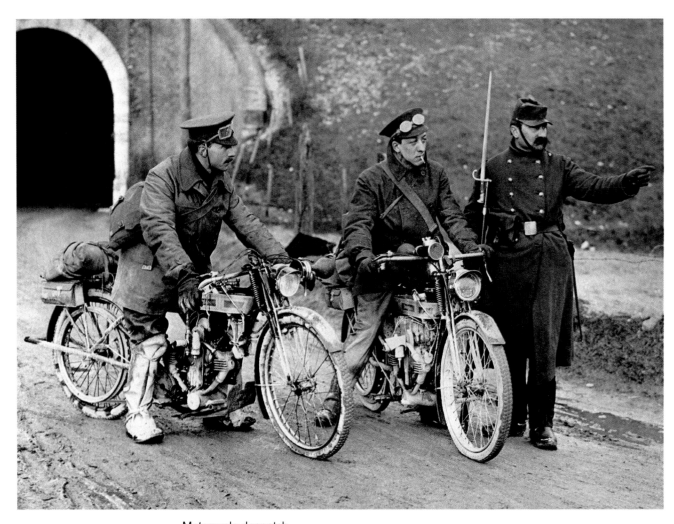

Motorcycle despatch
riders from the British
Expeditionary Force are
given directions by a French
sentry in northern France.
1st October, 1914

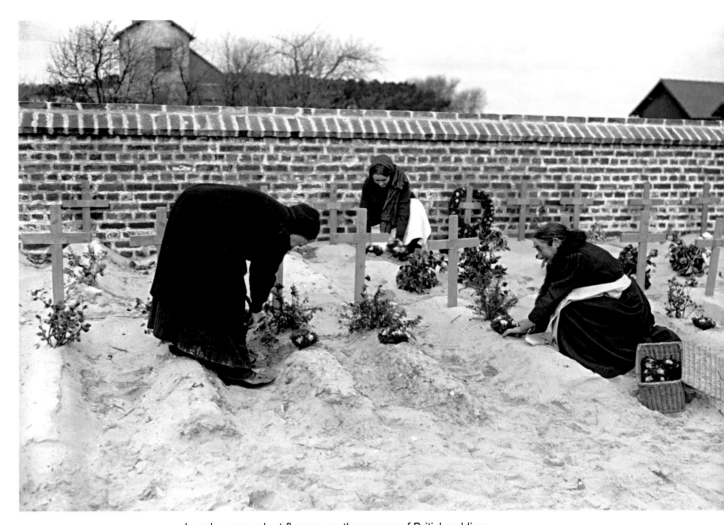

Local women plant flowers on the graves of British soldiers in Belgium. Tragically hundreds of thousands more burials would take place in the country during the First World War.
1st October, 1914

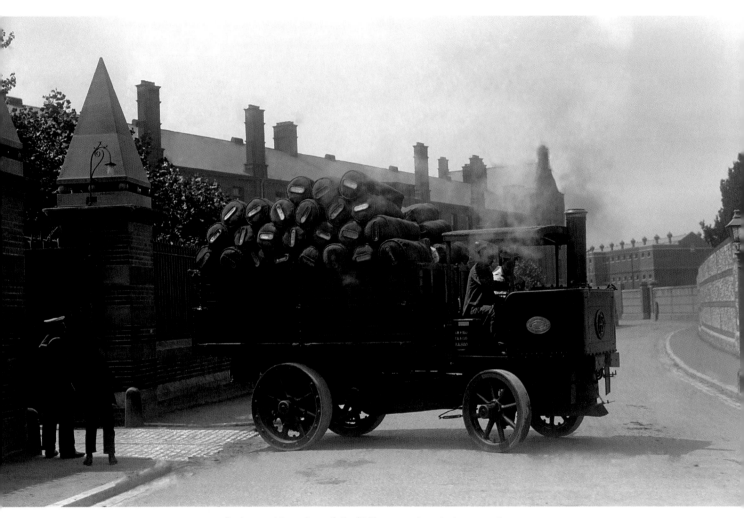

A steam-driven lorry full of kitbags arrives to transport reservists' luggage. In 1914, the regular British Army was an elite but relatively small force of about 250,000, many of whom were posted overseas. The reservists were essential as Britain mobilised against Germany.

1st October, 1914

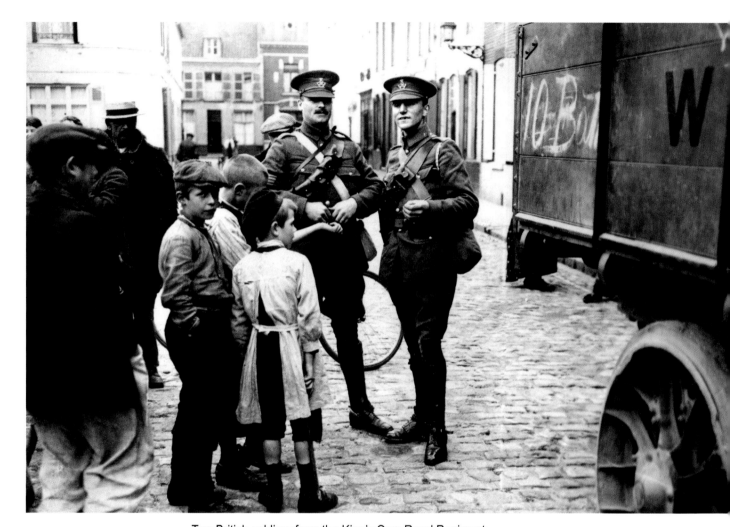

Two British soldiers from the King's Own Royal Regiment (Norfolk Yeomanry) greet locals in a square at Hazebrouck near St Omer in northern France. The town was home to Casualty Clearing Stations until heavy bombing rendered it unsafe for hospitals.

12th October, 1914

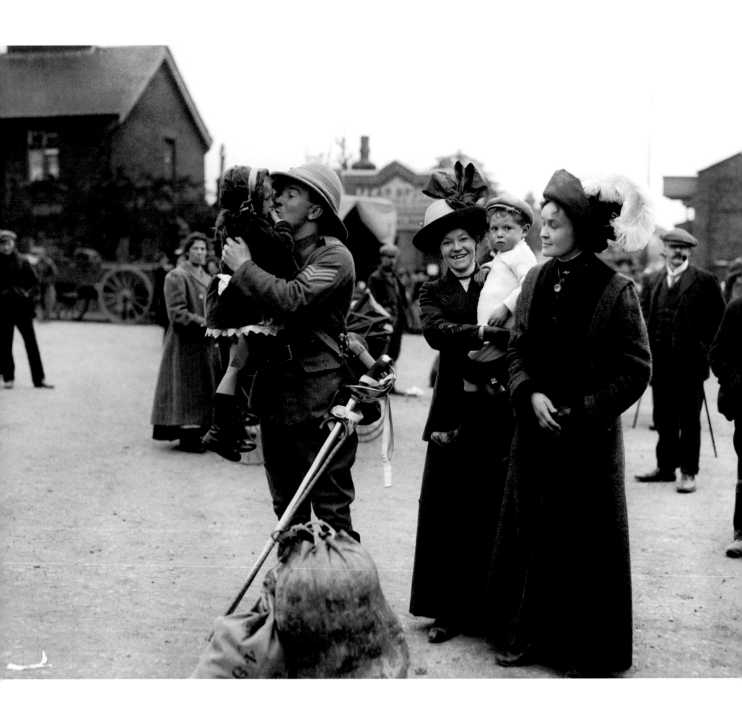

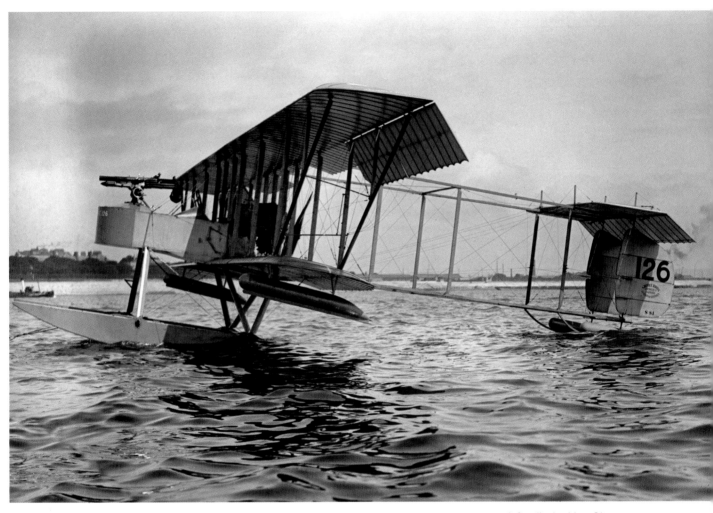

A fragile-looking Short Brothers *S.81* seaplane. The aircraft was carried by ship to German waters and used during an attack aimed at destroying Zeppelin sheds at Cuxhaven.

1st December, 1914

Facing page: A member of the 3rd (Prince of Wales') Dragoon Guards bids farewell to loved ones before leaving for France.

31st October, 1914

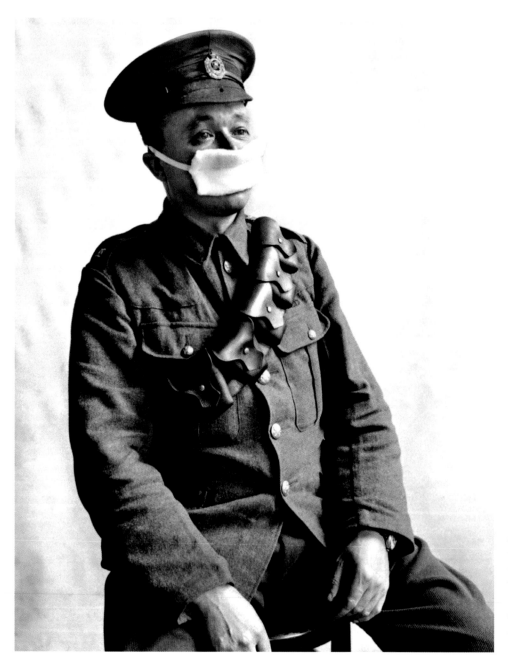

A Royal Engineer wears an early type of gas mask used during the initial stages of the First World War. Little more than a cotton pad, it offered little protection from chemical attack.
1915

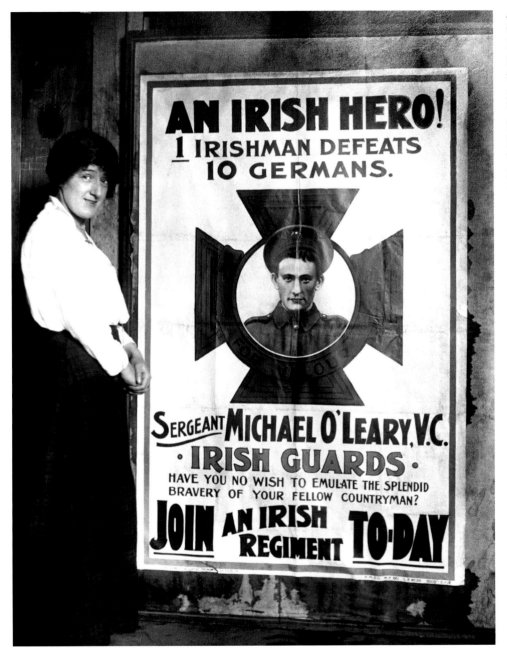

A poster featuring Victoria Cross recipient Sergeant Michael O'Leary of the Irish Guards is used in an effort to boost Irish volunteer numbers during the First World War. O'Leary survived the Great War and served in the Second World War where he rose to the rank of major.
1915

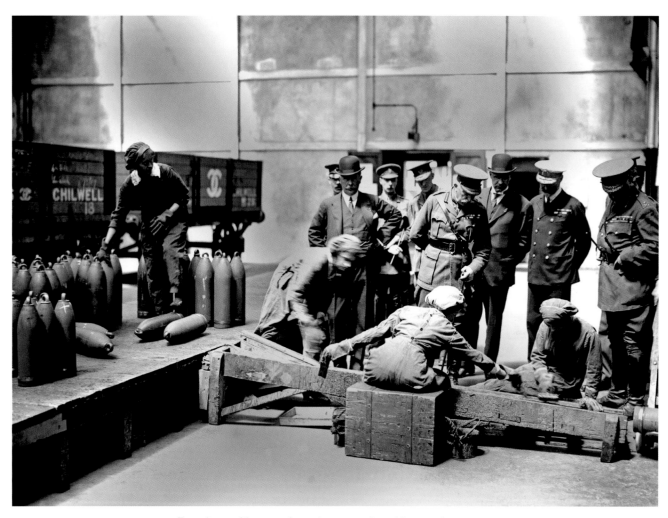

Female munitions workers, known as 'munitionettes'
marking British artillery shells destined for the Front. Military
dignitaries, including the Duke of Connaught (fourth L) and
Lord Petre (L), inspect their work.
1915

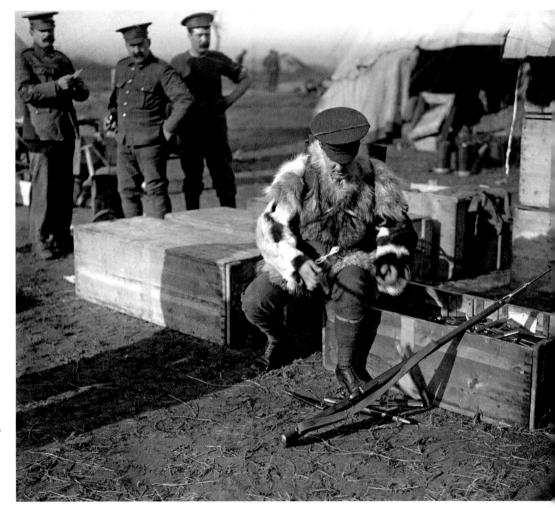

A British soldier, wearing an improvised fur jacket, checks through equipment in a transit camp behind the front lines in France. The onlooker (third R) doesn't seem to be feeling the cold quite as much as his colleague.
1915

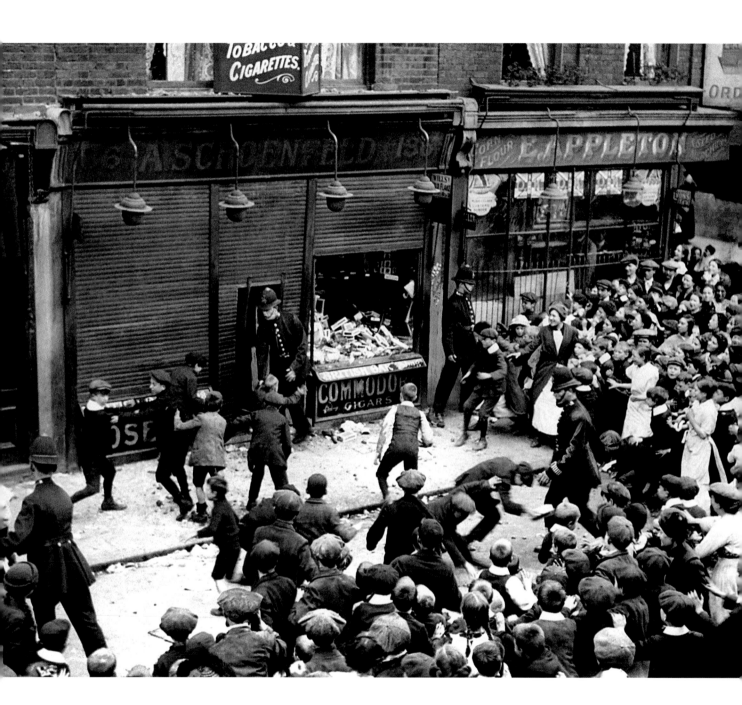

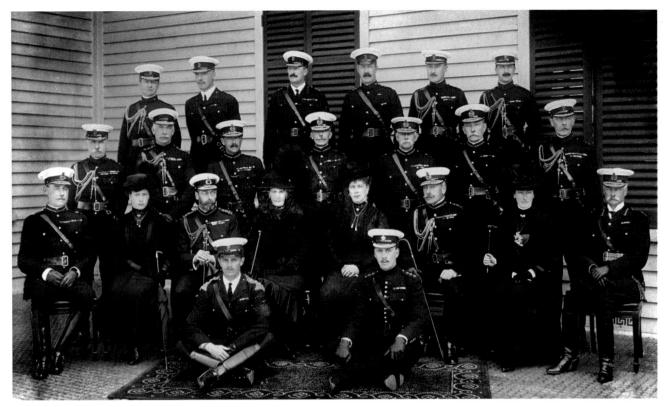

Members of the Royal Family sit alongside prominent members of the military, including King George V (second row from front, third L) and Queen Mary (second row, fifth L).
1st June, 1915

Facing page: Crowds demonstrate outside a shop in Chrisp Street, Poplar, London following the sinking of the RMS *Lusitania* by a German submarine on the 7th of May, 1915. Riots directed against those of German nationality or ancestry were common during the First World War.
13th May, 1915

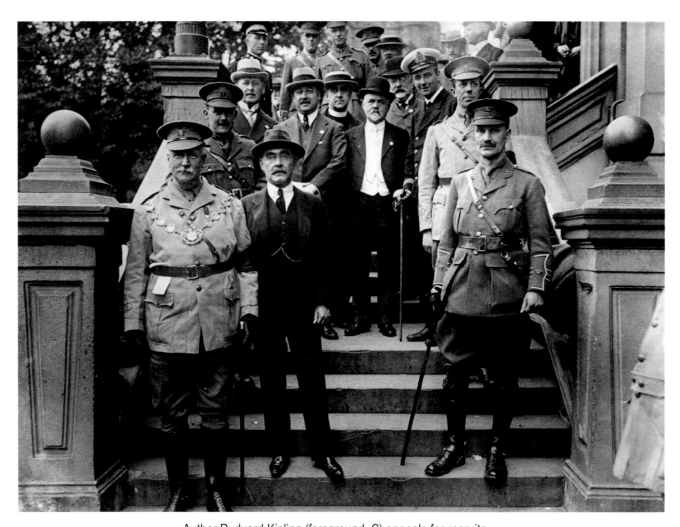

Author Rudyard Kipling (foreground, C) appeals for recruits in the seaside town of Southport. Tragically, Kipling's son John would die in battle just weeks later.
1st June, 1915

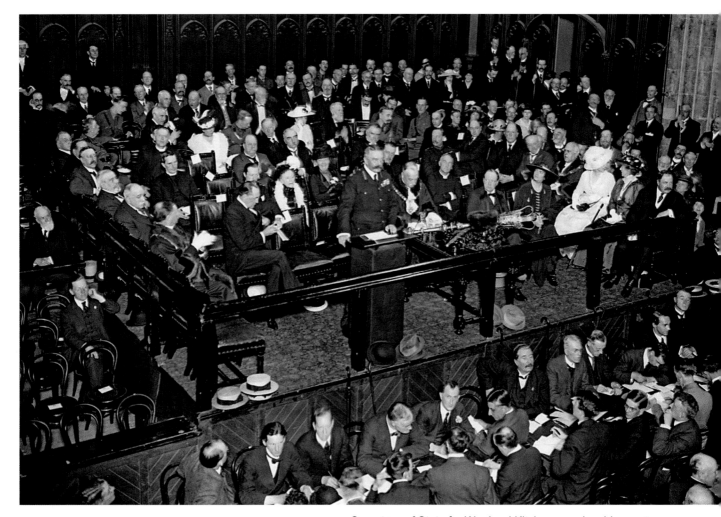

Secretary of State for War Lord Kitchener makes his great recruiting speech at the Guildhall in the City of London. Kitchener's face became familiar to millions on the iconic posters with the words 'Wants You!' below. Winston Churchill sits three places to his left.

9th July, 1915

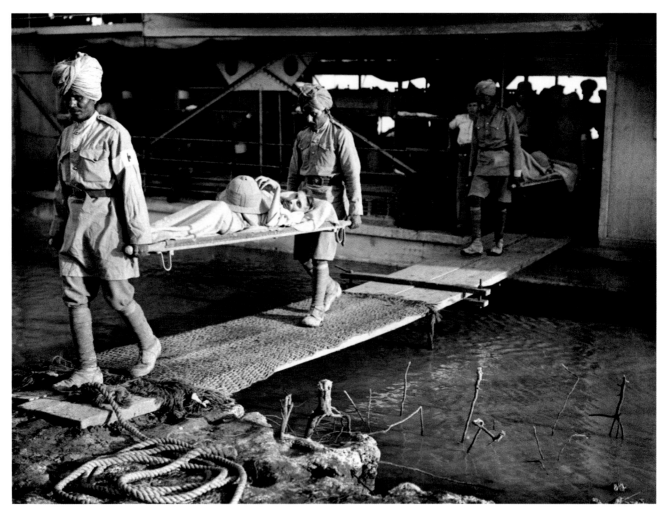

A British casualty is transferred from a boat by Indian Army stretcher bearers at Falariyeh in Mesopotamia. The Indian Expeditionary Force, containing British and Indian units, advance along the Tigris towards Baghdad.
1st August, 1915

Facing page: A soldier says farewell to one of the fallen near the appropriately named Cape Helles, where the Gallipoli landings took place. Tens of thousands of Turkish troops, more than 11,000 Australians and New Zealanders and 21,000 British soldiers perished during the Gallipoli Campaign.
1st November, 1915

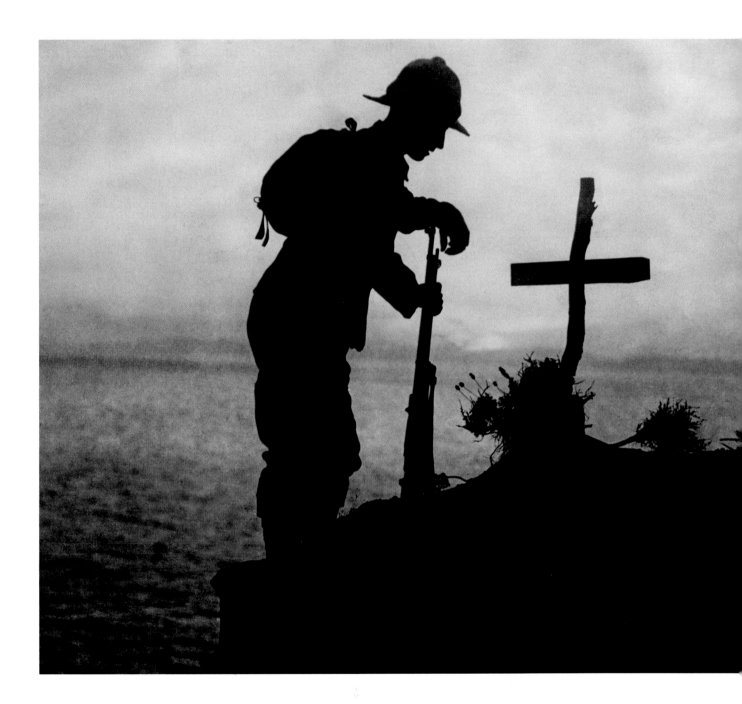

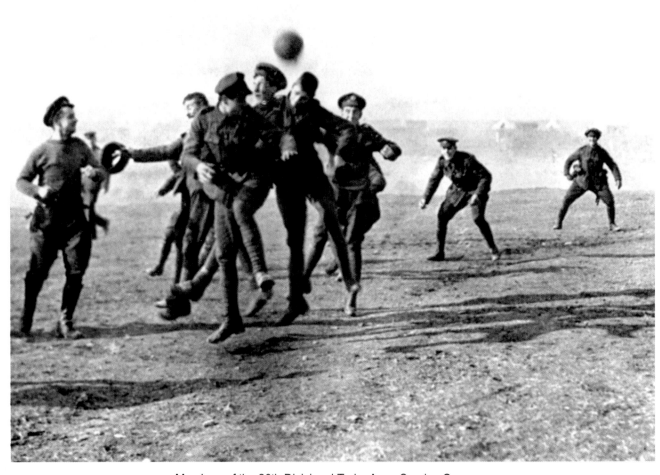

Members of the 26th Divisional Train, Army Service Corps, enjoy a break from hostilities with a Christmas Day game of football at Salonika in Greece. The ASC played a vital role in providing ammunition, food, water and other supplies to the front line.

25th December, 1915

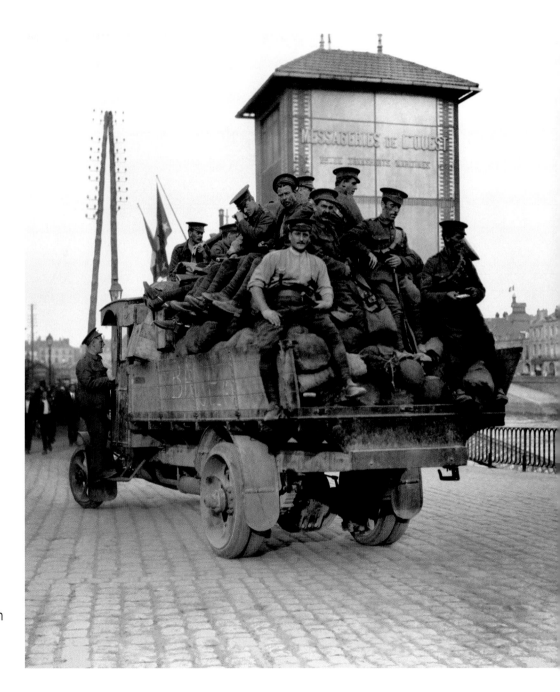

Royal Artillery soldiers hitch
a ride on a kitbag lorry at a
French port.
1916

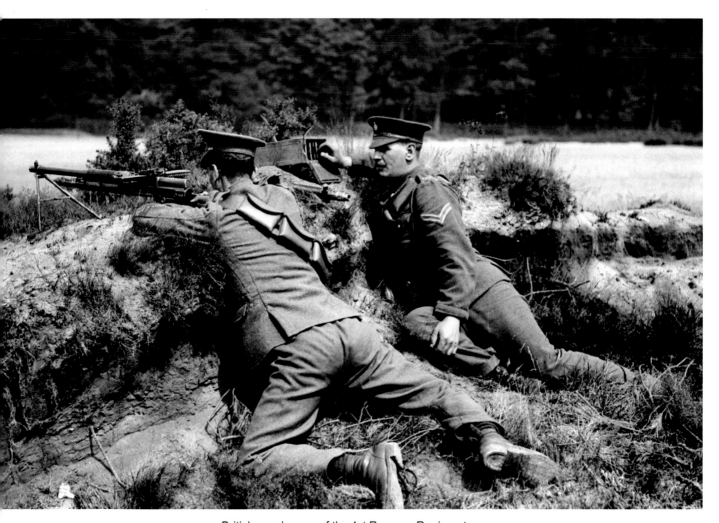

British cavalrymen of the 1st Reserve Regiment man a
Hotchkiss machine gun during training at Aldershot in
Hampshire. The Hotchkiss M1909 machine gun, used during
the First World War, had a range of nearly 4,000m.
1916

An aeroplane is unloaded
from a ship by the Royal
Flying Corps (RFC) – the
precursor to the Royal Air
Force (RAF) – in France.
The tail fin number has
been obscured by a wartime
censor.
1916

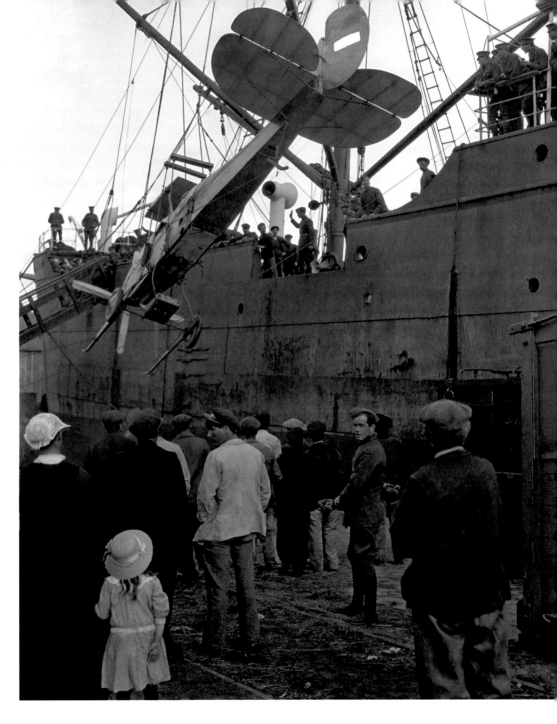

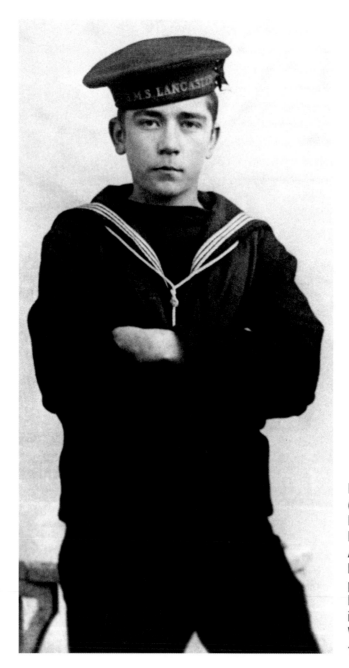

John Travers Cornwell died while serving on the HMS *Chester* during the Battle of Jutland, aged just 16. Despite severe wounds and the deaths of the majority of his fellow gun crew members, 'Boy Jack' remained at his post awaiting orders. He later died of his wounds but was posthumously awarded the Victoria Cross.
1916

Facing page: King George V (front row, third L), Queen Mary (second L), and Princess Mary (L) visit Aldershot – a major army base – in Hampshire. Also pictured is Field Marshall Sir Douglas Haig, Commander in Chief of Forces on the Western Front (third R).
1916

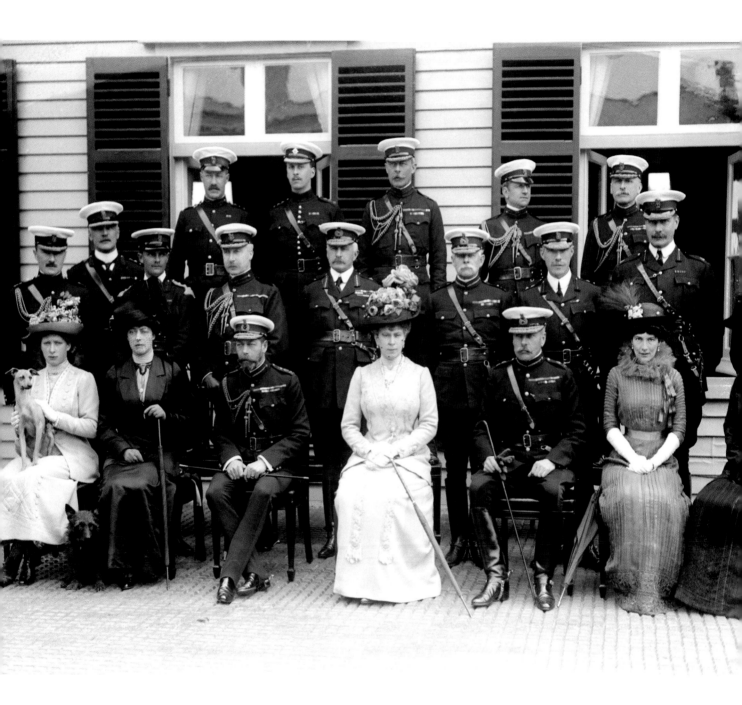

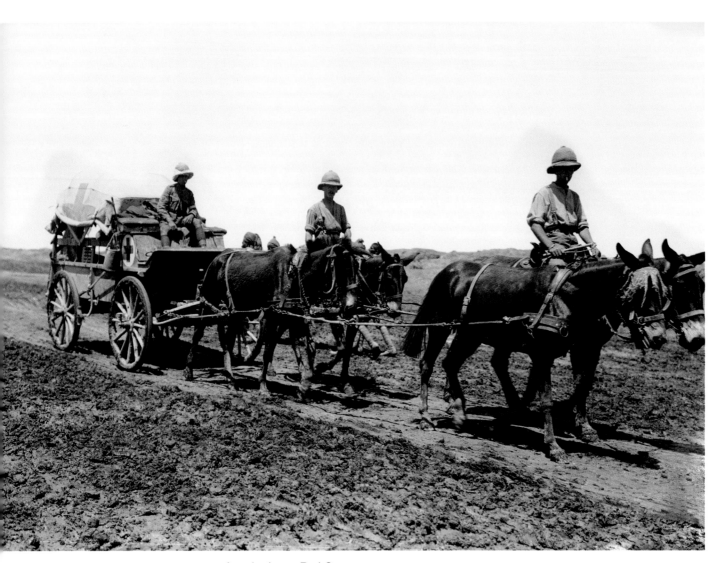

A mule-drawn Red Cross
wagon heads from the
trenches for a field hospital
during hostilities in the
Middle East.
1st March, 1916

Soldiers of the Gloucester Regiment stretch back as far as
the eye can see as they march through Piave on the way to
the front at Asiago in Italy.
1st April, 1916

Troops are carried in an improvised armoured locomotive
following the Easter Rising in Dublin, during which Irish
rebels fought against British rule in the country.
11th May, 1916

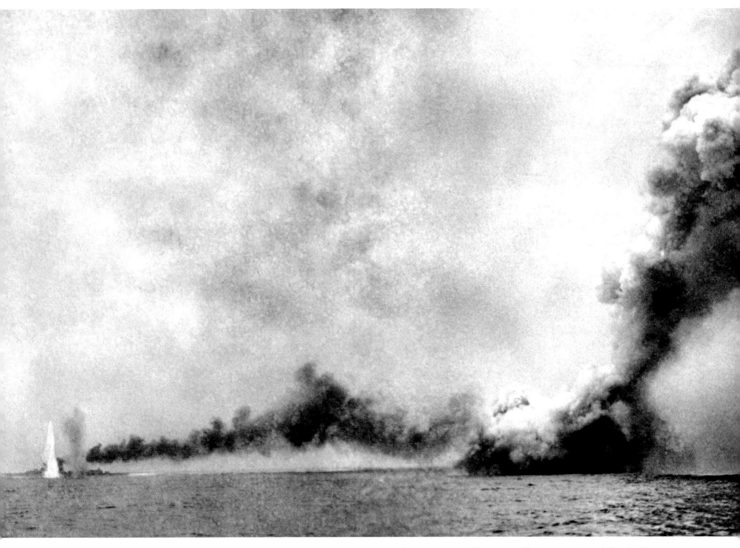

HMS *Queen Mary* (R) is engulfed in smoke while shells
pepper the ocean around the HMS *Lion* (L) during the Battle
of Jutland, the largest naval battle of the First World War.
31st May, 1916

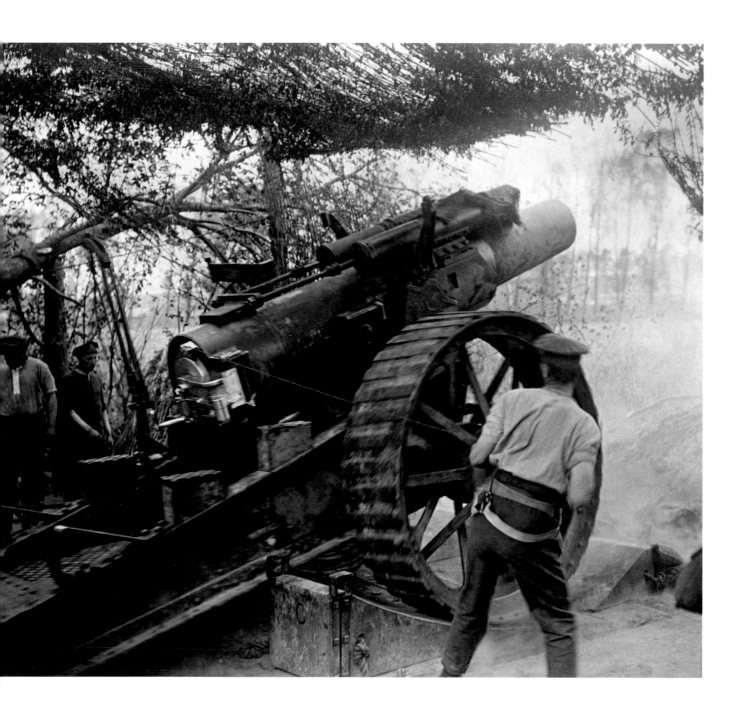

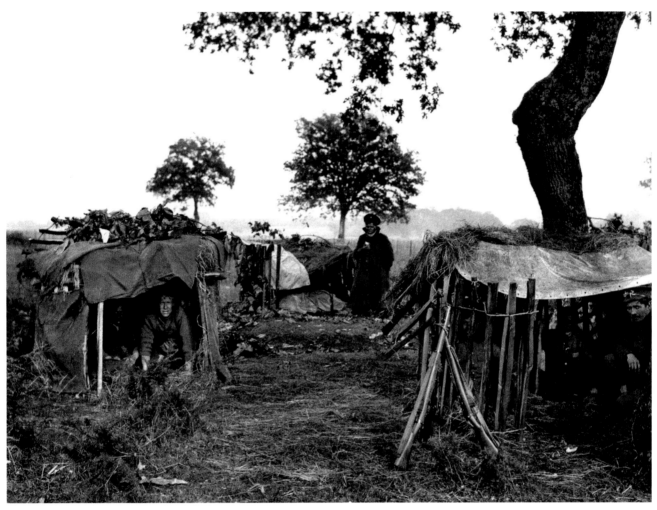

Facing page: A British artilleryman pulls the lanyard to fire an 8in Howitzer. These huge weapons could fire shells up to 12,300 yards (about seven miles) into enemy territory.
31st May, 1916

British soldiers take cover in rudimentary shelters made from tarpaulin and fencing in the French countryside.
1st June 1916

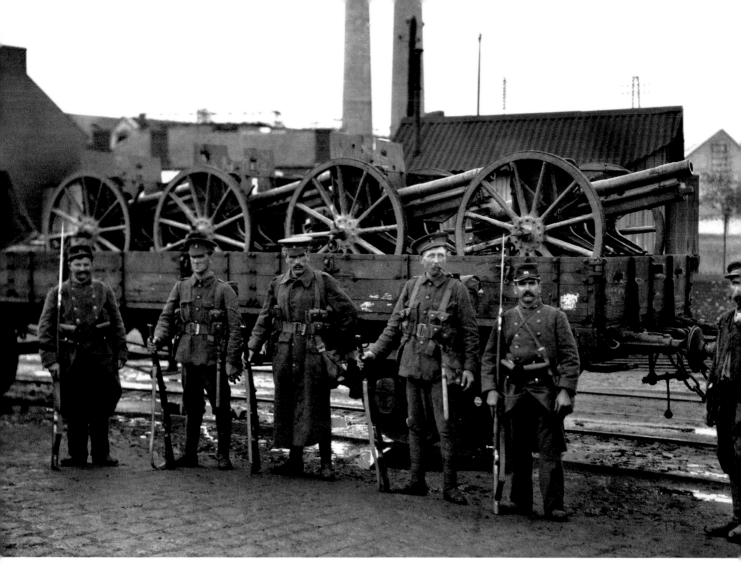

British troops, flanked by two
French infantrymen, proudly
display captured German guns.
1st June, 1916

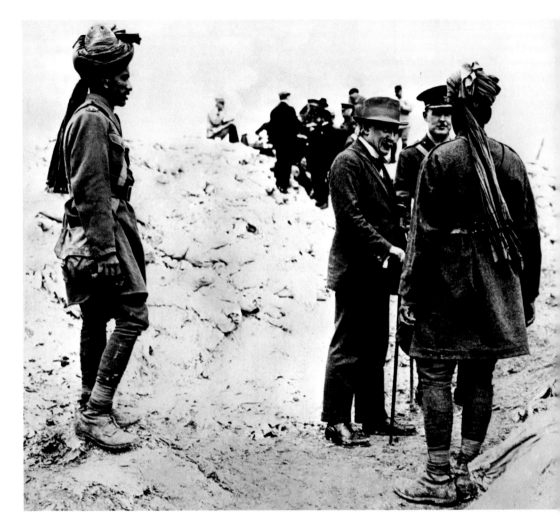

Secretary of State for War David Lloyd George discusses matters with Indian soldiers, 130,000 of whom served in Belgium and France during the First World War.

1st June, 1916

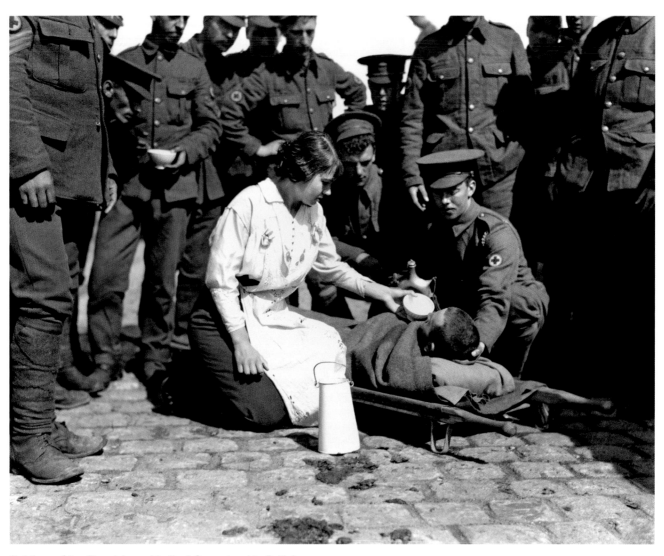

Soldiers of the Royal Army Medical Corps tend to British
wounded. During the First World War, the RAMC was
assisted by the British Red Cross, St John's Ambulance and
other volunteer bodies.
1st July, 1916

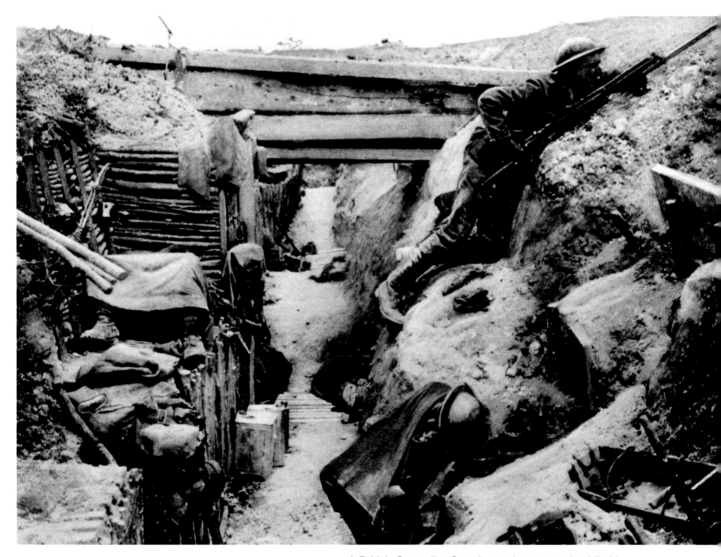

A British Grenadier Guardsman keeps watch while his comrades rest in a captured German trench at Ovillers, near Albert, during the Battle of the Somme. An unprecedented 20,000 British soldiers died and a further 40,000 were injured on the 1st of July, 1916, the first day of the battle.
1st July, 1916

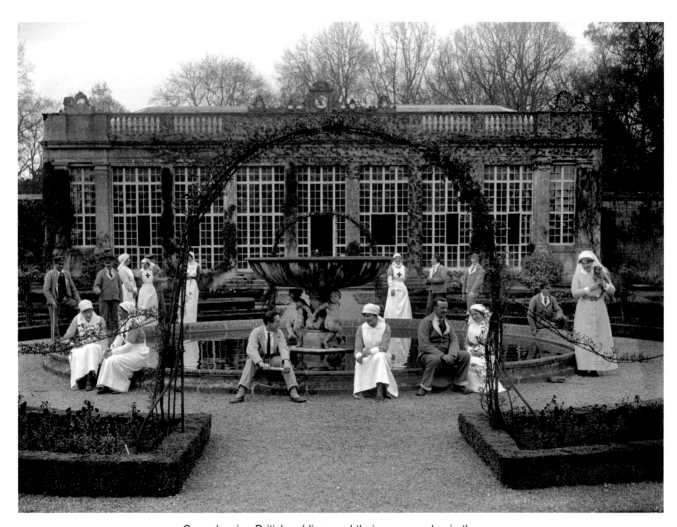

Convalescing British soldiers and their nurses relax in the gardens at Longleat in Wiltshire. The country seat of the Marquis of Bath was used as a relief hospital during the Great War.

1st July, 1916

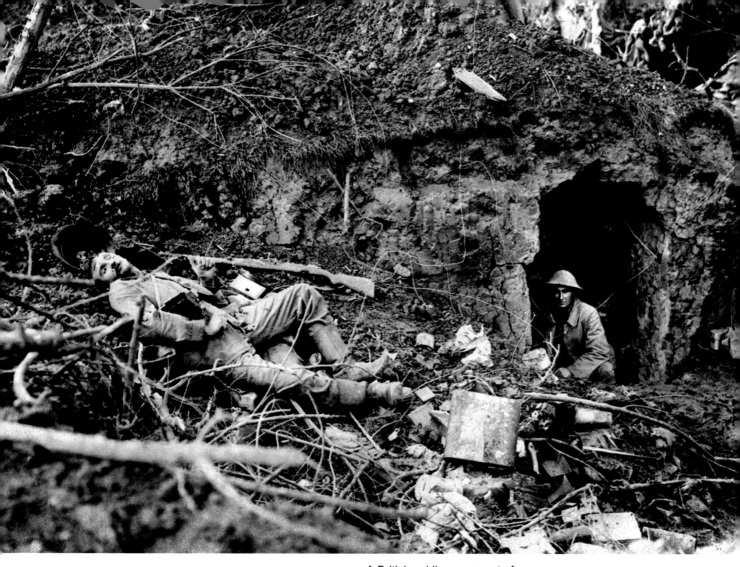

A British soldier gazes out of
his dugout past the body of a
German soldier at Flers. The
12 Battles of the Somme
would rage for more than
four months between July
and November 1916.
1st August, 1916

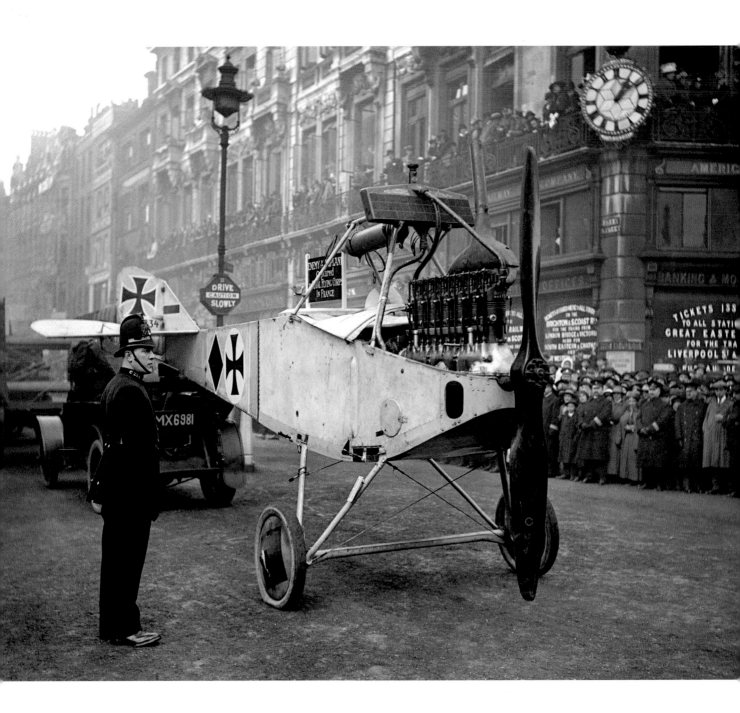

Facing page: The fuselage of a German aeroplane is paraded up Fleet Street, London as a trophy during the Lord Mayor's Show. The aircraft was captured on the 21st of May, when thick mist led its pilot to mistake the Royal Flying Corps' aerodrome at Treizennes, France for a friendly base, at which he landed.
1st August, 1916

Soldiers in Salonika, Greece, use a periscope to observe over the top of their trench wall.
24th August, 1916

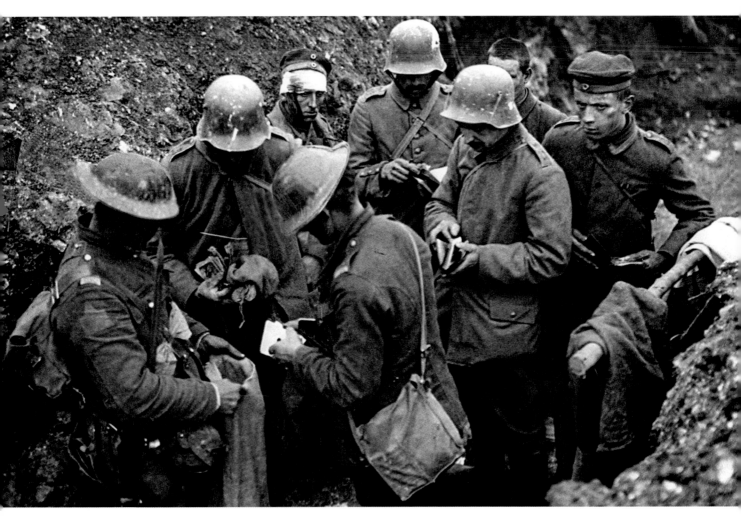

British troops sort through
German prisoners'
belongings in a trench during
the Battle of the Somme.
1st September, 1916

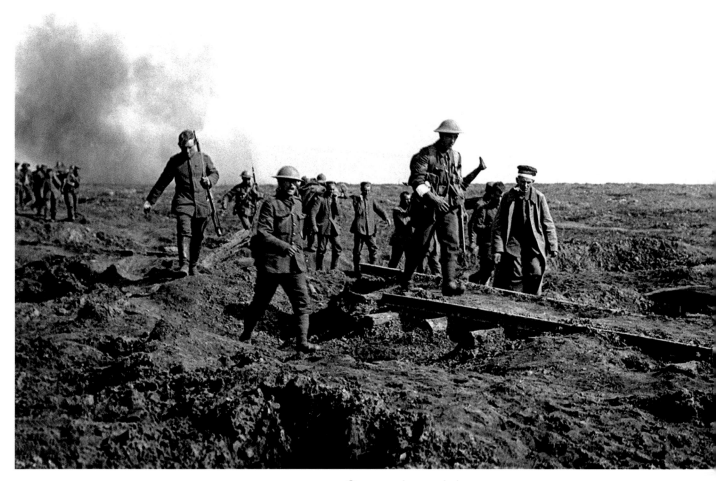

German prisoners help carry
British wounded back to their
trenches during the Battle of
the Somme. Incredibly, the
German soldier to the left is
still carrying his rifle.
9th September, 1916

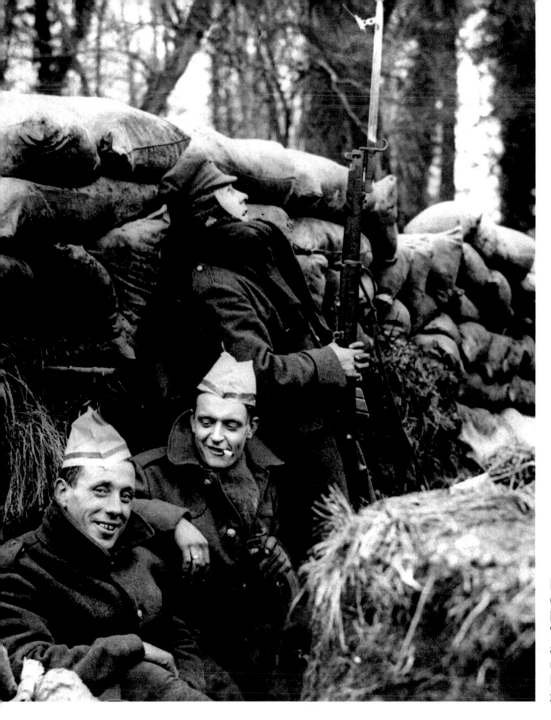

British soldiers celebrate
Christmas with paper party
hats in a trench on the
Western Front. A mirror
attached to a bayonet is
used to keep watch on No
Man's Land.
25th December, 1916

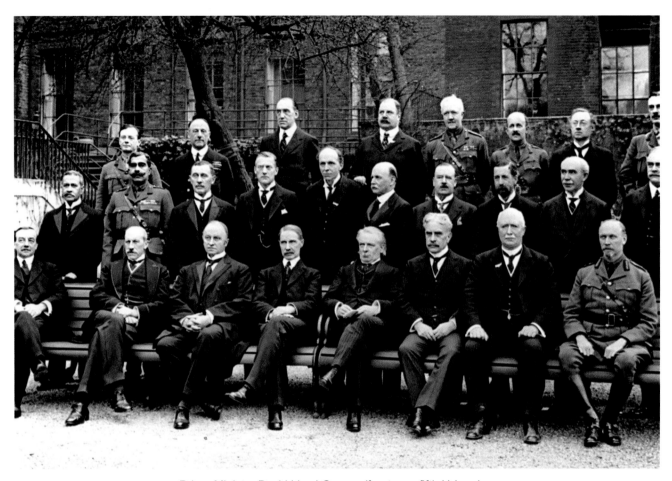

Prime Minister David Lloyd George (front row, fifth L) heads
a meeting of the Imperial War Cabinet. Prominent figures
include Leader of the Labour Party Arthur Henderson (front
row, far L), Chancellor of the Exchequer Andrew Bonar Law
(front row, fourth L), First Sea Lord Admiral John Rushworth
Jellicoe (back row, second L) and Secretary of State for War
The Earl of Derby (back row, fourth L).
1917

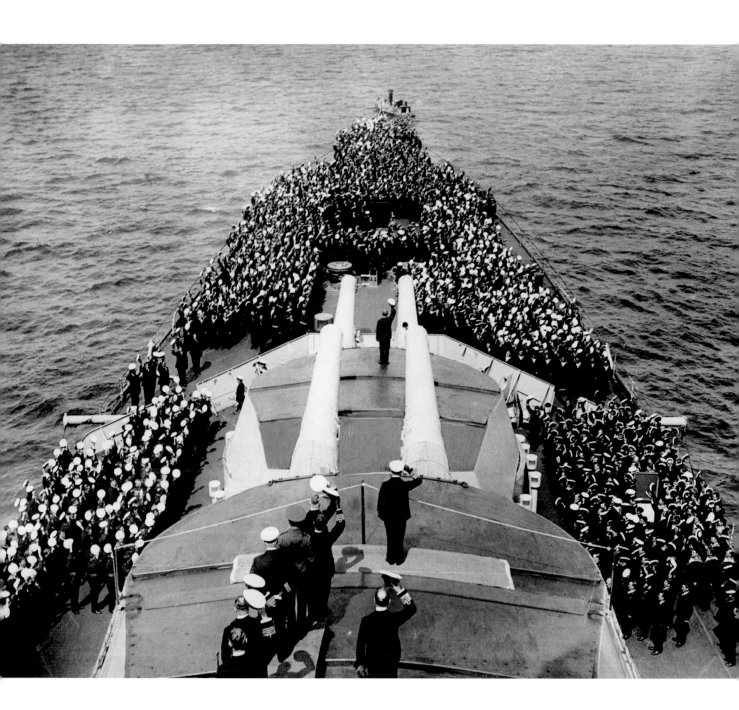

Facing page: The crew of HMS *Repulse* cheer King George V. The *Repulse* was a 26,500-ton battle cruiser serving in the North Sea during the First World War. Following a peace time career, she saw action again during the Second World War, eventually being sunk by Japanese bombers and torpedo planes in December, 1941.
1917

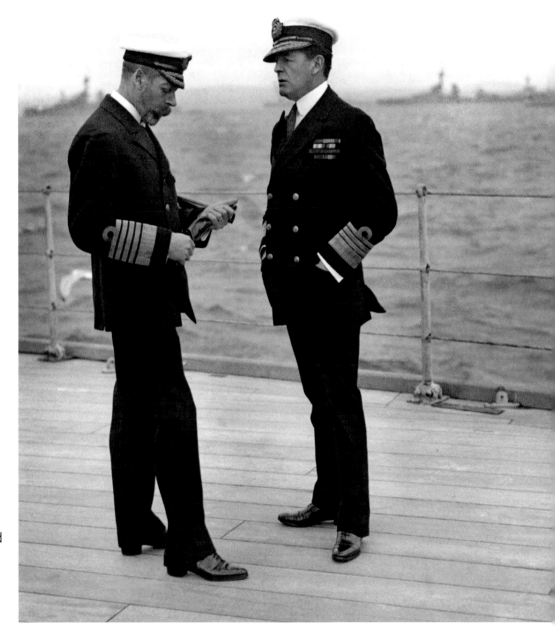

Commander of the Grand Fleet, Admiral David Beatty (R) discusses matters with King George V. Beatty would receive the surrender of the German High Fleet off the coast of Scotland, following the Armistice declaration.
1917

Lord Jellicoe was
Commander of the Grand
Fleet during the first half
of the Great War, before
handing over the reins
to Admiral Beatty and
assuming the position of
First Sea Lord. Jellicoe, who
had joined the Royal Navy
in 1872, became Governor
General of New Zealand
after the Second World War.
1917

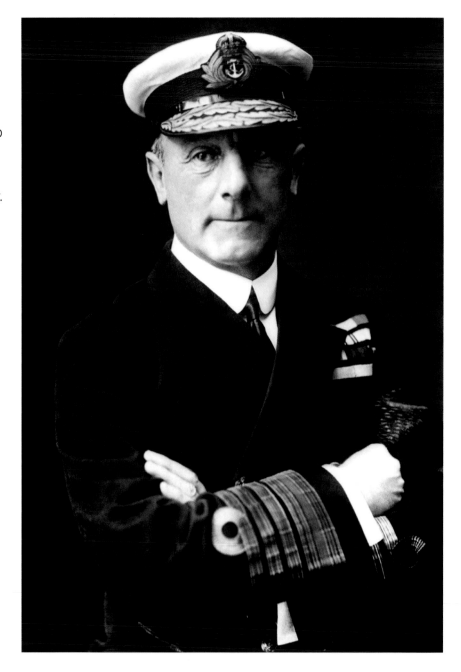

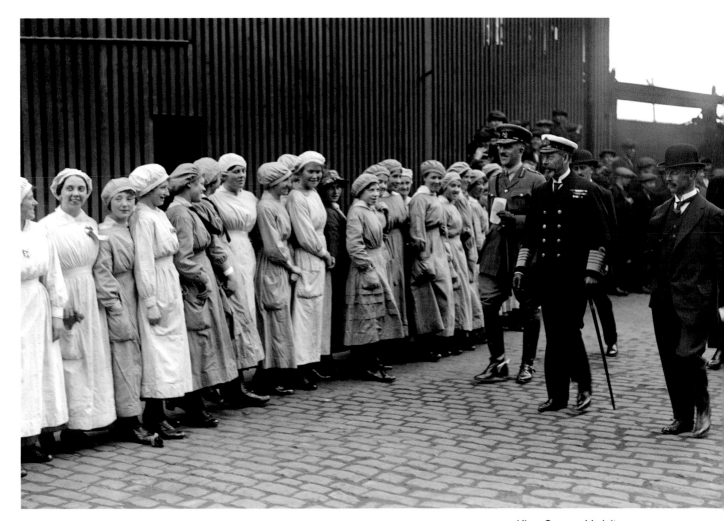

King George V visits a
shipbuilding and engineering
company in Glasgow.
1st May, 1917

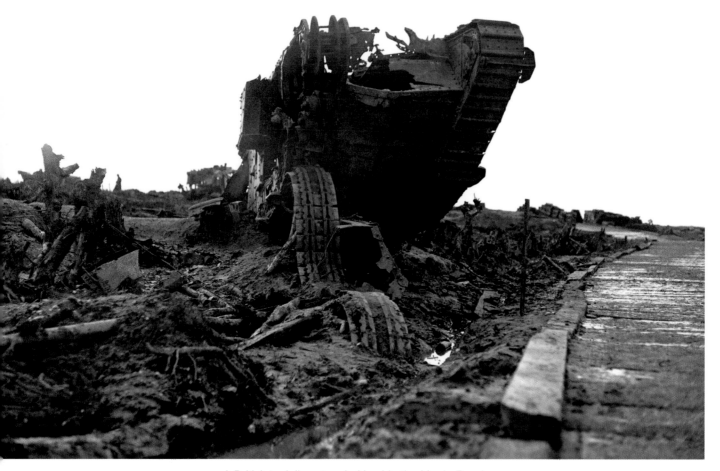

A British tank lies stranded beside the Menin Road near Ypres, Belgium. The road was used as a supply route by the British Army and was bombed intensively by German artillery. The first Allied tanks were put into action in 1916 in an effort to break the trench war stalemate. Although early tanks were unreliable, they would ultimately prove a powerful weapon.

25th September, 1917

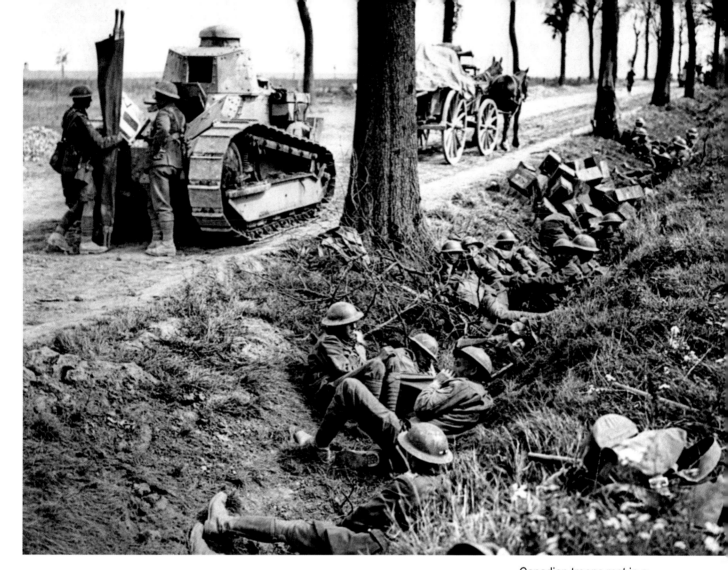

Canadian troops rest in a
ditch beside a road on the
Western Front. To the left
is a seven-tonne French
Renault light tank.
31st May, 1918

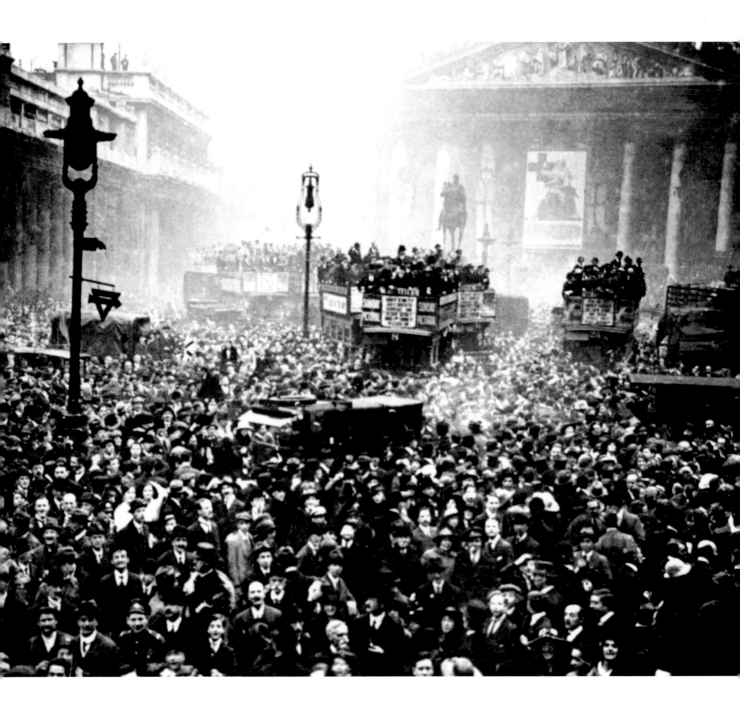

Facing page: Thousands of people gather outside the London Stock Exchange after the announcement of the Armistice, which would bring the First World War to an end.
11th November, 1918

Journalists and photographers view a machine gun post in an abandoned German trench.
11th November, 1918

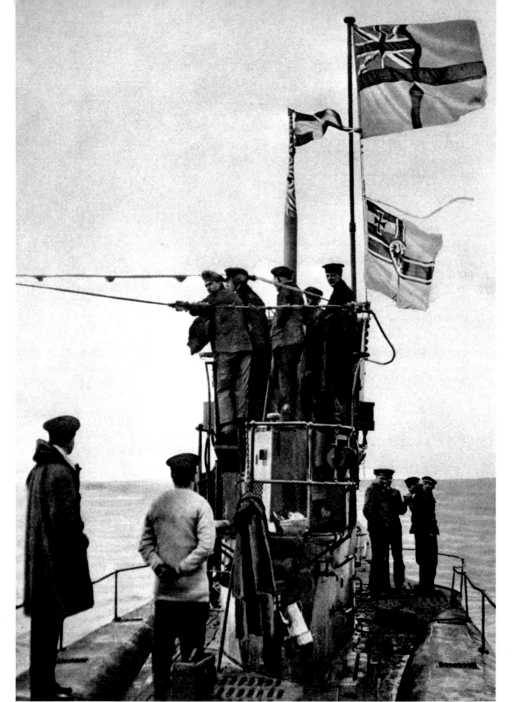

German submarine *U-48* is one of 39 submarines to surrender to the Royal Navy at the Essex port of Harwich. During the First World War, Germany produced 360 U-boats, of which around half were lost.

21st November, 1918

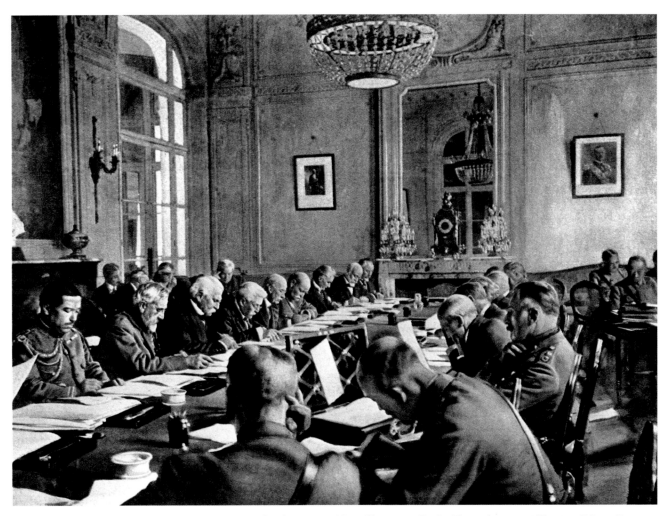

The Inter-Allied Conference at Versailles, near Paris. The subsequent Treaty of Versailles, signed on the 28th of June, 1919, more than six months after the end of hostilities, restricted Germany's military capacity, forced it to make reparations to the Allied Powers and, among other things made it renounce rights to overseas territories. Sir Douglas Haig, Commander in Chief of Forces on the Western Front, can be seen (R) leaning back in his chair.
28th June, 1919

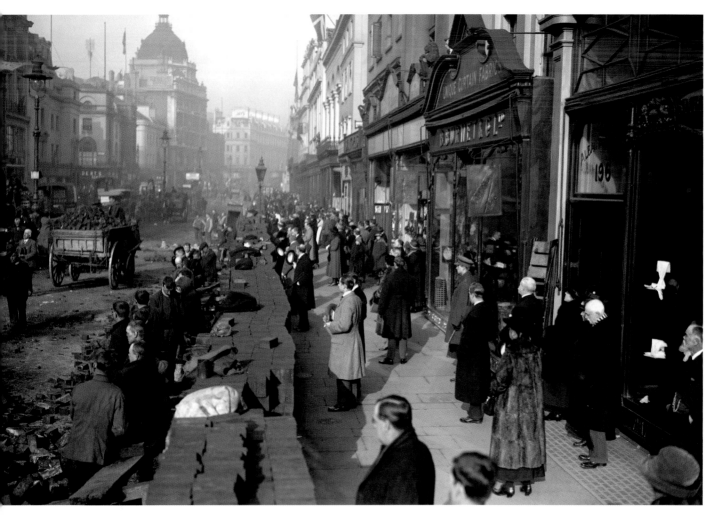

Workers and pedestrians pay their respects to those killed
in the First World War, with a two-minute silence, one year
after fighting ceased. The tradition is carried out to this day
at 11am on the 11th of November each year.
11th November, 1919

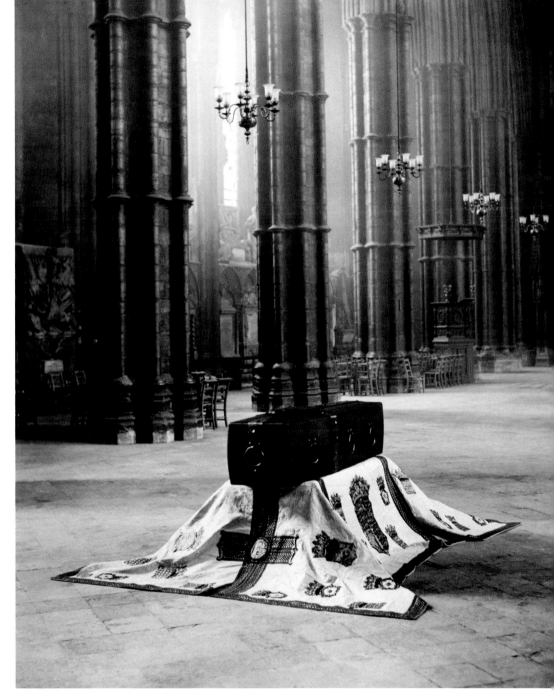

The coffin of the Unknown Warrior rests in Westminster Abbey, London. The unidentified soldier's body, brought from an unmarked grave, was buried in the Abbey on the 11th of November, 1920 and covered with six barrels of Flanders earth. The inscription on his coffin read: *'A British Warrior Who Fell in the Great War 1914-1918. For King and Country'.*
9th November, 1920

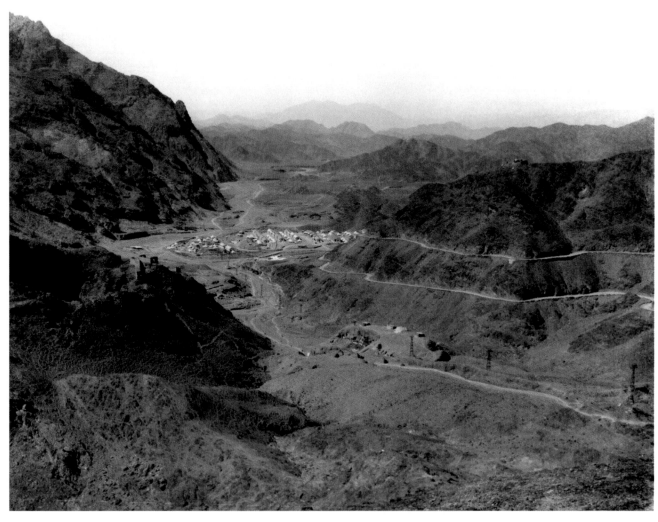

The North West Frontier of India, showing the northern
entrance of the Khyber Pass at Landi Khana, occupied by
the 1st Gurkha Rifles. The mountains beyond are Afghan
territory. The region was the background for numerous
uprisings and conflicts under British rule.
5th March, 1922

Sepoy Ishar Singh of the 28th Punjab Regiment becomes the first Sikh soldier to receive the Victoria Cross, the British Empire's highest military honour for bravery. He was cited for conspicuous bravery in Waziristan, then a political hotspot near the Afghan border.

10th March, 1922

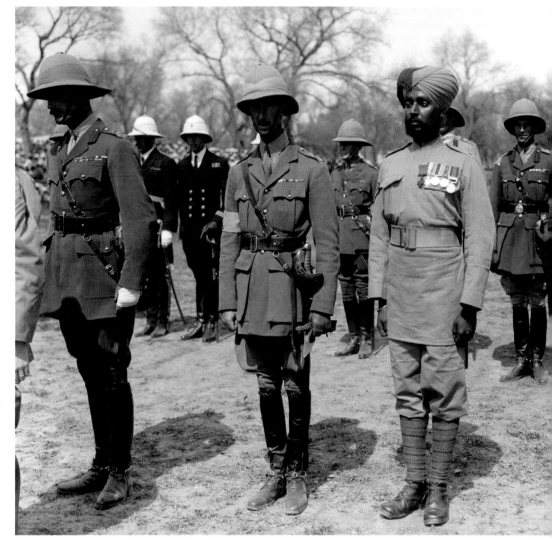

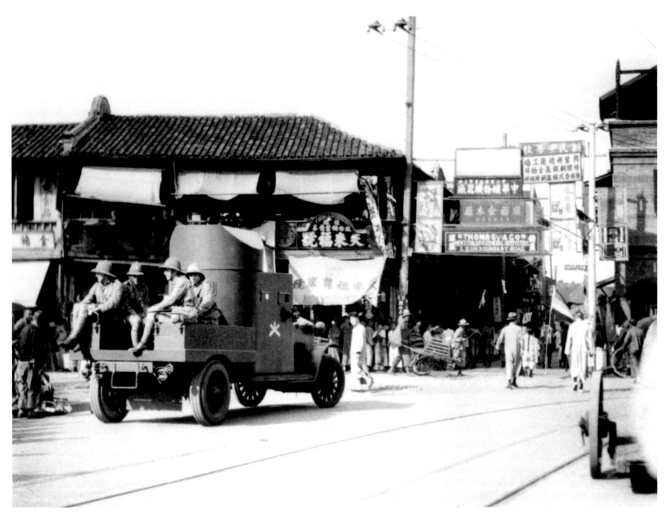

A British armoured car
patrols a street in Shanghai,
China, during a tense period
of nationalist-communist
conflict.
2nd February, 1927

Facing page: French soldiers salute as British troops leave
the Buller Barracks in Wiesbaden. There had been a British
Army presence in Germany since the conclusion of the First
World War.
13th December, 1929

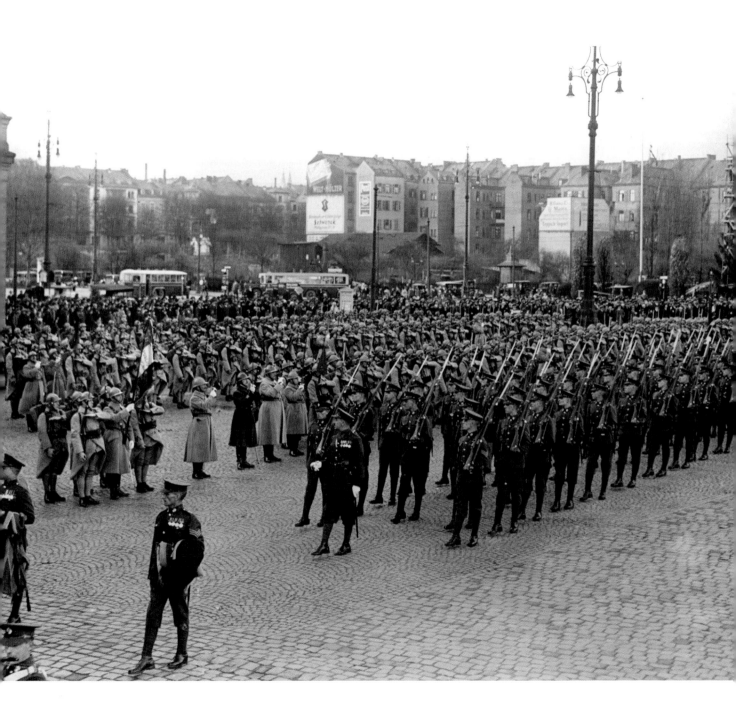

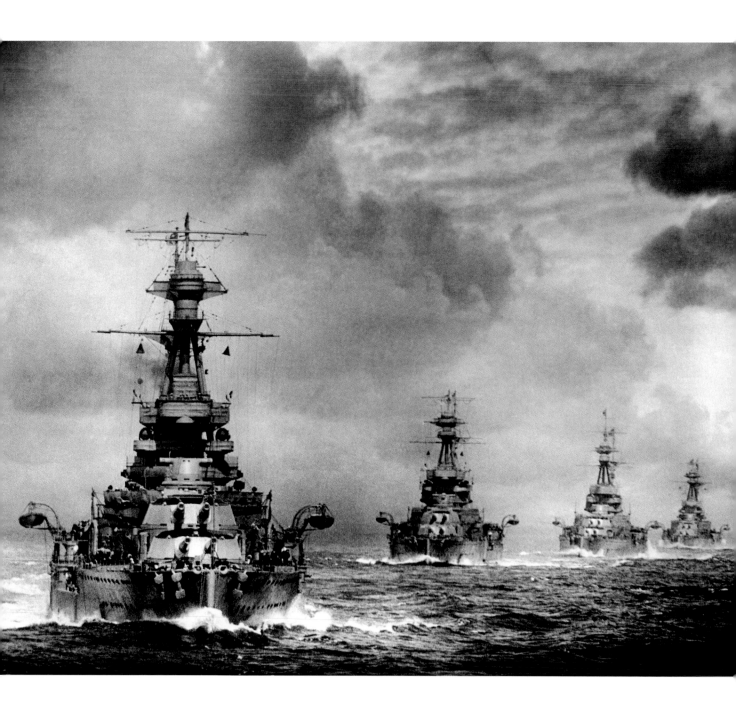

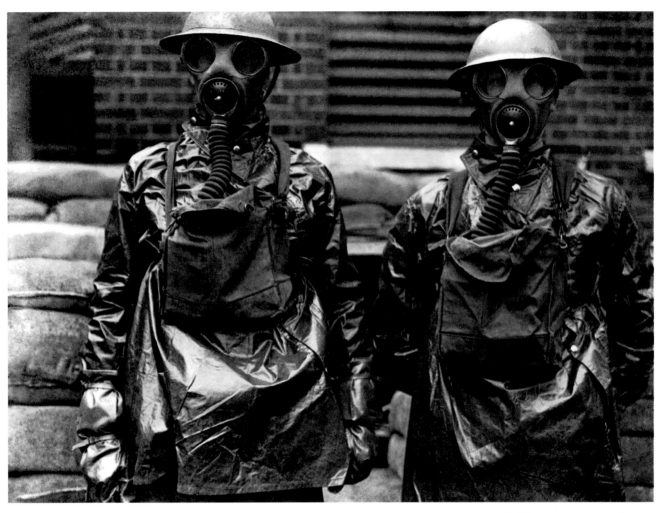

Soldiers wear gas masks during a 1938 air raid drill as tensions on the Continent heighten.
4th February, 1938

Facing page: Royal Navy warships put on an impressive show of strength during the inter-war period.
17th January, 1930

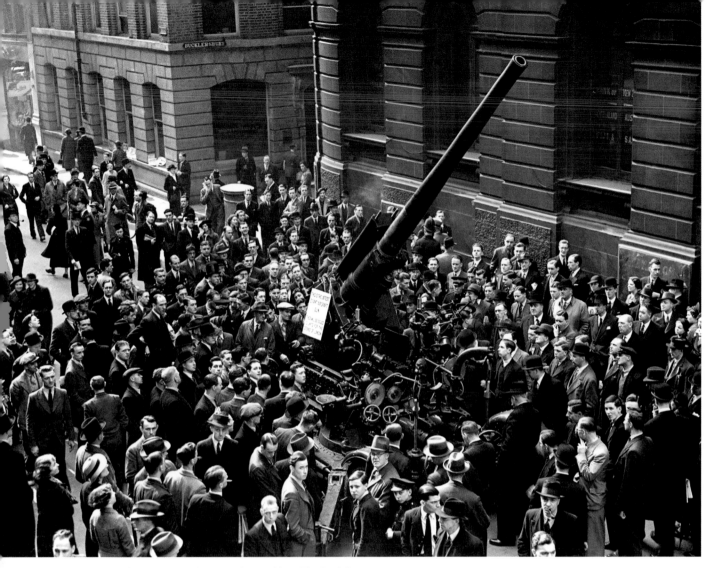

An anti-aircraft gun draws the crowds outside a Territorial Army recruiting bureau at Mansion House, London. Thousands of AA gun batteries would be installed in Britain during the Second World War.

4th February, 1938

Facing page: British Prime Minister Neville Chamberlain returns from talks with German Chancellor Adolf Hitler in Munich. He holds an agreement signed by the Führer, which he believes shows Germany's desire never to go to war with Britain again. Chamberlain hails the talks as securing *"peace for our time"* but Hitler invades Poland on the 1st of September the following year, sparking the Second World War.

30th September, 1938

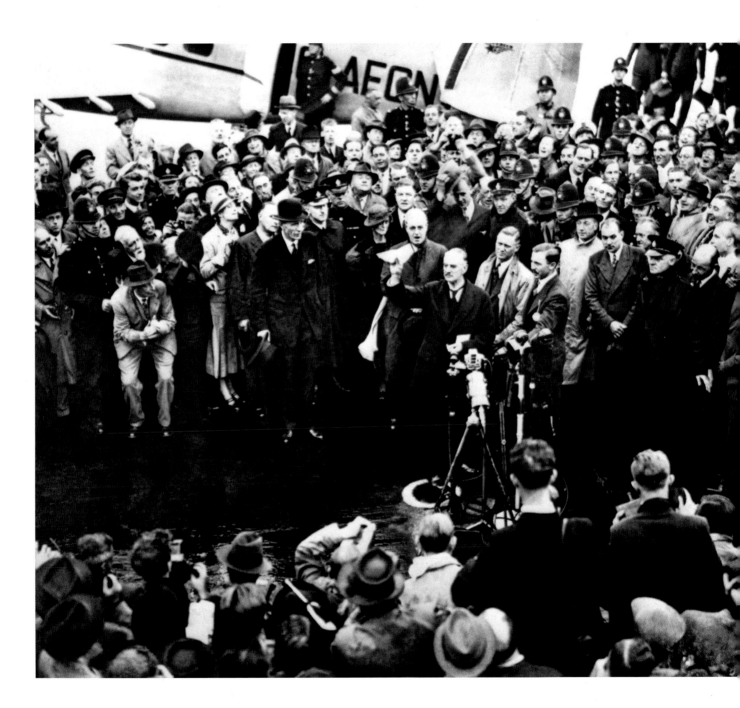

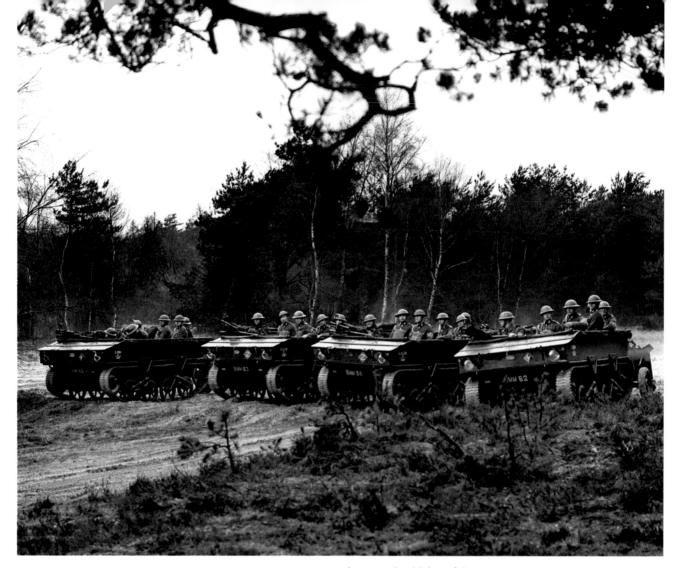

Armoured vehicles of the
British Army take part in a
military exercise.
10th January, 1939

MPs inspect a 3.7in anti-aircraft gun. With a greater altitude range than weapons of the First World War, more than 1,000 were in use by 1940.
10th January, 1939

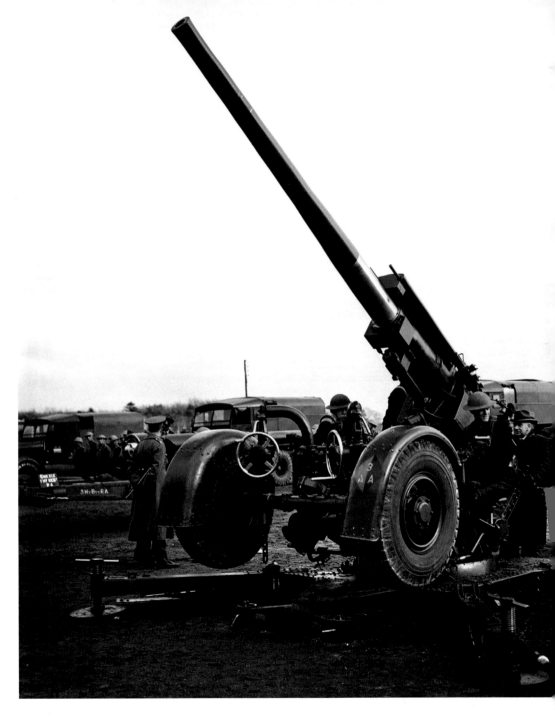

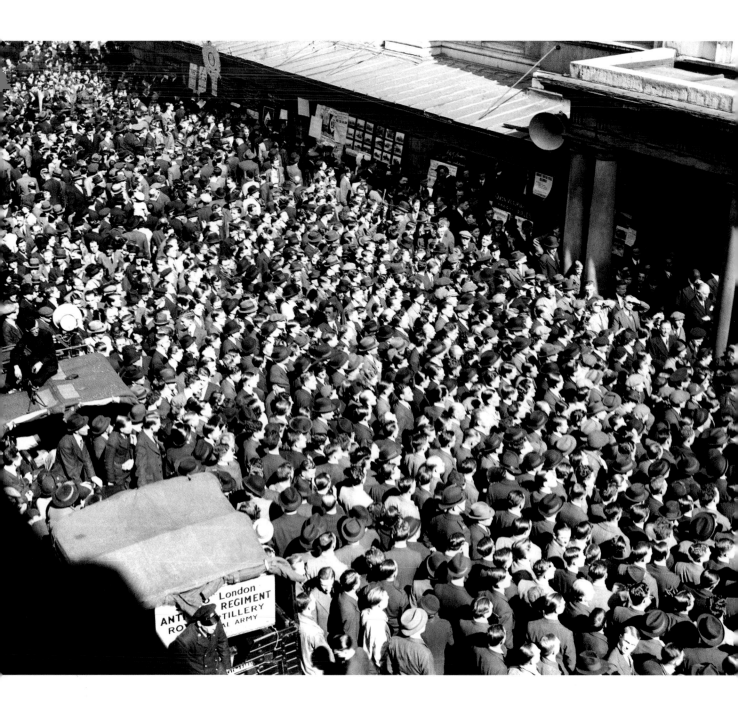

Facing page: In a fervent display of patriotism, hundreds of men queue to join the Territorial Army. Early in 1939 it was announced that the number of men serving in the Territorials would be increased to 340,000.
10th April, 1939

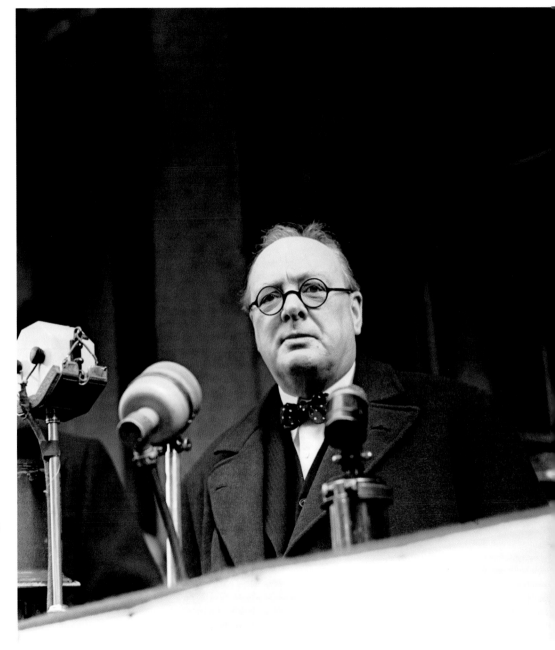

Winston Churchill addresses a recruiting meeting at Mansion House in London as tensions rise overseas. He would serve in the War Cabinet and become Prime Minister a year later.
24th April, 1939

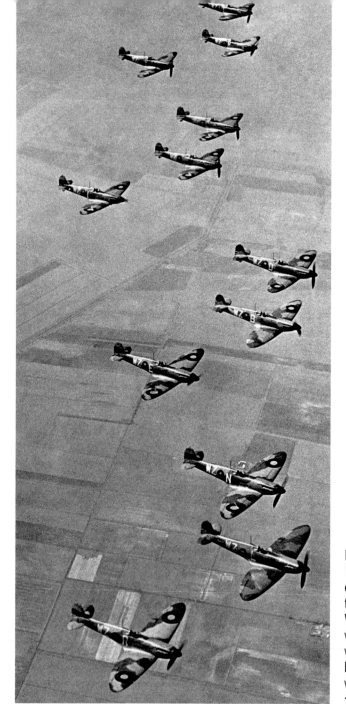

Supermarine *Spitfires* of No 19 Fighter Squadron, based at Duxford in Cambridgeshire, fly in formation. The agile plane would prove an indispensable aircraft in the Battle of Britain the following year.
1st May, 1939

Facing page: Vickers *Wellington* bombers on RAF exercises just months before the outbreak of the Second World War. The *Wellington* was Bomber Command's key weapon until four-engined bombers appeared on a wider scale in 1941.
1st May, 1939

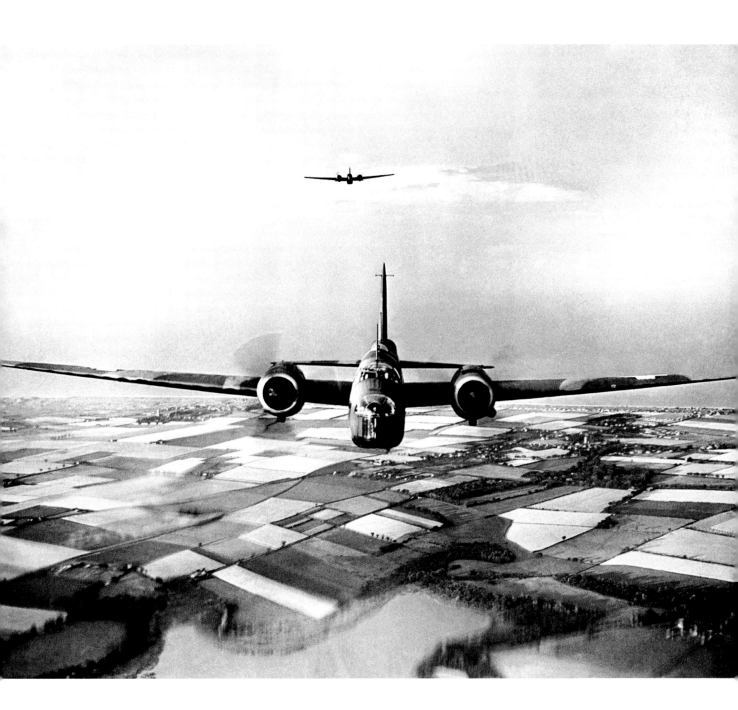

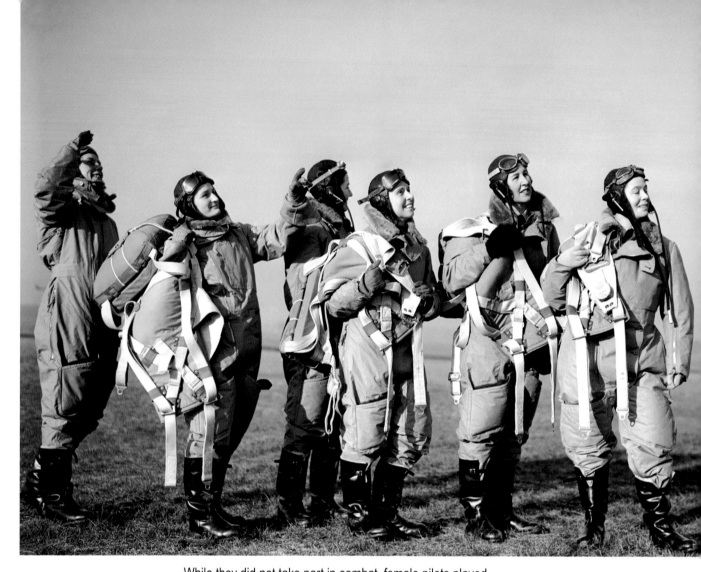

While they did not take part in combat, female pilots played a key role in the Second World War, flying new and refitted planes to air bases. In 2008 British Prime Minster Gordon Brown announced that surviving female pilots of the Air Transport Auxiliary were to receive a commemorative badge recognising their efforts.

15th June, 1939

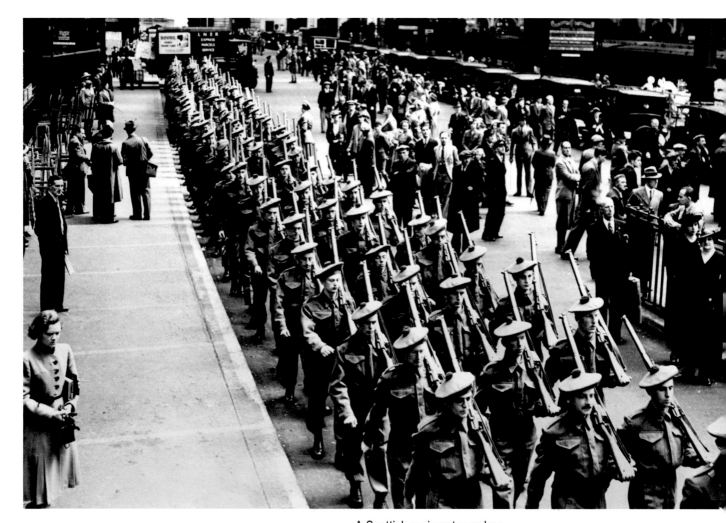

A Scottish regiment marches
through London on its way to
a camp.
1st July, 1939

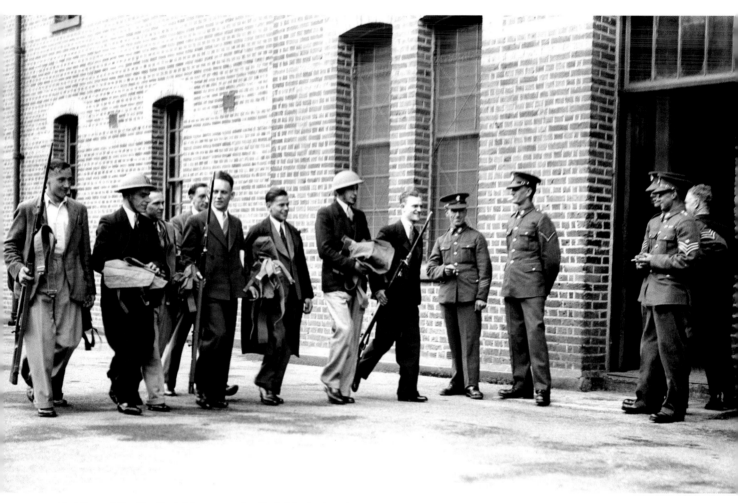

Soldiers of the Territorial Army receive their kit at a London
barracks during the build-up to the Second World War.
The Territorials were split into a 'First Line' comprising
14 armoured and infantry divisions and a 'Second Line' of
12 divisions.
24th July, 1939

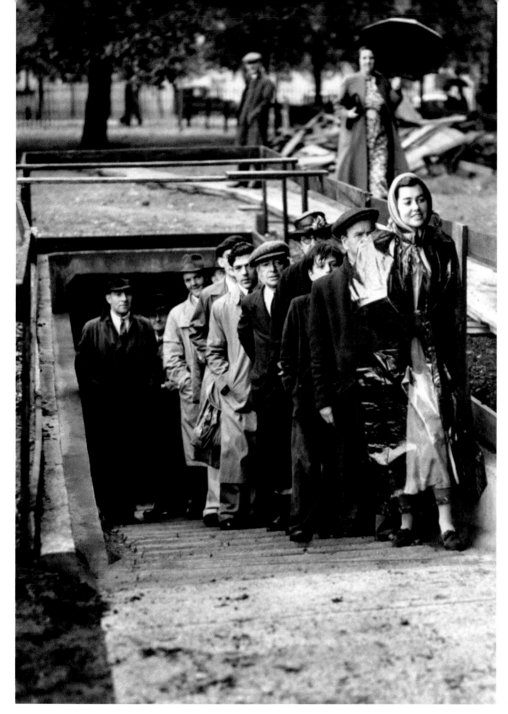

Civilians emerge from an air raid shelter into a London Park. Members of the public used London Underground platforms as overnight shelters during the Second World War. In 1940 work began on a number of deep-level shelters below existing tube stations, designed to hold up to 8,000 people each.

August, 1939

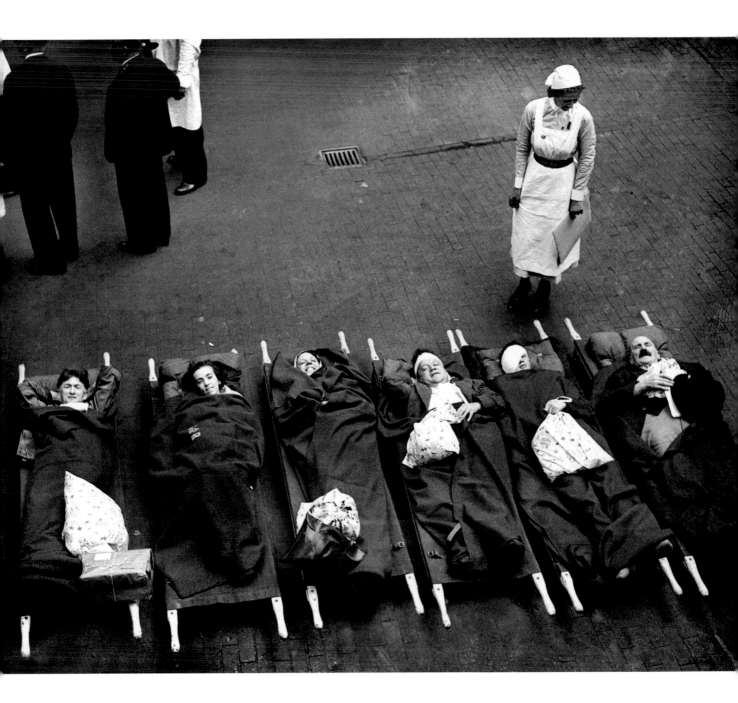

Facing page: Patients are evacuated from St Bartholomew's Hospital in Smithfield, London. Most of its nursing staff and patients were moved from the centre of the capital, either to Hill End or Cell Barnes hospitals in St Albans, as the threat of air attack increased. St Bart's was affected by bombing as early as September 1940.

August, 1939

London's Piccadilly Circus just before the start of the Second World War. The famous Shaftesbury Memorial with its winged statue (not actually *Eros*, but his brother *Anteros*) has been covered prior to being removed for the duration of the conflict.

August, 1939

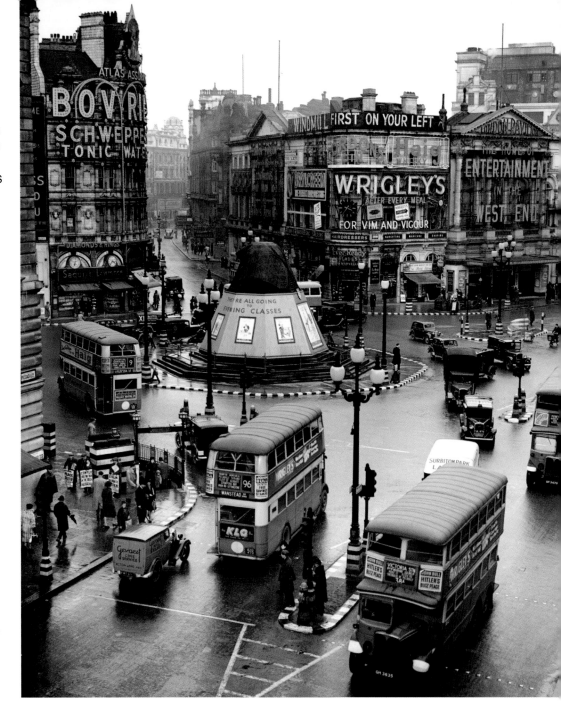

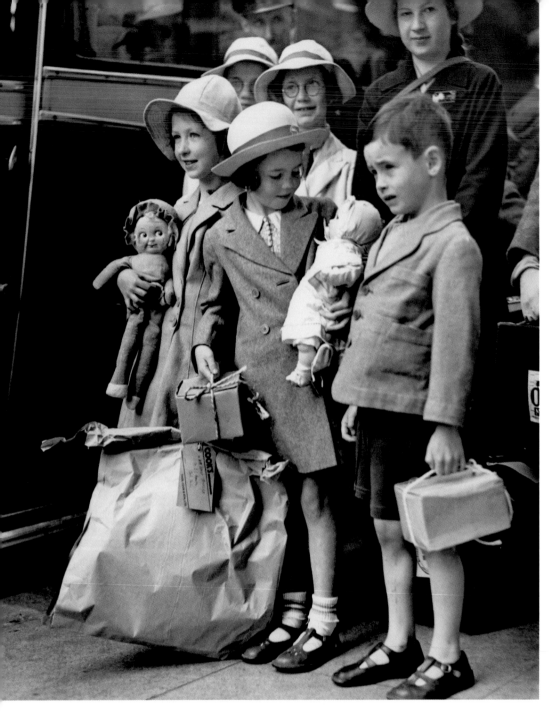

Children, carrying their luggage and gas mask boxes, prepare to be evacuated from London to the relative safety of the countryside. Around three million people, the majority of them children, were moved from urban areas at risk from bombing, during Operation Pied Piper.
1st September, 1939

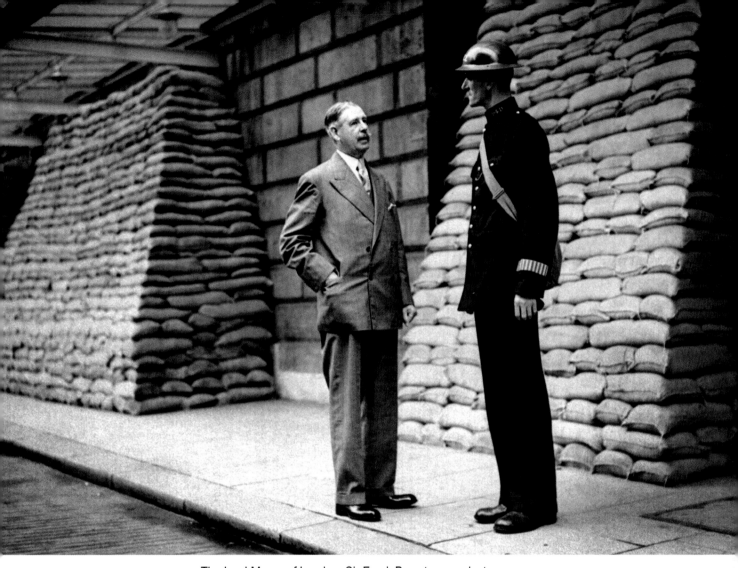

The Lord Mayor of London, Sir Frank Bowater, speaks to
PC Nichols, the City's tallest policeman. Behind them, huge
numbers of sandbags have been used to protect the front of
a building from air raid damage.
September, 1939

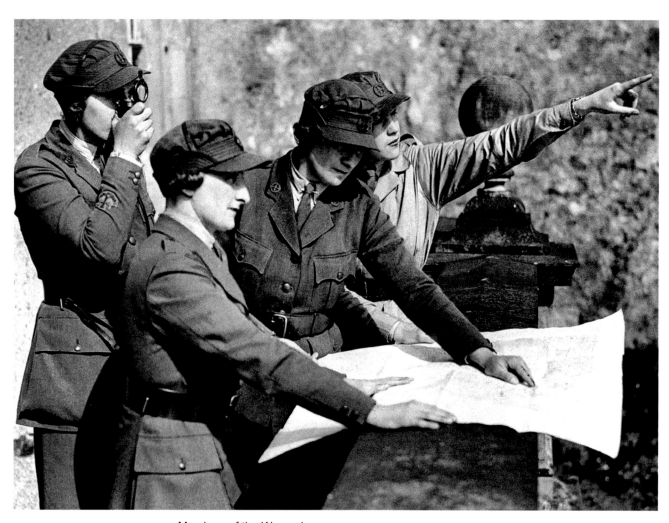

Members of the Women's
Transport Service (Northern
Ireland Section) study a map
from the terrace of Killyleagh
Castle in County Down.
September, 1939

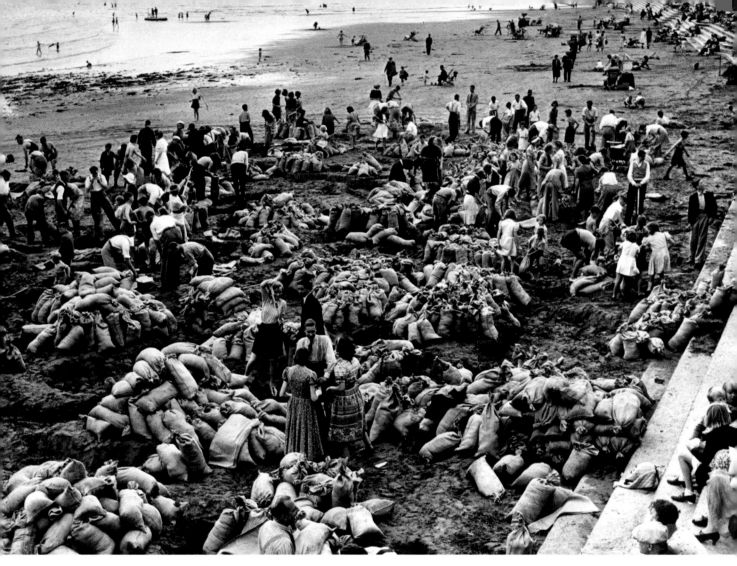

Holidaymakers, evacuees
and residents help Air Raid
Precaution (ARP) wardens
fill sandbags on the beach at
Torquay in Devon. The bags
would be used to protect
buildings from bomb blasts.
September, 1939

Gunners at an anti-aircraft battery on Wanstead Flats in east London relax with a game of darts. Their aim would need to be even more accurate in the years to come.
September, 1939

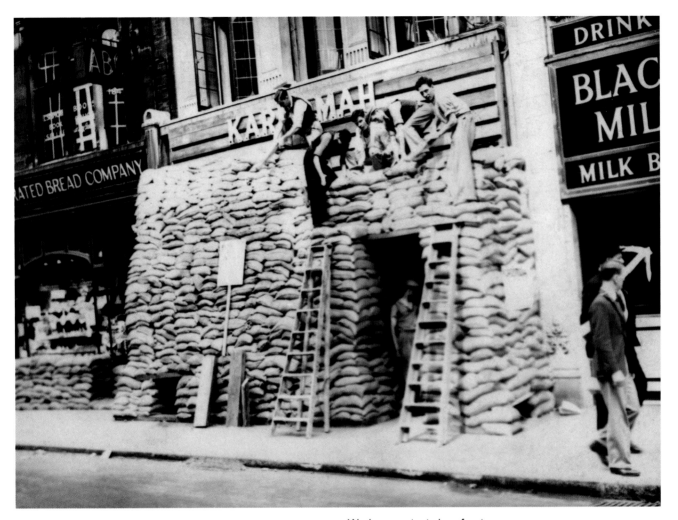

Workers protect shop fronts
with sandbags during the early
days of the Second World War.
3rd September, 1939

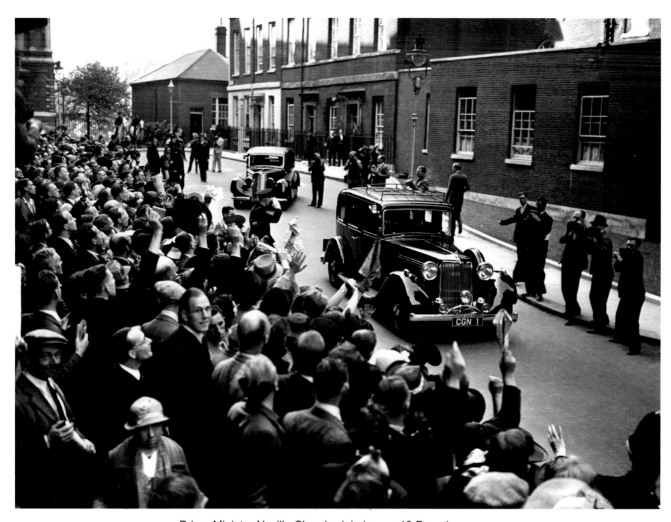

Prime Minister Neville Chamberlain leaves 10 Downing
Street at the beginning of the Second World War.
Chamberlain famously broadcast the news on BBC radio
that, following the German invasion of Poland, *this country
is at war with Germany*".
3rd September, 1939

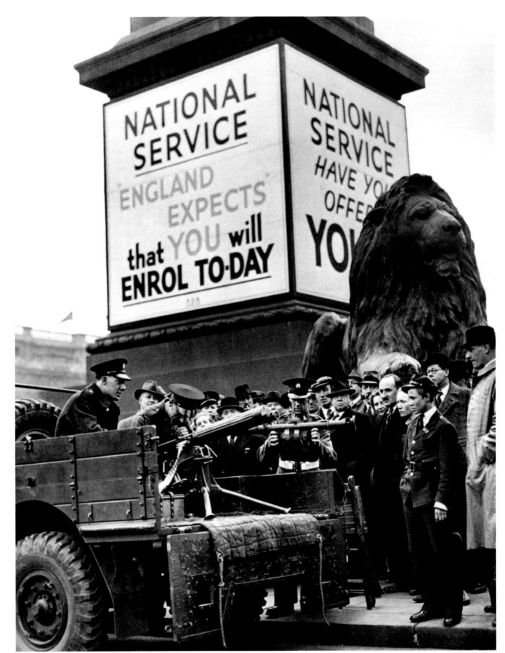

Soldiers demonstrate a Vickers machine gun and range finder to onlookers in Trafalgar Square as part of a recruitment drive at the start of the Second World War. The huge poster at the foot of Nelson's Column leaves civilians in little doubt as to what their country expects of them.

5th September, 1939

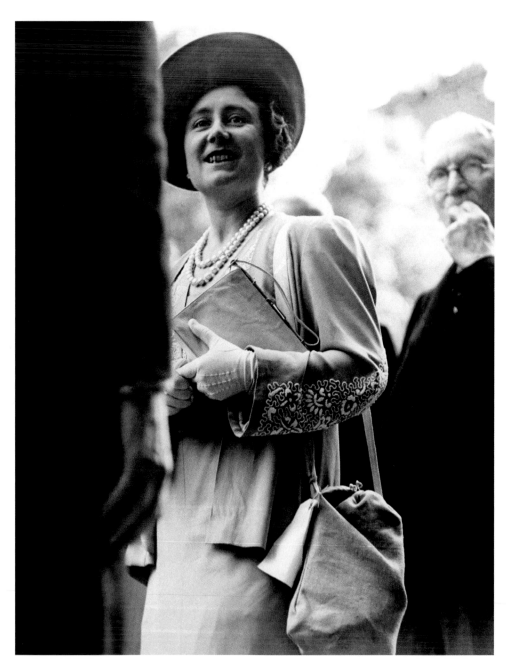

Queen Elizabeth, who became Queen Elizabeth the Queen Mother following the death of her husband King George VI, arrives at the British Red Cross Society in Grosvenor Crescent, London. The Royal Family played an important role in maintaining the nation's morale during the Second World War.
6th September, 1939

Britain at War • Twentieth Century in Pictures

Volunteers sign up for
the Auxiliary Territorial
Service (ATS), the women's
branch of the British Army,
in Chelsea. In 1941 the
National Service Act was
passed, calling up unmarried
women to the war effort. The
ATS ultimately comprised
190,000 members.
9th September, 1939

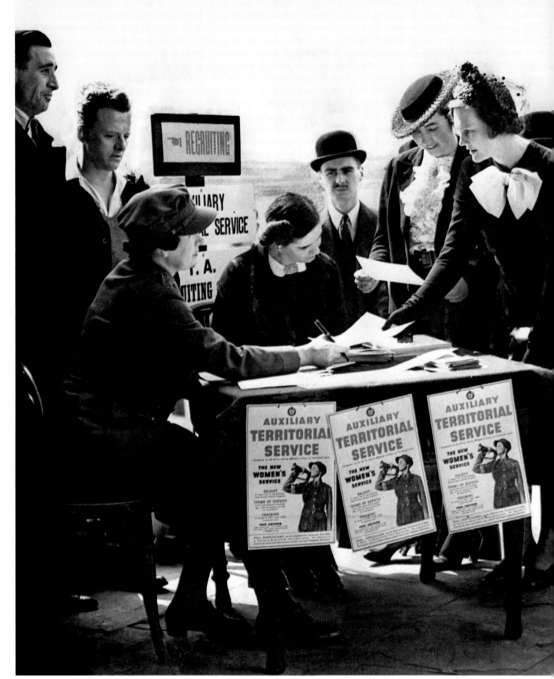

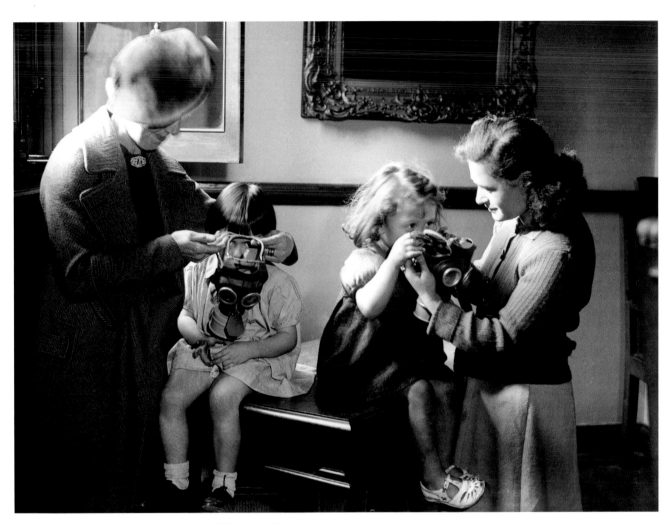

Every civilian in Britain was
issued with a mask due
to the fear of German gas
attacks. Persuading children
to try on the uncomfortable
apparatus was sometimes a
difficult task.
12th September, 1939

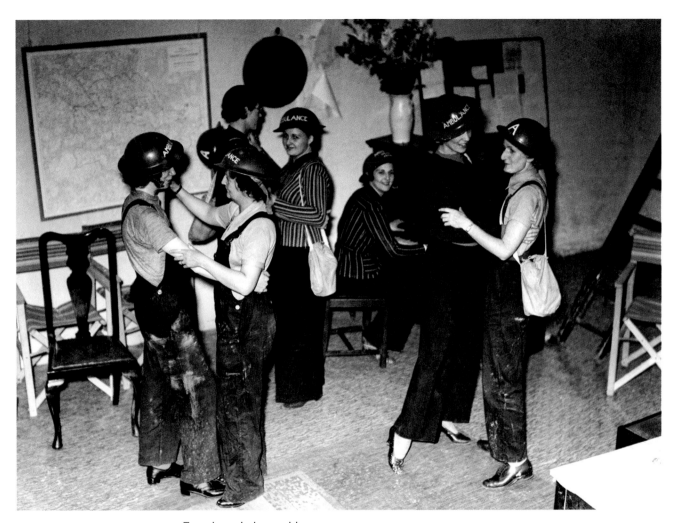

Female ambulance drivers
enjoy a spot of dancing,
accompanied by a piano.
12th September, 1939

An air raid siren is erected
on a London street. When
civilians heard the siren's
distinctive rising and falling
tone, they would make
for the nearest shelter.
Many homes had their
own Morrison or Anderson
shelters while some
took refuge on London
Underground platforms.
12th September, 1939

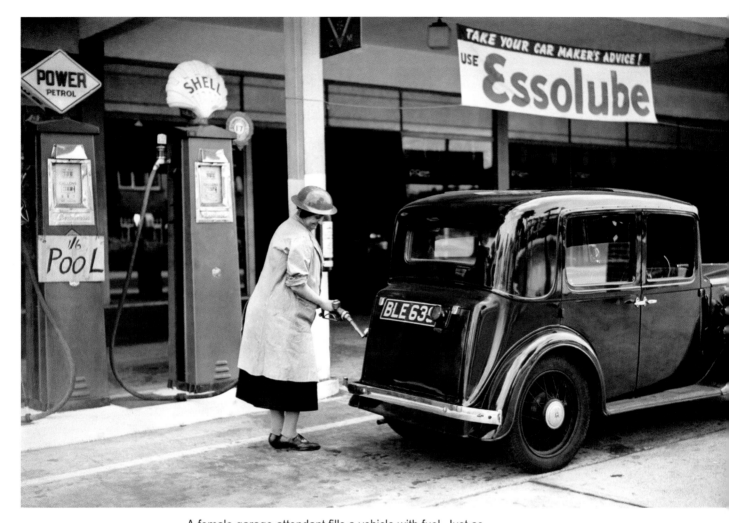

A female garage attendant fills a vehicle with fuel. Just as foodstuffs and clothing were rationed during the Second World War, there were quotas for petrol usage, which were not relaxed until 1950, five years after the end of hostilities.
12th September, 1939

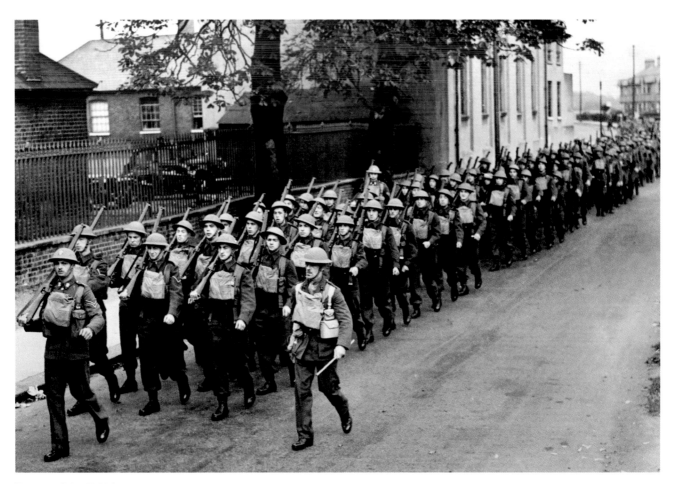

Troops of the British
Expeditionary Force march
through London streets
during the early days of the
Second World War.
15th September, 1939

Facing page: A rope is tied
to the entrance door of a
garden Anderson shelter, so
occupants can find their way
to it in the blackout.
4th October, 1939

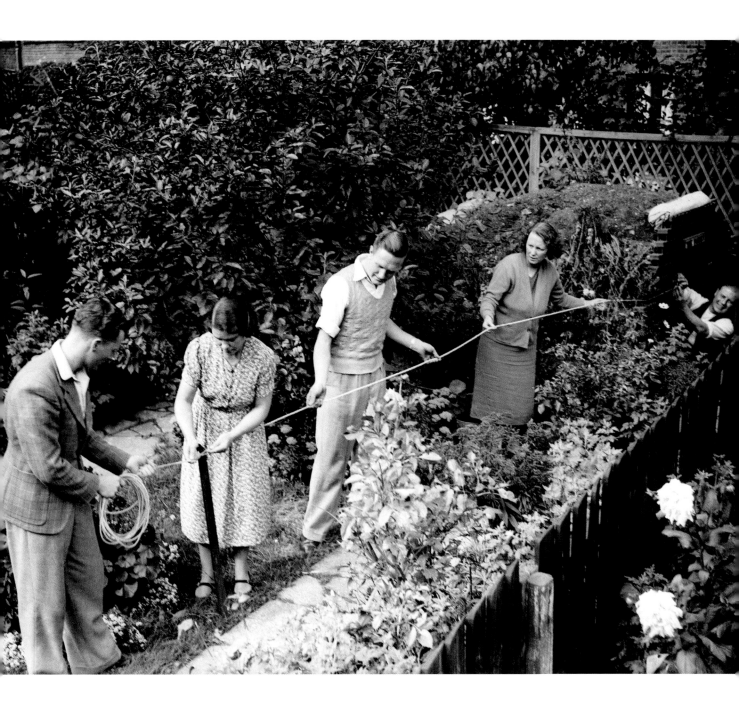

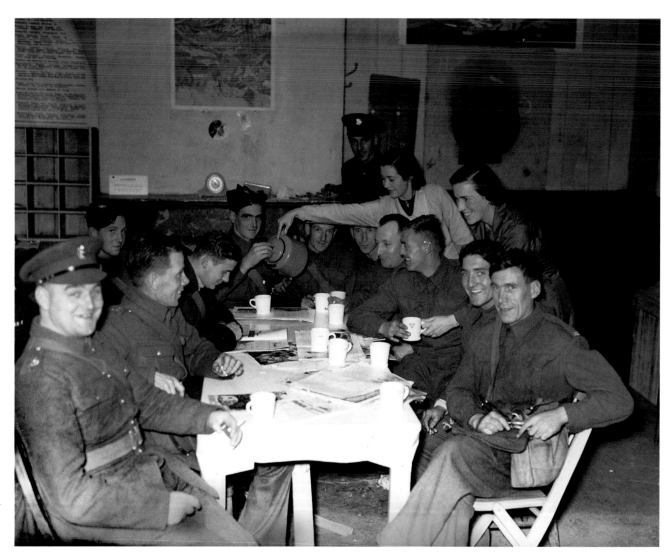

Soldiers of the British Army
enjoy tea in an air raid
shelter.
4th October, 1939

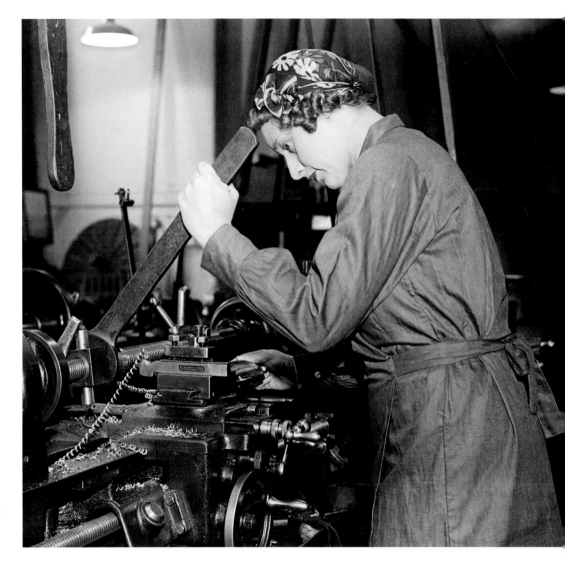

A woman trains at the Paddington Technical Institute in London. Women engineers were vital to industry with large numbers of men on active service.

4th October, 1939

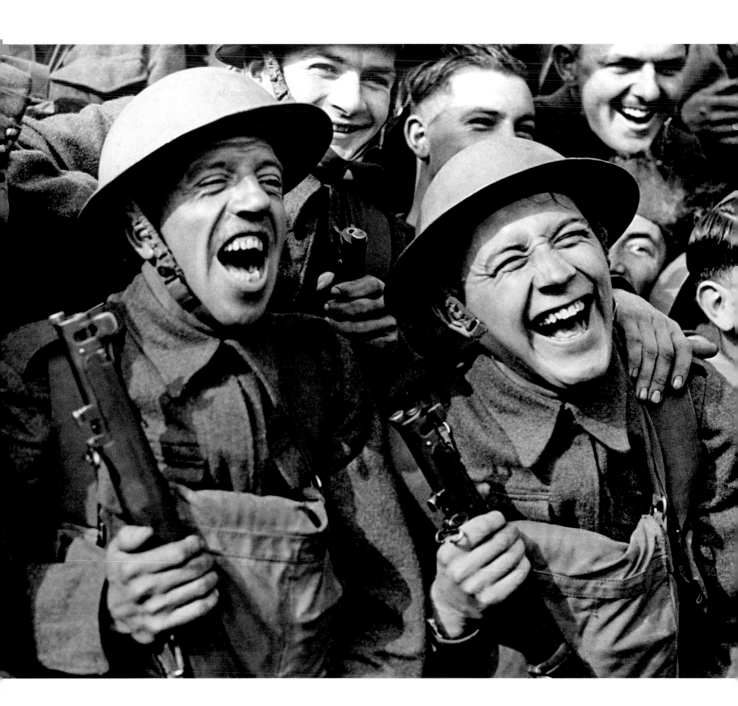

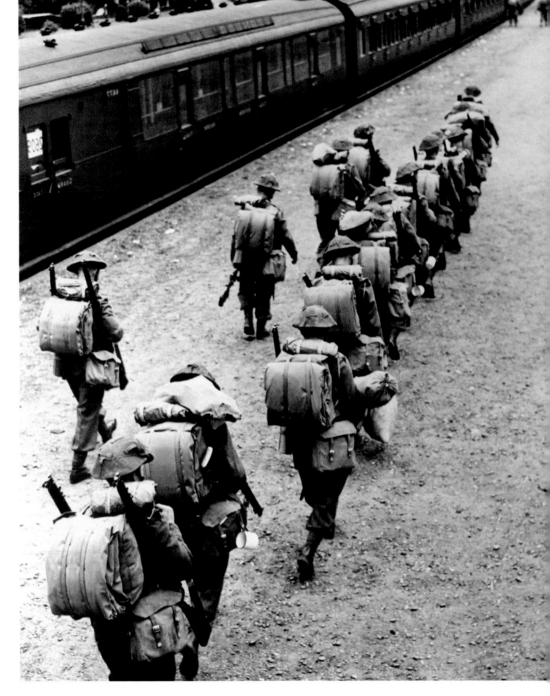

Facing page: Troops enjoy an Entertainments National Service Association (ENSA) show. The likes of 'forces sweetheart' Vera Lynn, entertainer George Formby and comics Harry Secombe and Spike Milligan played a vital morale-building role during the Second World War.
8th October, 1939

Soldiers prepare to board a train on their way to France as part of the British Expeditionary Force.
10th October, 1939

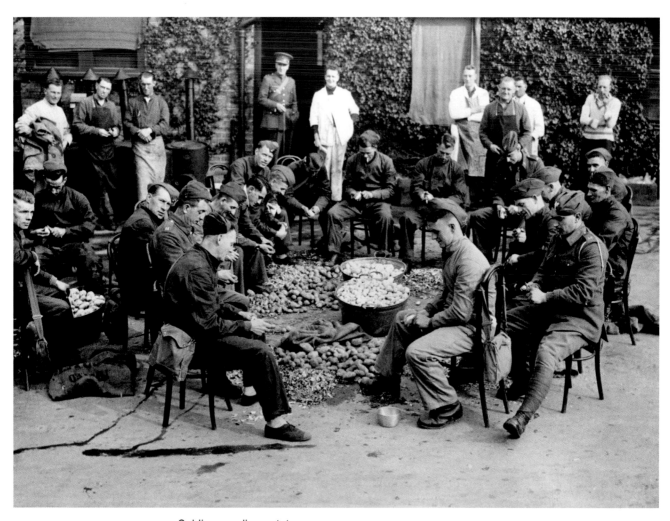

Soldiers peeling potatoes
– a tedious yet necessary
diversion.
10th October, 1939

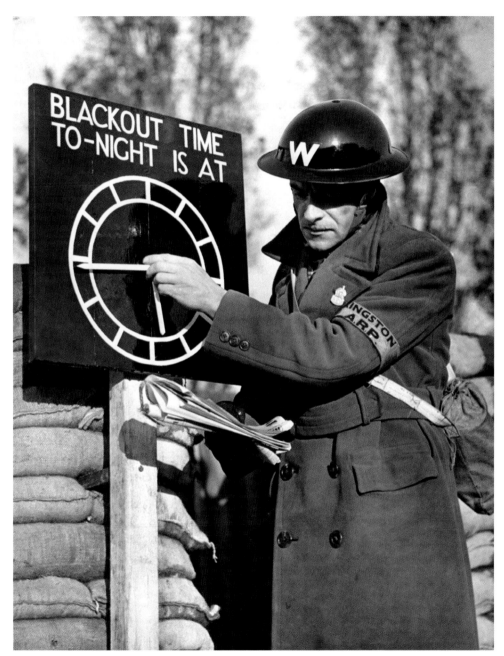

A warden sets a blackout time clock indicator at an Air Raid Precautions (ARP) site near London. Keeping lighting to a minimum at night made it more difficult for German bombers to attack urban areas. Civilians used close-fitting blackout blinds on windows and other measures to lessen the aerial threat. Cries of *"Put that light out!"* became common from irate wardens.
1st November, 1939

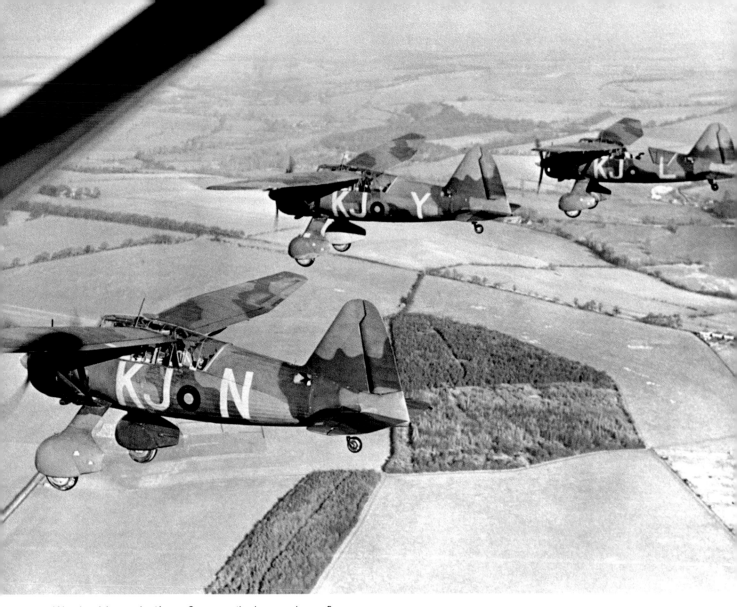

Westland *Lysander* 'Army Co-operation' monoplanes fly over Salisbury Plain in Wiltshire. Boasting short take-off distances, the *Lysander* was invaluable in the picking up and dropping off of agents in enemy territory.
1st November, 1939

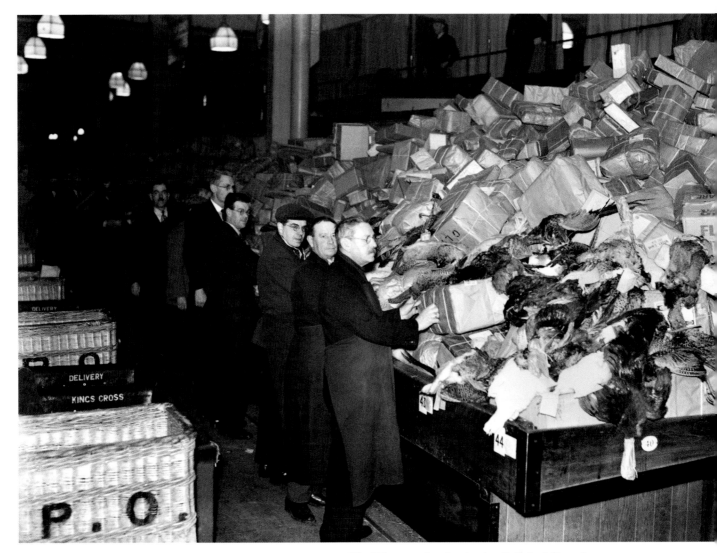

The War wasn't going to stop British civilians from celebrating Christmas. Thousands of parcels are processed at Mount Pleasant sorting office in London.
7th November, 1939

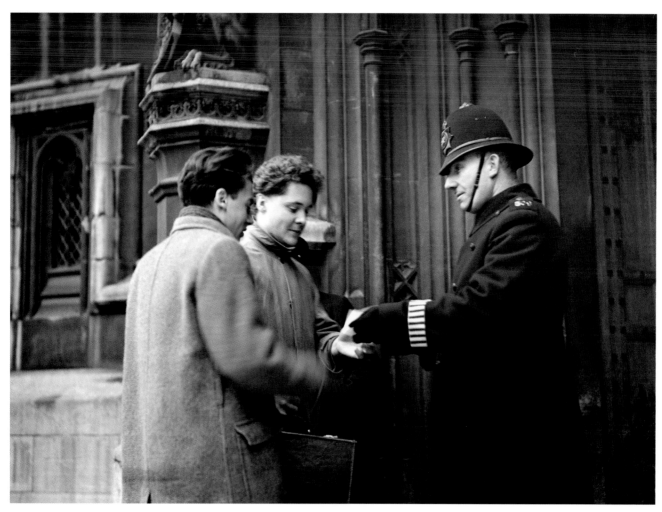

A policeman carefully
scrutinises two men's House
of Commons passes during
the early months of the
Second World War.
13th December, 1939

Facing page: Civil air guards line up on parade. In 1938, with
the threat of war with Germany looming, the Civil Air Guard
(CAG) was formed by the Air Minister, Sir Kingsley Wood to
provide inexpensive flying tuition for men and women aged
18 to 50. When war came the Guard would be able to offer
the RAF its services.
15th December, 1939

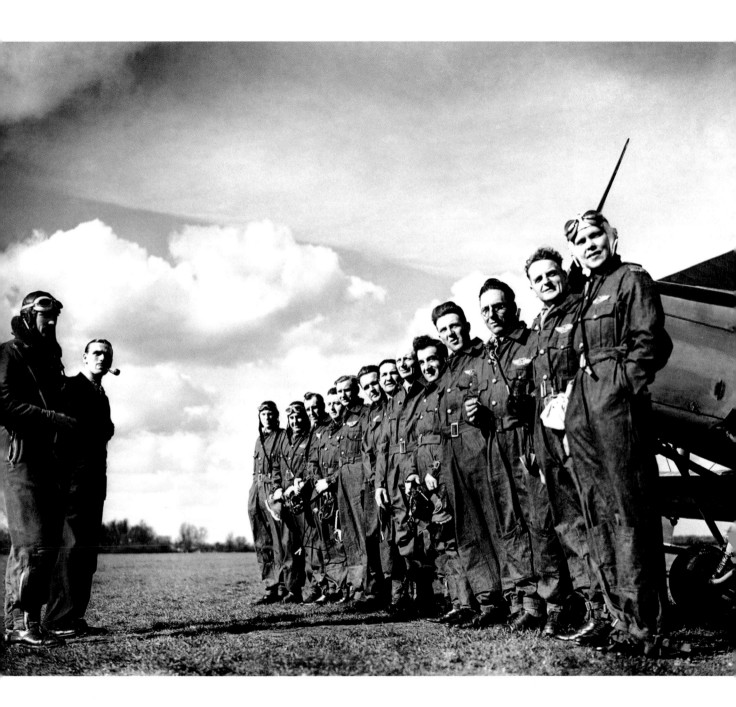

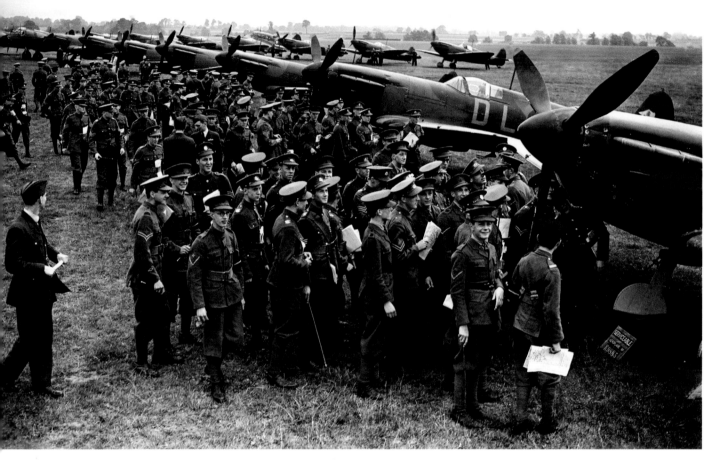

Public school cadets inspect the iconic British plane of the
Second World War – the *Spitfire*. Originally designed by
Reginald J Mitchell and powered by a 1,030hp Rolls-Royce
Merlin engine, the fast and graceful *Spitfire* earned a special
place in British hearts.
15th December, 1939

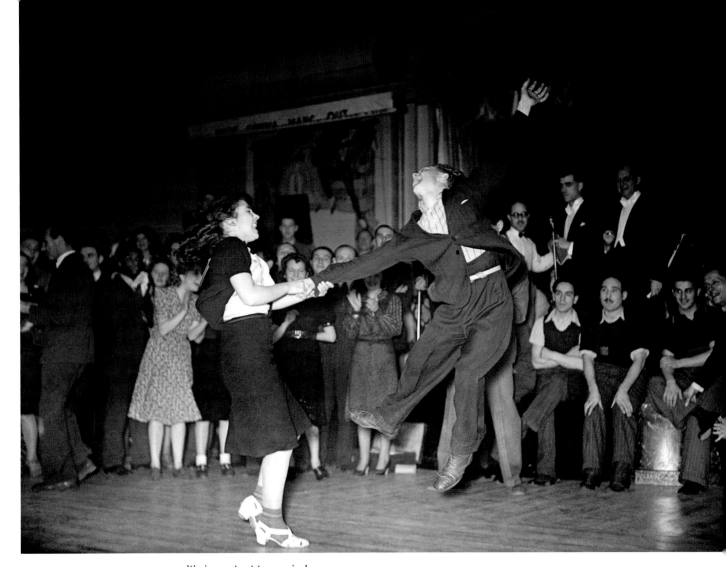

It's important to unwind, even in times of war. The athletic *Jitterbug* was a popular form of dance during the 1930s and 1940s.

16th December, 1939

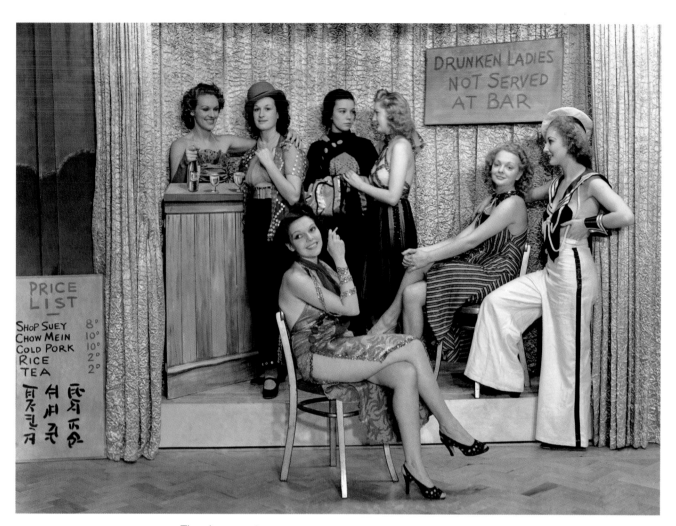

The show must go on –
cabaret girls pose at the
Paradise Club in London.
16th December, 1939

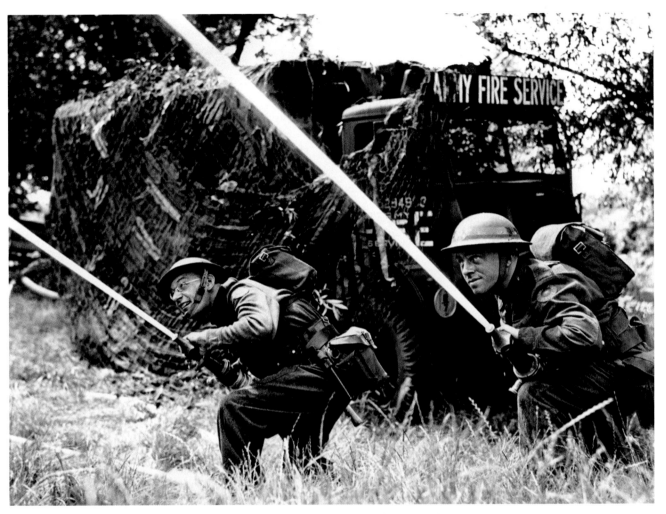

Soldiers of the British Army
Fire Service (AFS) prepare
for action early in 1940.
The AFS was responsible
for fighting fires at military
camps.
1940

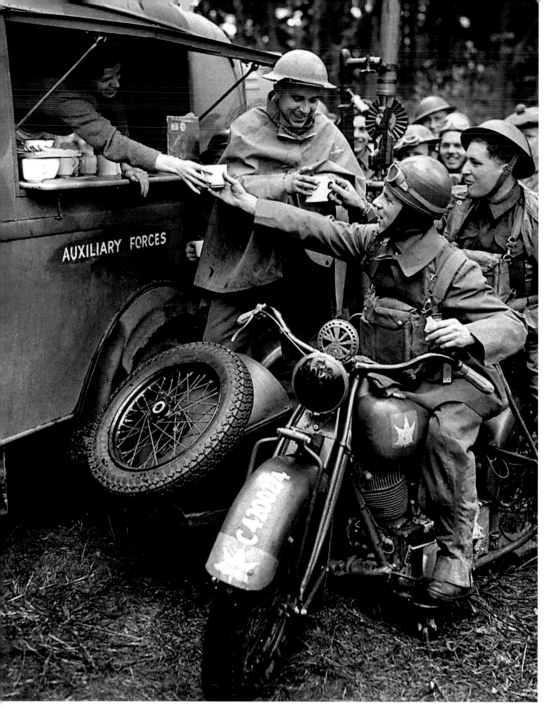

Facing page: A Royal Navy warship displays its considerable firepower. A battleship such as the HMS *Valiant* had as many as eight 15in guns and 14 6in weapons.
1940

A motorcyclist of the 1st Canadian Reconnaissance Squadron grabs a quick cup of tea. A First World War Lewis machine gun can be seen behind. The government of Canada, under Prime Minister Mackenzie King, declared war on Germany on the 10th of September, 1939, a week after the British.
1940

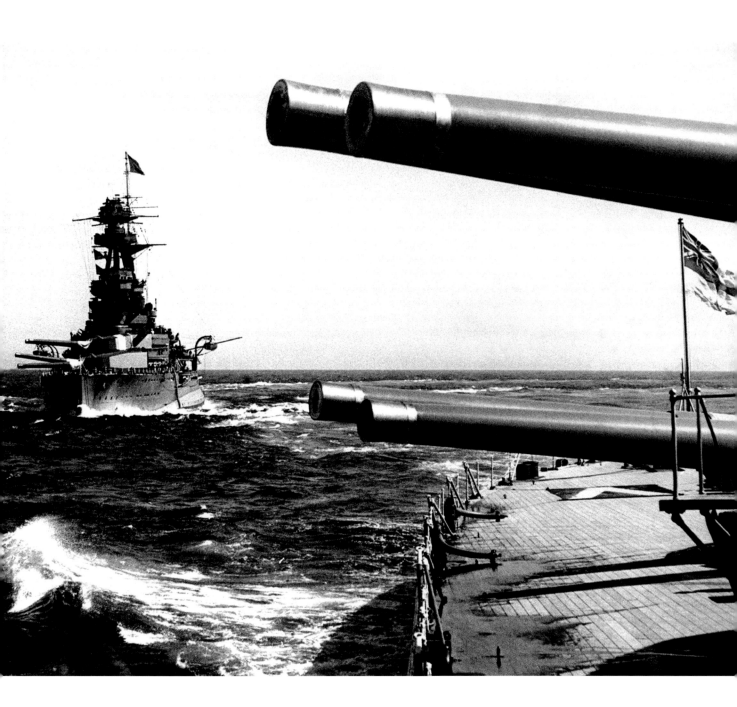

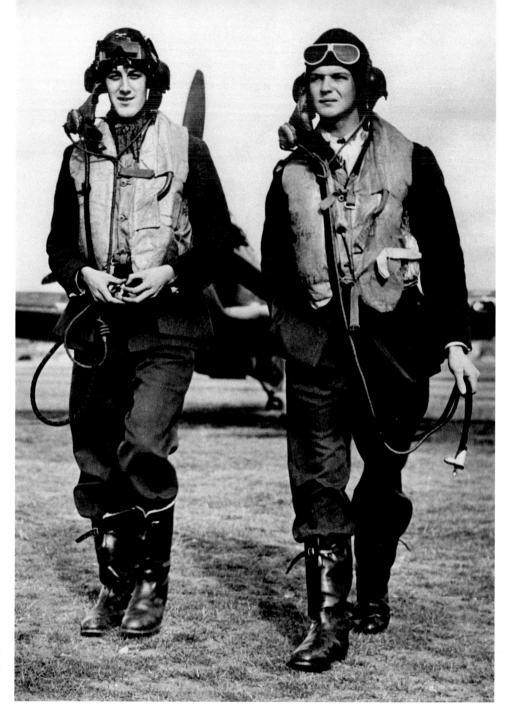

Two Royal Air Force pilots
from Fighter Command leave
their aircraft during the Battle
of Britain period.
1940

A female city worker puts on a brave face after a building is wrecked during a daylight Luftwaffe raid on London.
1940

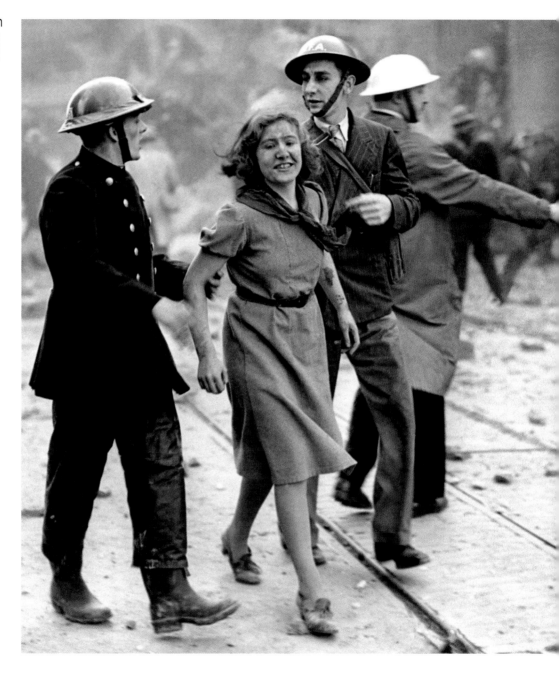

Facing page: While many children in London and other major British cities were evacuated to the country, some were sent overseas. Shown here is a group of London schoolchildren among the 1,000 who would leave their families for the relative safety of Canada.

1940

Recycling is not a new phenomenon – civilians in East Ham, London were encouraged by the Borough Corporation to save waste materials of all descriptions that could be reused for the war effort.

1940

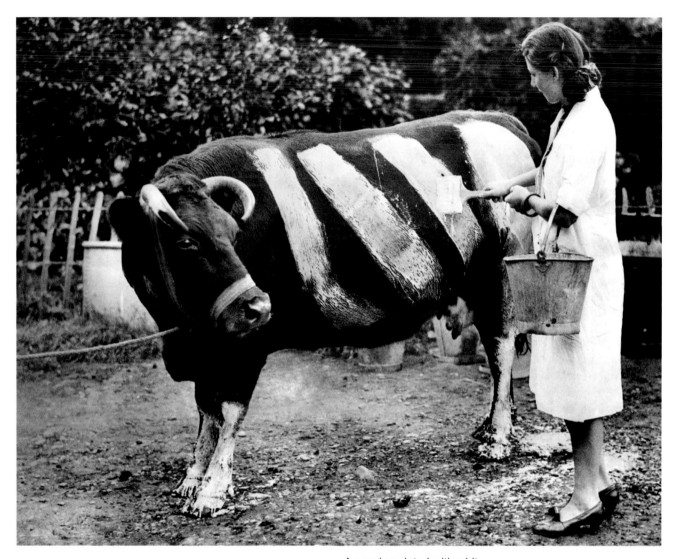

A cow is painted with white stripes for camouflage purposes. It is unclear how this practice would have aided a farmer.
24th February, 1940

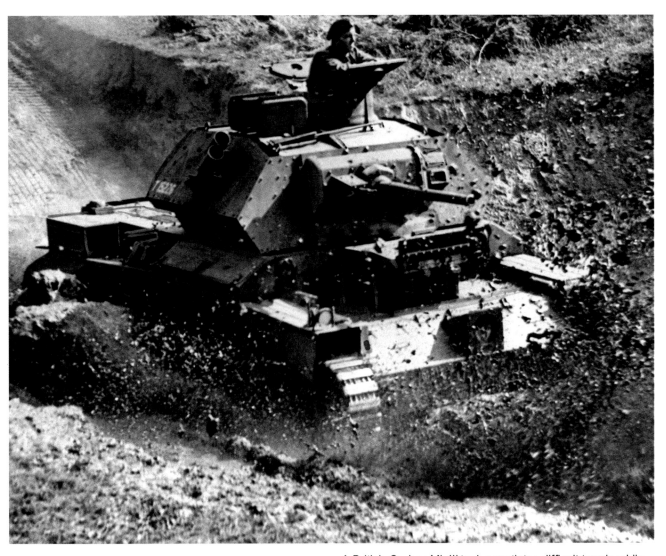

A British *Cruiser Mk III* tank negotiates difficult terrain while on manoeuvres. The tank weighed in the region of 14 tonnes but was capable of 30mph, and carried a crew comprising a commander, gunner, loader and driver.

1st March, 1940

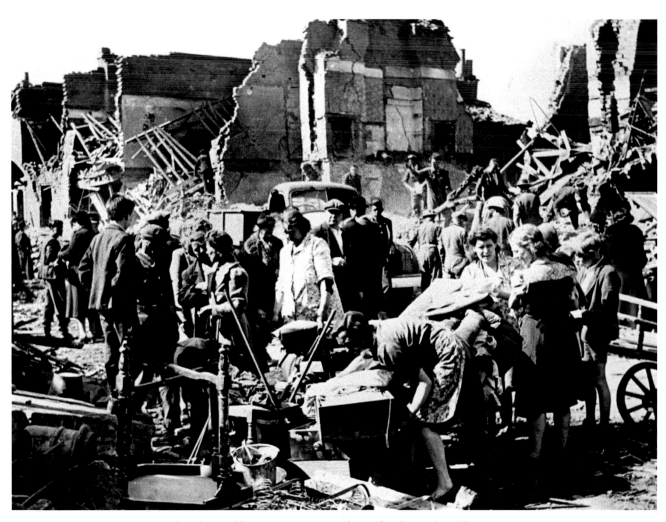

London residents rescue possessions after heavy bombing. On the 7th of September, 1940, the Luftwaffe launched a massive daylight attack on the East End, which resulted in 430 deaths. Bombers would return to London on each of the next 57 nights. The heavy aerial bombardment of the capital and other major towns and cities came to be known as the Blitz, named after the German word for lightning.
1st March, 1940

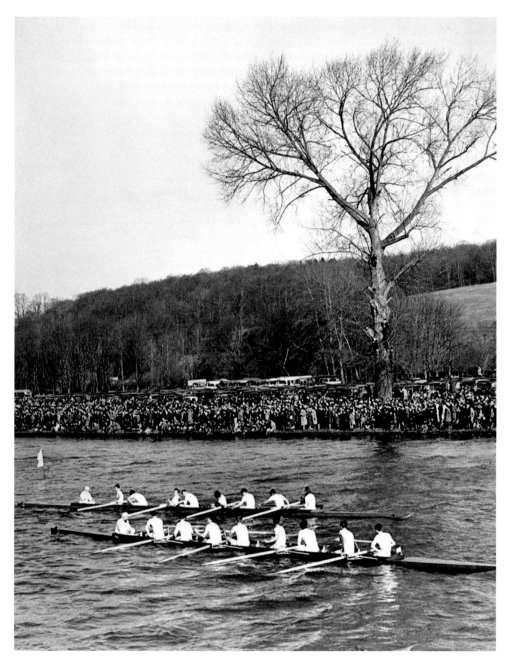

Cambridge defeat Oxford in the unofficial 1940 University Boat Race held at Henley-on-Thames. Oxford would turn the tables in unofficial races in 1943 and 1944, while their rivals reasserted their authority in 1945.

24th March, 1940

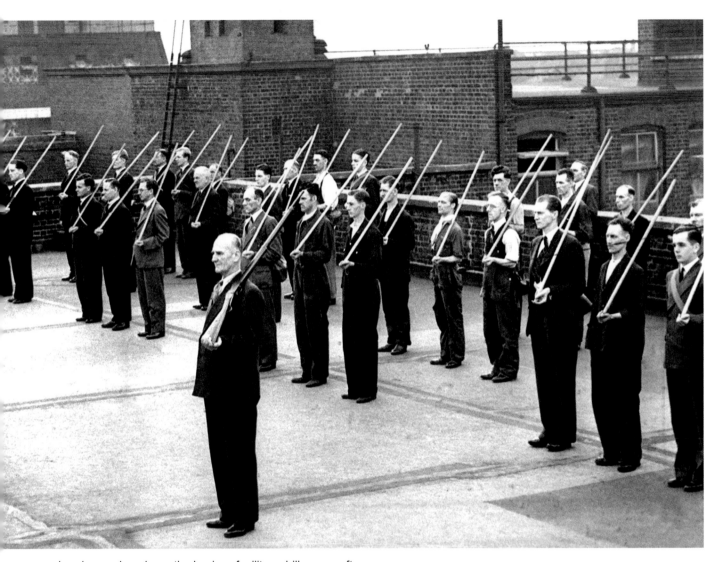

London workers learn the basics of military drill on a rooftop.
Only the man in the foreground carries a genuine weapon,
albeit an antiquated rifle.

1st May, 1940

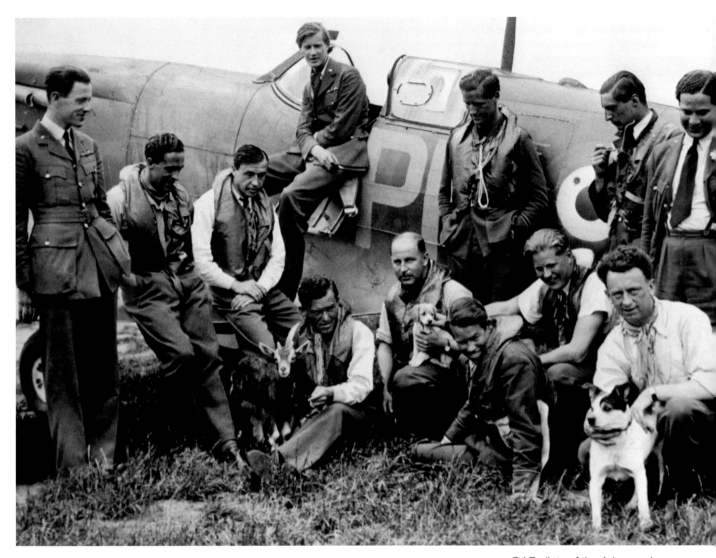

RAF pilots of the Advanced
Air Striking Force, fighting
the war over France, relax
with their mascots beside a
Spitfire.
31st May, 1940

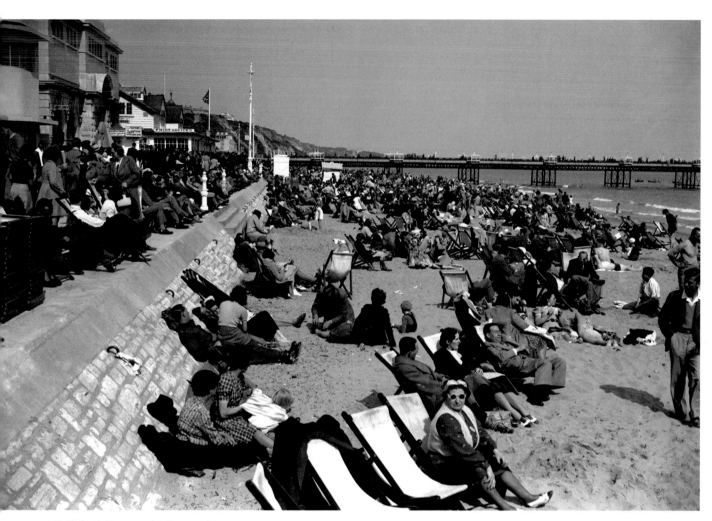

British civilians make the most of the warm weather on the beach at Bournemouth, on England's south coast – a few weeks later, the beach was closed to the public, mined and strewn with barbed wire.

1st June, 1940

Facing page: British soldiers are assisted by the Royal Navy on their return to England following the evacuation from the beaches of Dunkirk, Northern France. Approximately one third of a million troops – the majority from the British Expeditionary Force – were rescued from the advancing German Army between the 26th of May and the 4th of June, in an evacuation codenamed Operation Dynamo.

4th June, 1940

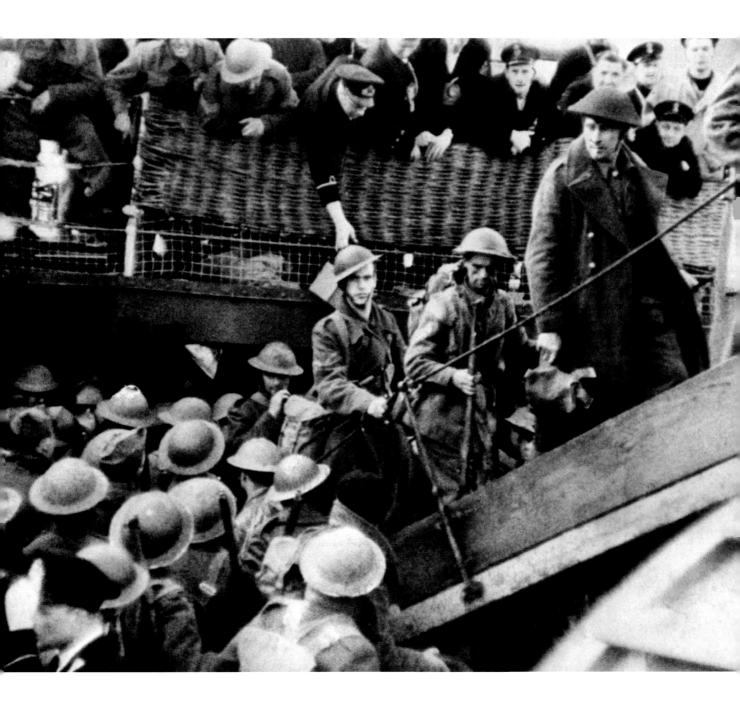

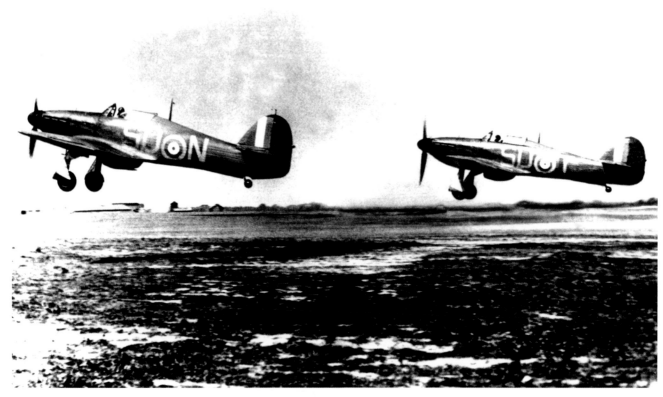

Two RAF Hawker *Hurricanes* take off from an unknown
airfield. The *Hurricane* and the *Spitfire* were Britain's
principal fighters during the Second World War and would
take on the likes of the Messerschmitt *Bf 109* for control of
the skies during the Battle of Britain in 1940.
20th July, 1940

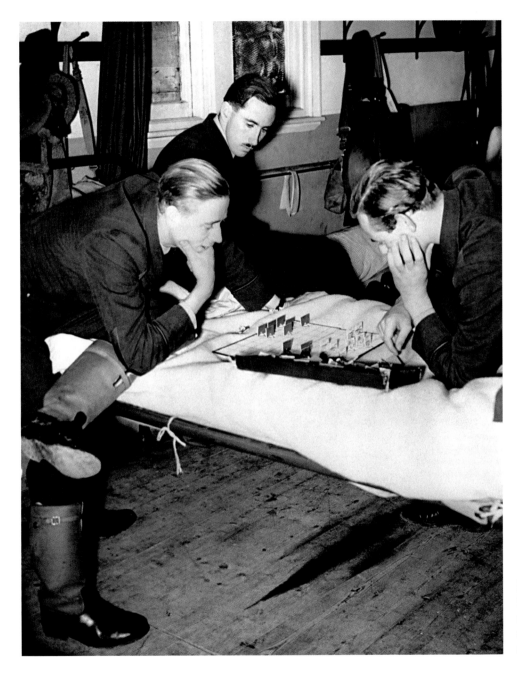

Fighter pilots of the RAF wait for the signal to 'scramble' and take to their aircraft during the Battle of Britain.
September, 1940

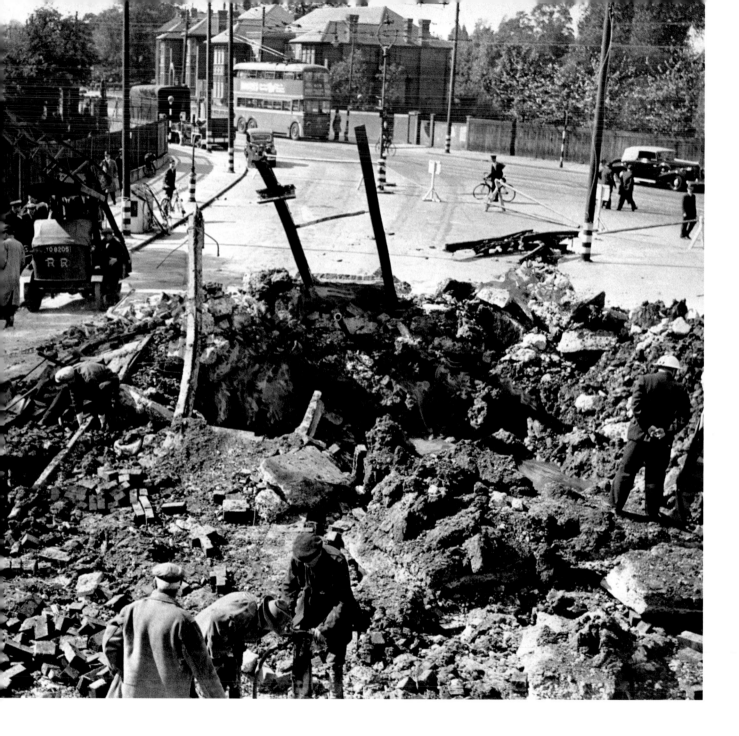

Facing page: Work goes on to repair heavy bomb damage to a road in north London.
September, 1940

A London telephone operator wearing a steel helmet continues to work at her switchboard despite the threat of German air raids.
September, 1940

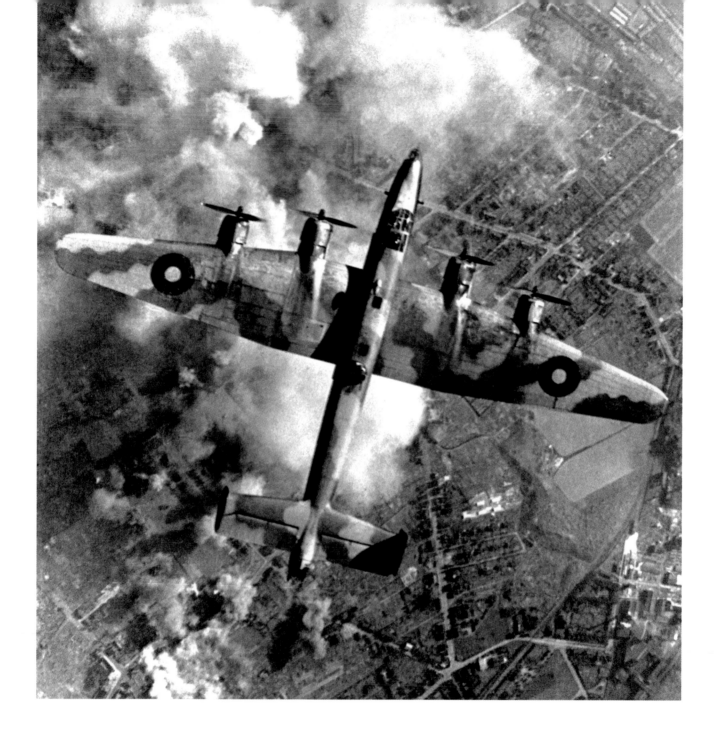

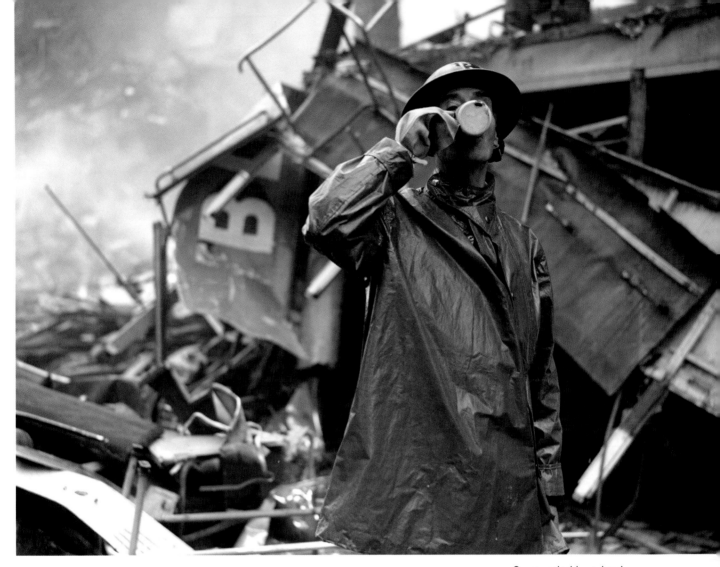

Facing page: A British *Halifax* bomber flies over its target in Germany late in 1940. Although not as famous or successful as the *Lancaster*, the *Halifax* played a vital role, continually being improved throughout the Second World War. Powered by four Rolls-Royce Merlin engines, a total of 6,176 were built before the plane was declared obsolete in 1946.
September, 1940

Surrounded by ruined buildings bombed by the Luftwaffe, a fireman takes a much-needed break during the early days of the Blitz.
9th September, 1940

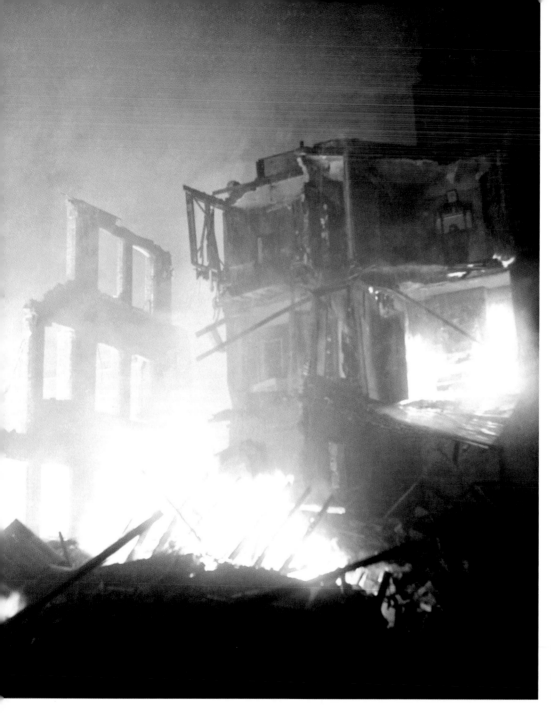

Facing page: Firemen in High Holborn, London, discuss matters during the aftermath of a German bombing raid. Built in 1940, a network of air raid shelter tunnels ran 100ft below High Holborn.

9th September, 1940

Incendiaries were dropped by the Luftwaffe throughout the Blitz, intended by Hitler to destroy British morale prior to invasion, causing huge fires in London (pictured) and other British industrial towns, cities and ports. By May 1941 some 43,000 civilians, half of them in London, had been killed in the bombing.

9th September, 1940

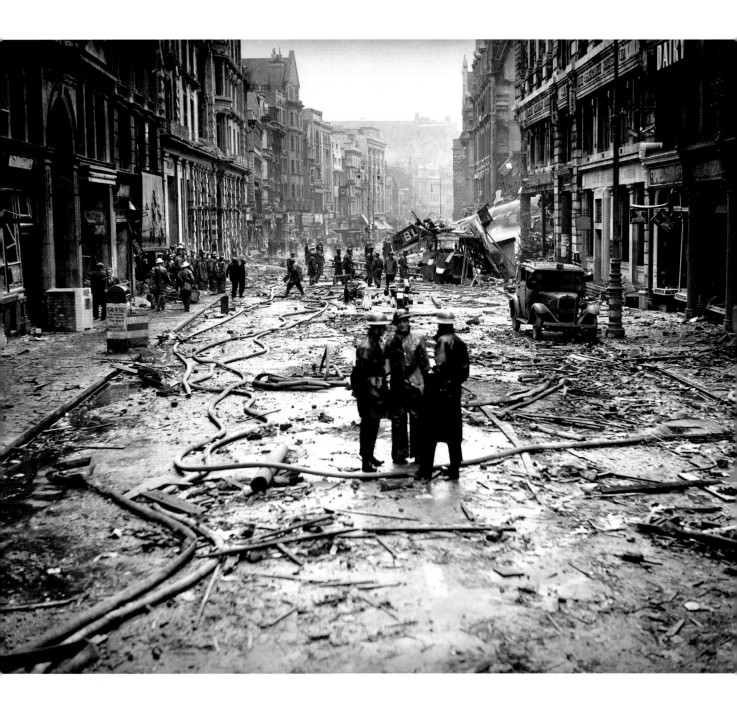

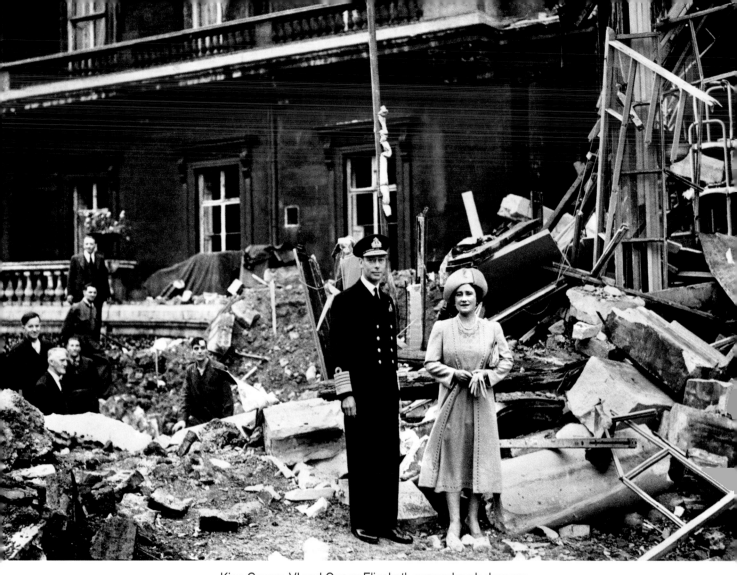

King George VI and Queen Elizabeth survey bomb damage
at Buckingham Palace. The Luftwaffe deliberately targeted
the Royal residence, believing it would affect the nation's
morale. However, the Queen famously stated, *"I'm glad we
have been bombed. Now I can look the East End in the face."*
10th September, 1940

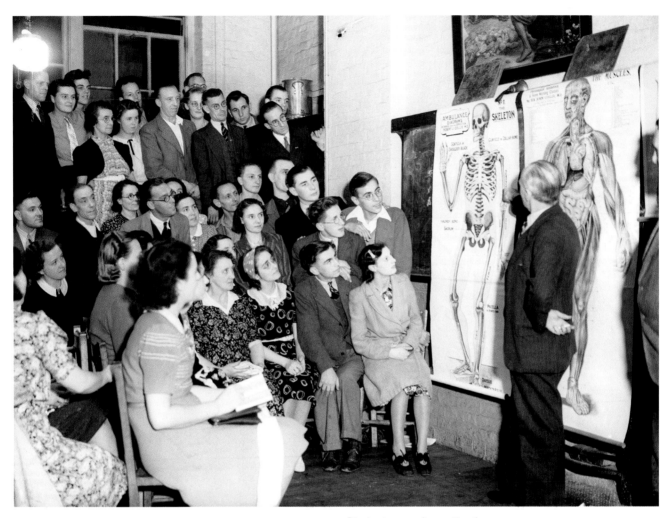

Students pay close attention during a first aid lesson run by London County Council. Knowledge of basic injury treatment would have been essential during the Blitz.
16th September, 1940

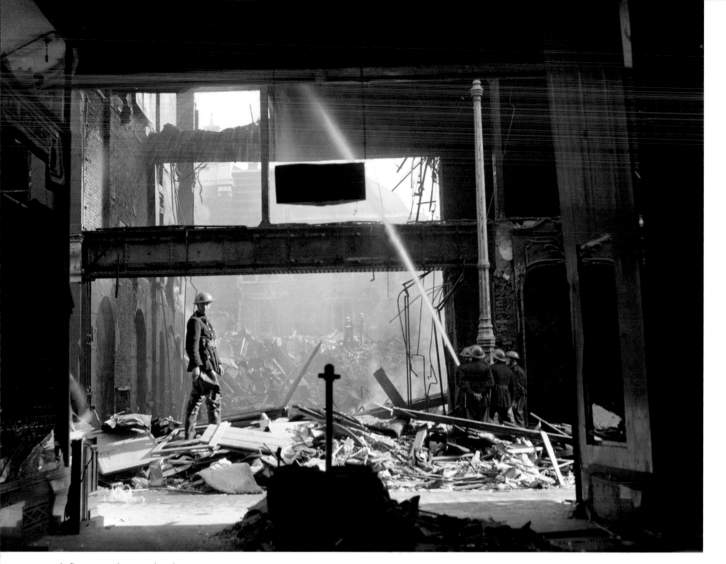

A fireman glances back at
the remains of a Naval and
Military Tailors' premises in
London as colleagues set
about quelling the remains of
another blaze.
16th September, 1940

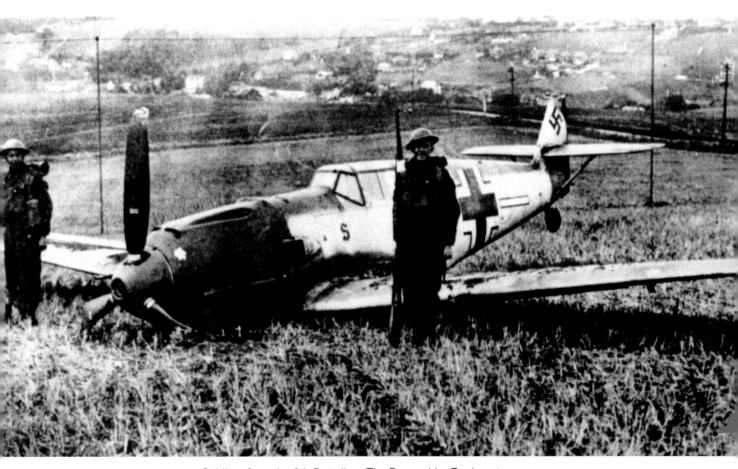

Soldiers from the 9th Battalion, The Devonshire Regiment,
stand guard over a Messerschmitt *Bf 109*, which crash-
landed near Beachy Head, East Sussex, during the Battle of
Britain. In summer 1940, the German Luftwaffe sought to win
air superiority over southern Britain and the English Channel.
Success was seen as essential if Germany was to invade the
British Isles.
30th September, 1940

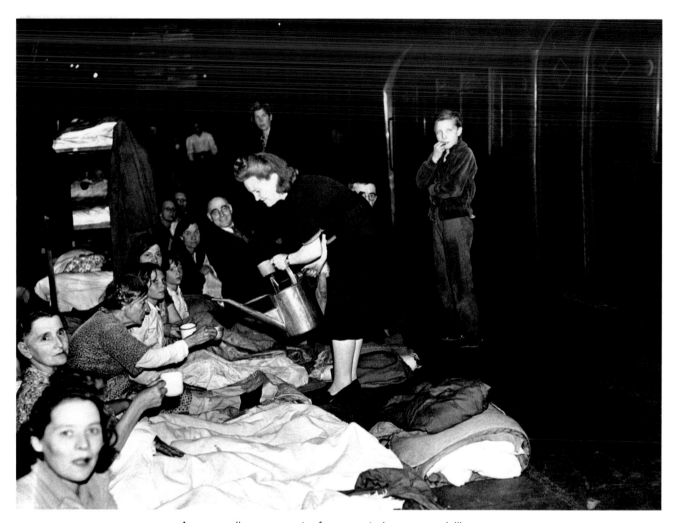

A woman dispenses water from a watering can as civilians
take cover on a London Underground platform during the
Blitz. Often the trains on the Tube would still be running, so it
was important to stay well away from the edge.
10th October, 1940

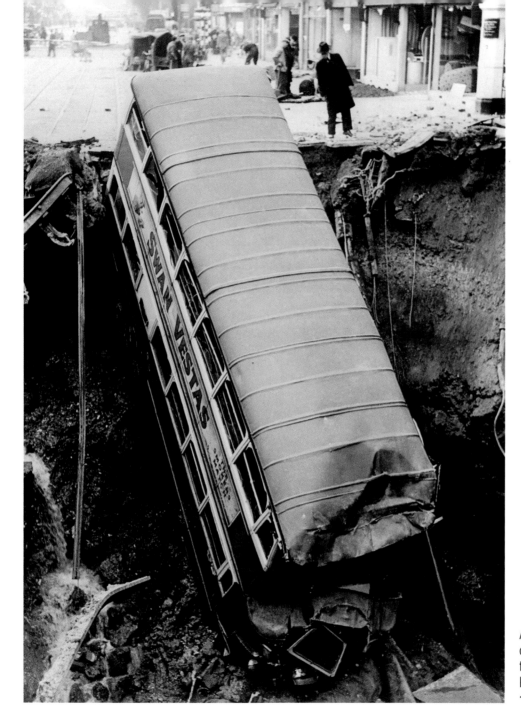

A man peers over the edge
of a huge bomb crater
that has almost engulfed a
London bus.
14th October, 1940

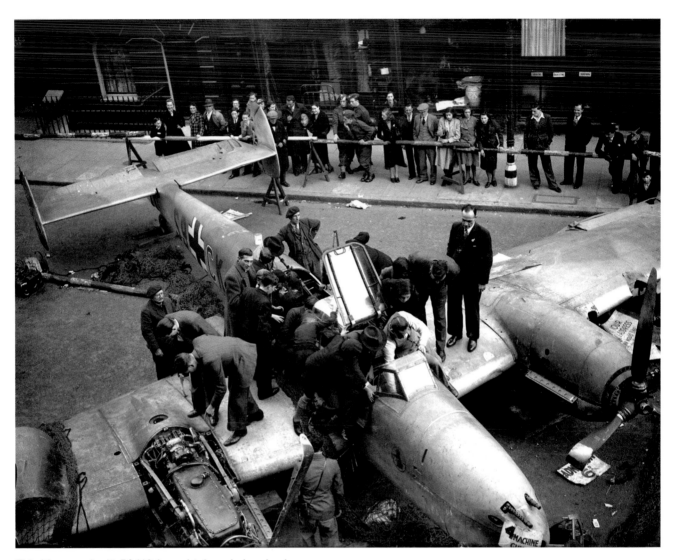

This Messerschmitt *Bf 110*, brought down in London by
anti-aircraft fire, is made available to public inspection for an
admission charge of 6d.
17th October, 1940

Two Londoners at the entrance of their Anderson shelter, by the ruins of their home. Named after Sir John Anderson, who was given special responsibility for air raid precautions prior to the Second World War, these corrugated steel buildings were provided free to householders whose incomes were below £250 per year. Those with more money were charged £7.

25th October, 1940

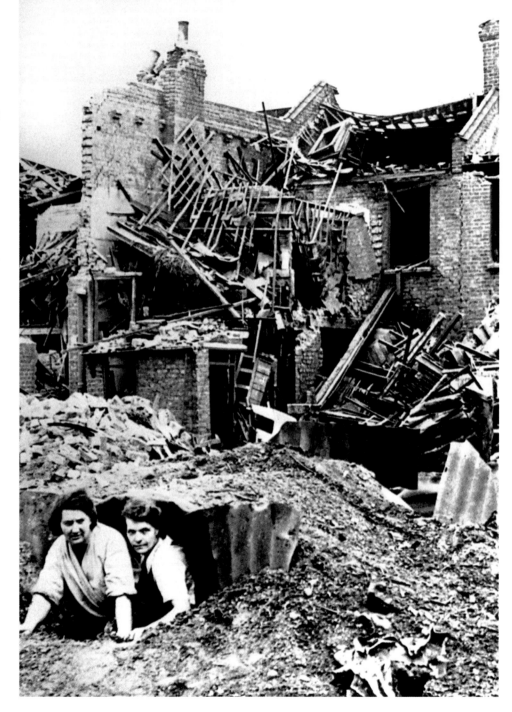

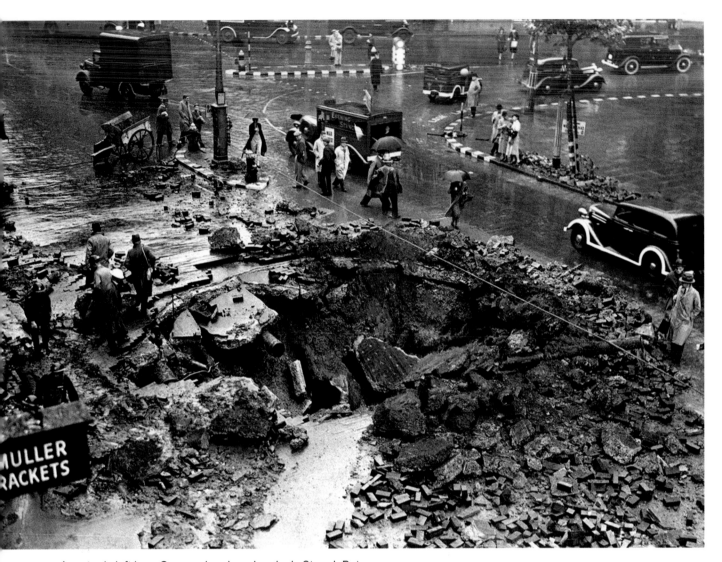

A crater is left by a German bomb on London's Strand. Between
September 1940 and May the following year, the Luftwaffe
dropped more than 35,000 tonnes of bombs on Britain.

1st November, 1940

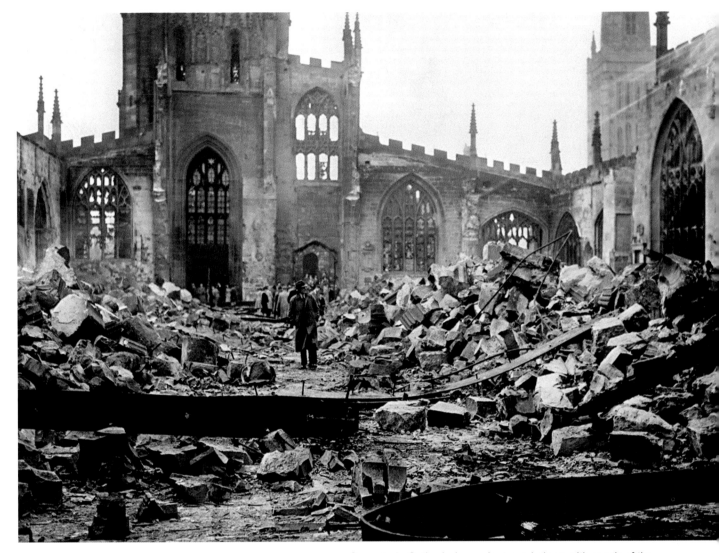

Coventry's Cathedral was destroyed along with much of the city in a devastating raid on the 14th of November 1940, carried out by over 500 German bombers.
14th November, 1940

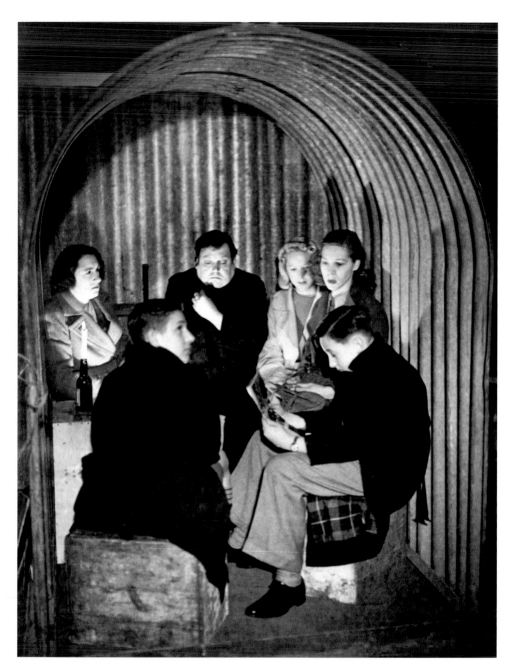

A demonstration of the Anderson shelter. Six feet in height, when installed this type of shelter would be buried to a depth of 4ft, then covered with a minimum thickness of 15in of soil to form a blast-absorbing bank. Over two million were installed.

1st December, 1940

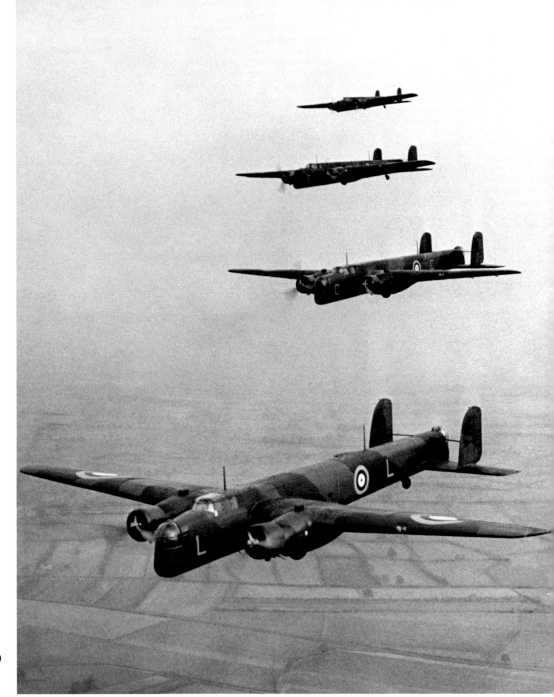

RAF Armstrong Whitworth AW38 *Whitley* bombers fly in formation. There were seven versions of the *Whitley* produced, the most common being the Mk V which employed two 1,145hp Rolls Royce *Merlin* engines and had a range of 1,500 miles. Crewed by five airmen, it could carry 7,000lb of bombs.

1941

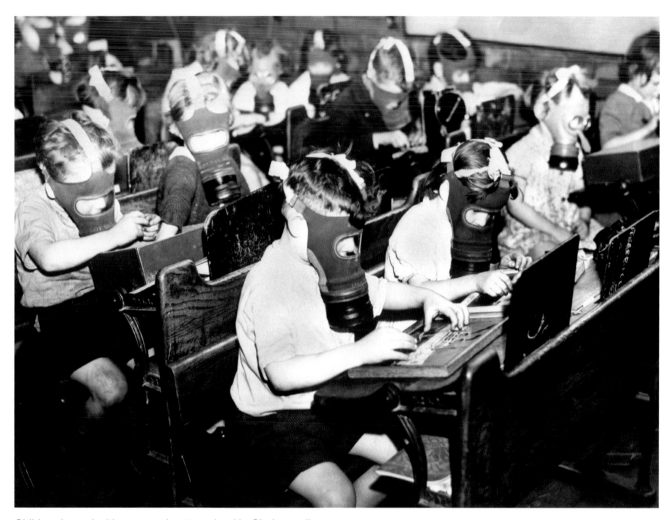

Children issued with gas masks at a school in Clerkenwell, north London. During the 'phoney war' following the mass evacuation in September 1939, many children returned home – by January 1940 nearly 60 per cent were back with their families.
1941

Facing page: Land Girls relax with a cup of tea and a cigarette in Essex. With so many men away fighting and with huge pressure on domestic farming resources, at one point there were 80,000 members of the Women's Land Army and 6,000 in the Women's Timber Corps, also known as the 'Lumberjills'.
1941

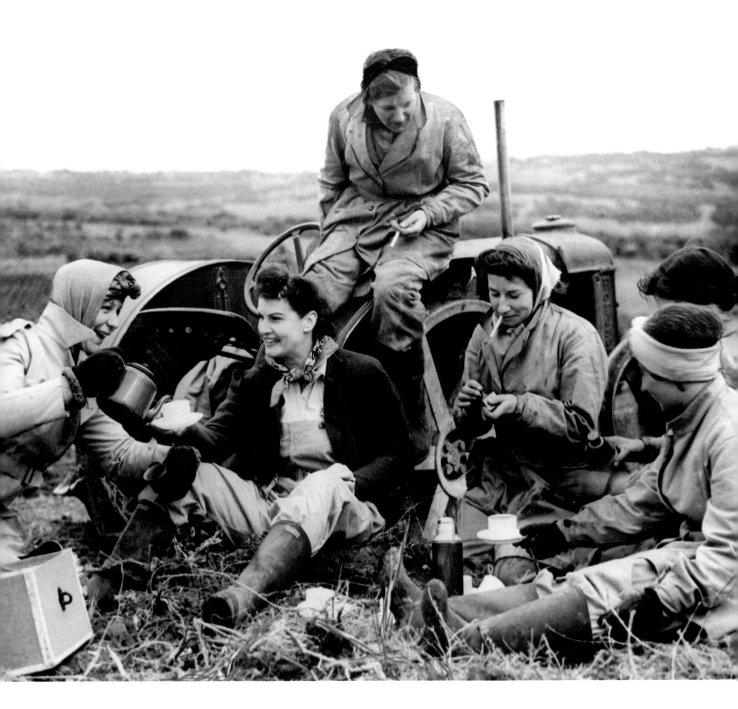

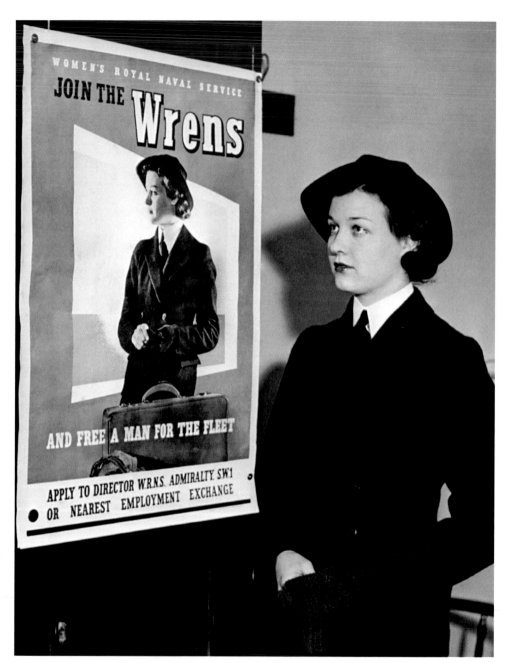

The actual model selected for a Women's Royal Naval Service recruitment poster poses beside her printed image. Among scores of other roles, many 'Wrens' were involved in the planning of naval operations and maintenance. Thousands served overseas, 303 losing their lives during the Second World War.

1941

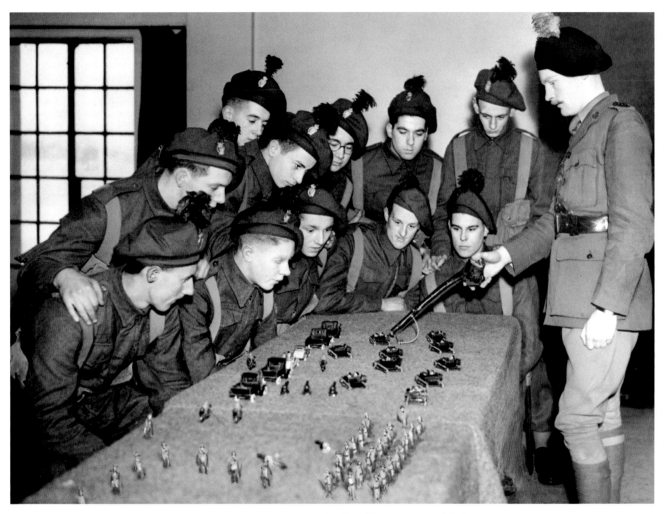

An officer uses models to
illustrate troop movements
to a group of young soldiers
from the Royal Ulster Rifles.
1941

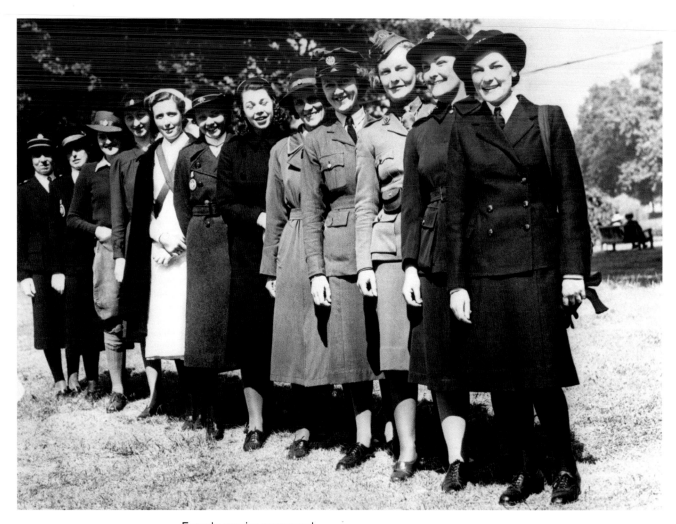

Female service personnel
show off a multitude of
uniforms.
1941

A Londoner – still managing to raise a smile – retrieves valuables from what remains of his home after a German bombing raid. Millions of incendiaries and an estimated 40,000 high explosives were dropped on the capital during the Blitz, damaging or destroying more than a million properties.

1941

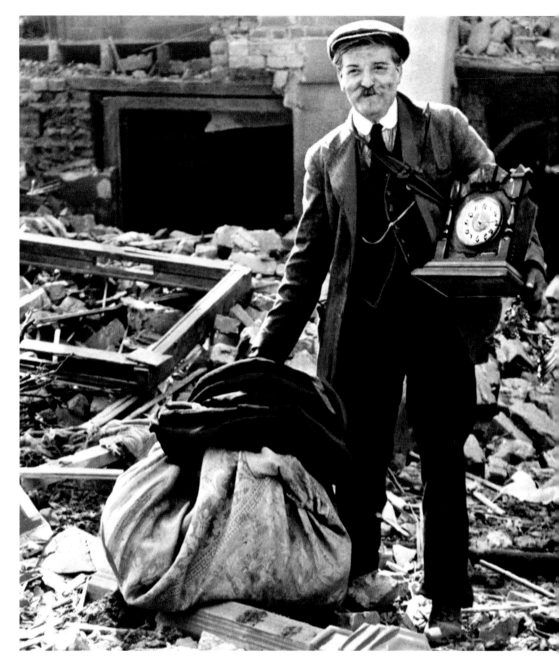

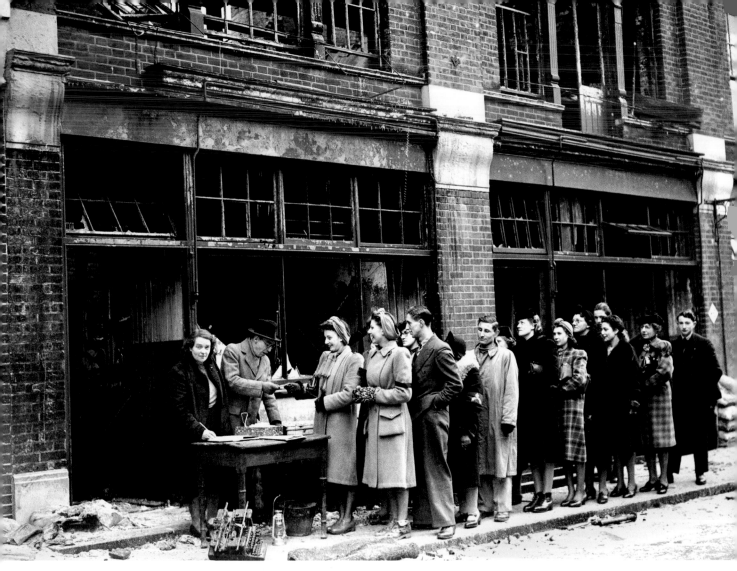

Staff of the Sport and
General Press Agency
receive their wages outside
their offices after a German
bombing raid.
3rd January, 1941

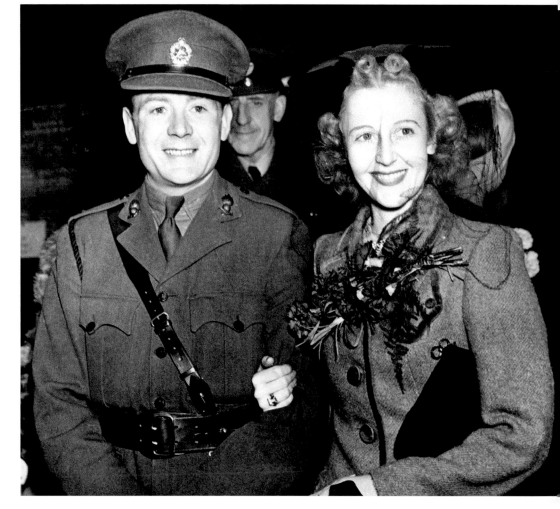

Film star John Mills, then a Second Lieutenant, marries fellow actor Hayley Bell in Marylebone, London. Mills, who was later knighted, starred in famous war-related movies such as *We Dive at Dawn*, *This Happy Breed* and *Ice Cold in Alex*.
16th January, 1914

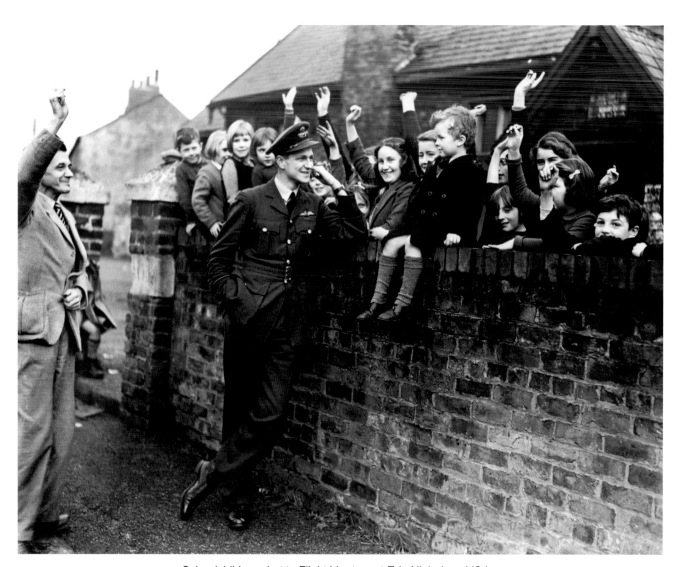

Schoolchildren chat to Flight Lieutenant Eric Nicholson VC in Ulleskelf, Yorkshire. Nicholson was awarded Britain's highest military honour for his courage in action in August 1940.
11th March, 1941

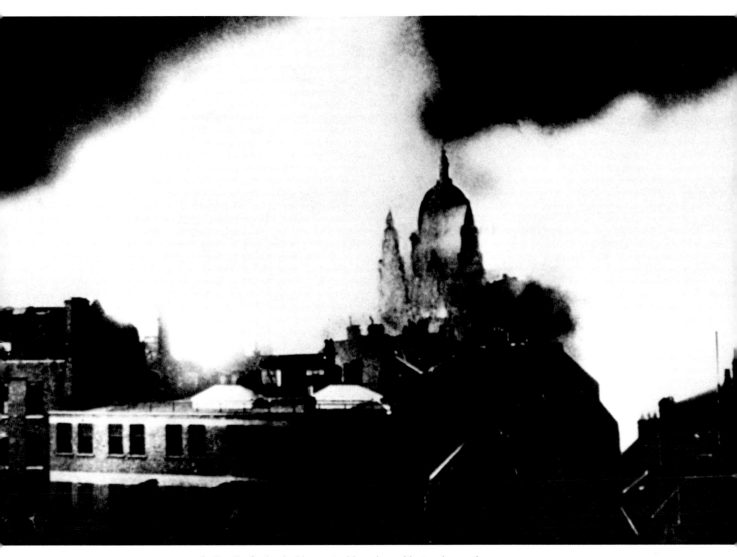

St Paul's Cathedral in central London withstands another
night of heavy Luftwaffe bombing during the Blitz.
10th May, 1941

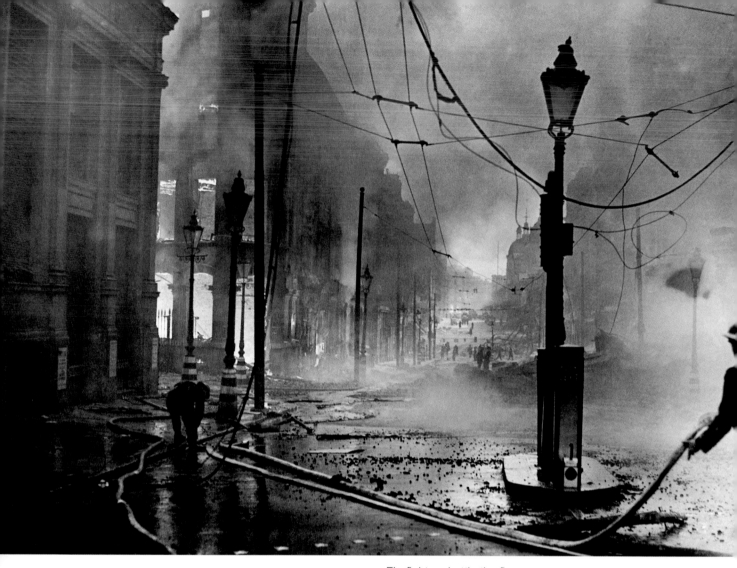

Firefighters battle the flames
in Charterhouse Street,
Holborn, as the City feels
the full force of a German
incendiary attack.
10th May, 1941

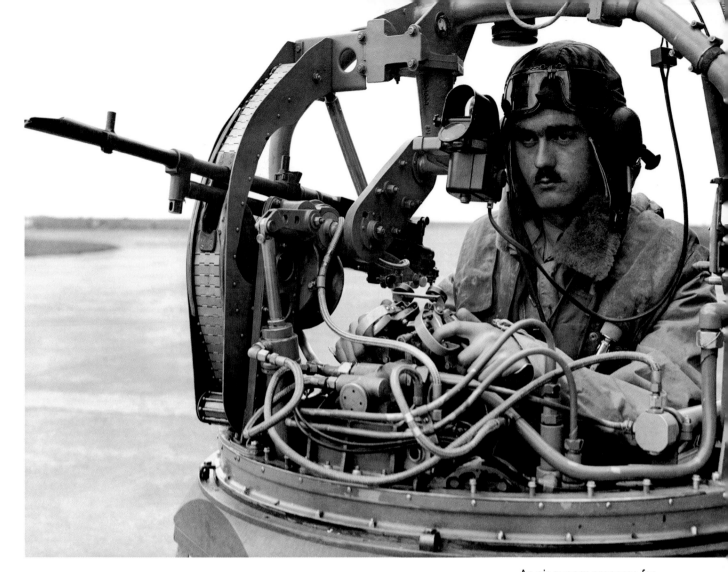

An air gunner prepares for
action at an RAF school of
technical training.
27th May, 1941

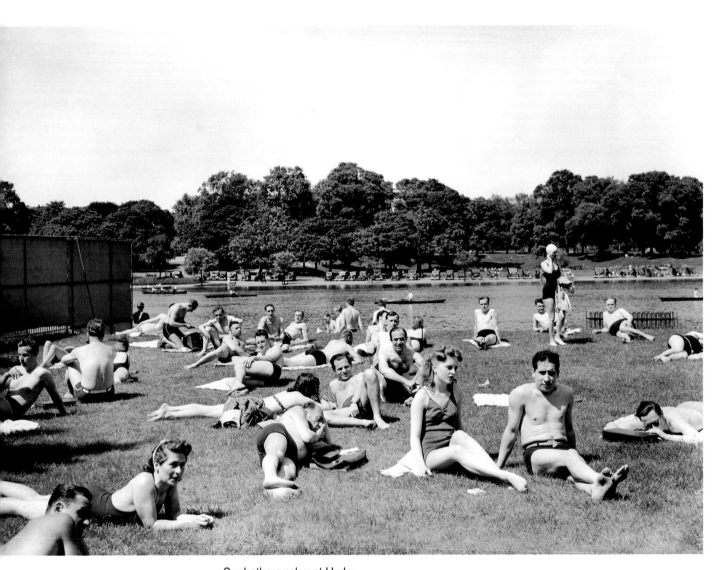

Sunbathers relax at Hyde
Park Lido, a welcome
distraction from the
hardships of war.
16th June, 1941

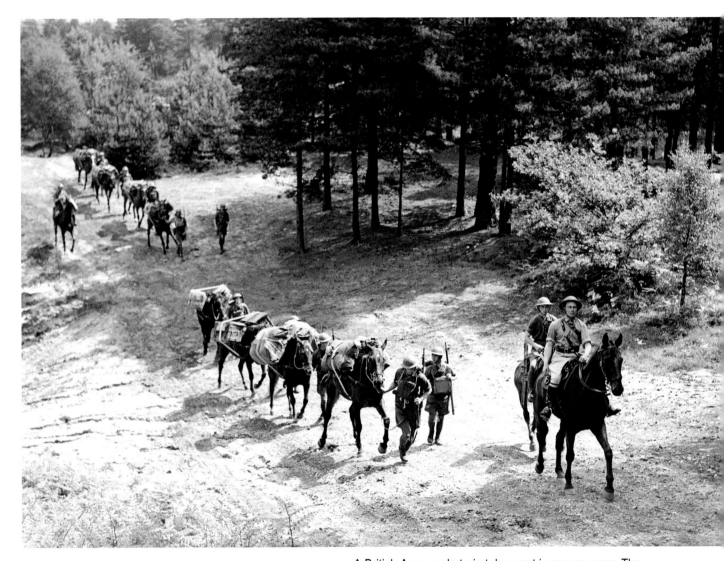

A British Army mule train takes part in manoeuvres. The hardy beasts of burden were put into action in North Africa, Burma and Italy by the military during the Second World War.

20th June, 1941

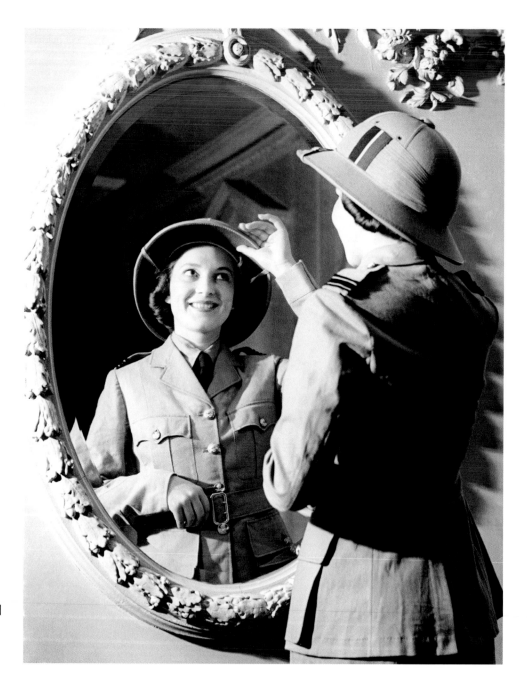

A Women's Auxiliary Air Force (WAAF) recruit tries out a new uniform designed to be worn in the Middle East.

27th June, 1941

A British police officer looks ill at ease as he is engaged in conversation by a member of the Luftwaffe in St Helier, Jersey. The Channel Islands were invaded by the Nazis in June 1940 and were the only part of the British Isles to be occupied by Germany throughout the Second World War.

1st July, 1941

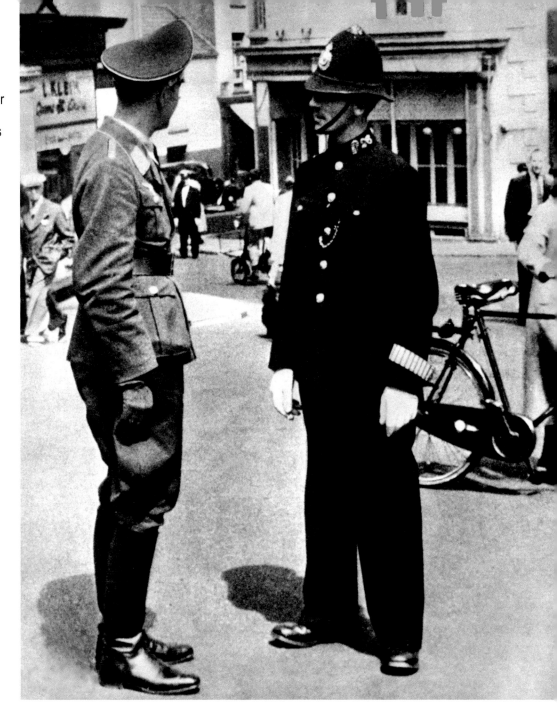

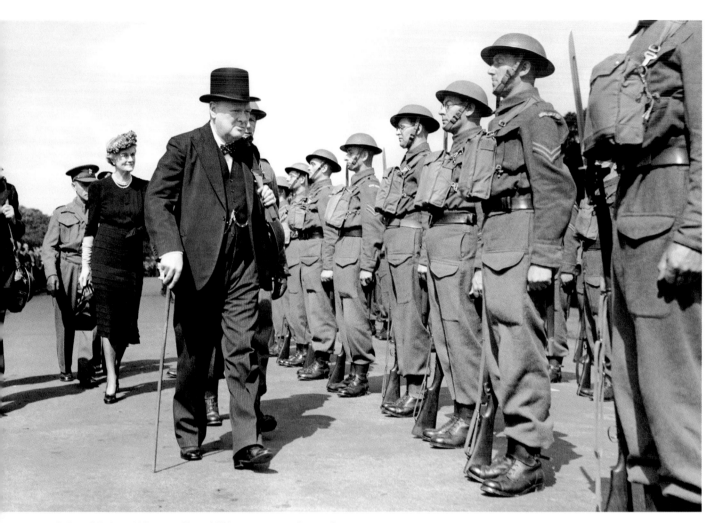

Prime Minister Winston Churchill inspects members of
the Home Guard in Hyde Park, London. Formed in 1940,
the Government had hoped that 150,000 men, otherwise
ineligible for military service, would come forward. In reality
more than 1.4 million men volunteered to do their bit to
protect Britain's shores.

14th July, 1941

Facing page: Men and women work side-by-side on a
Beaufighter Night Fighter. Built by the Bristol Aeroplane
Company, these twin-engined fighters were designed to be
used during night raids or in bad visibility.

5th August, 1941

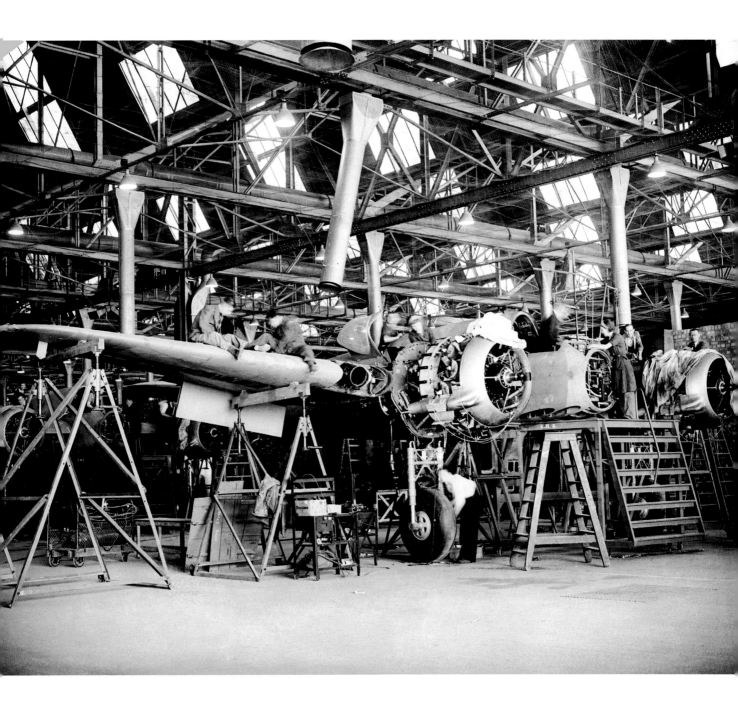

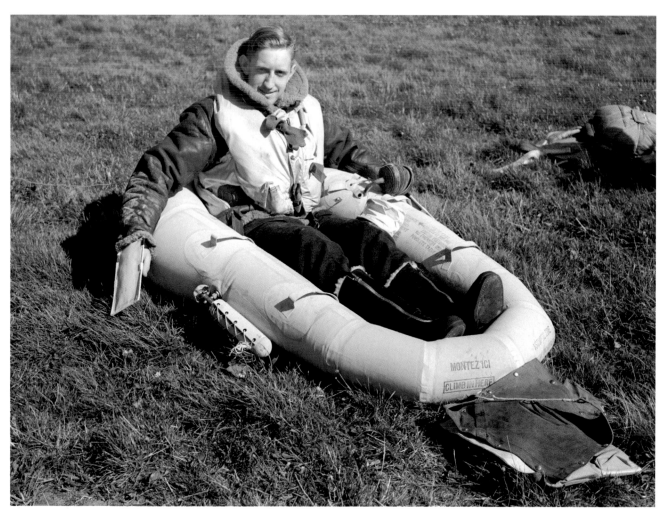

An RAF fighter pilot tries
out his new dinghy complete
with make-shift paddles
issued in case of a crash
landing at sea.
28th August, 1941

Facing page: Two evacuees
from Islington in London get
to grips with life on the farm
in Porthcurno, Cornwall.
1st September, 1941

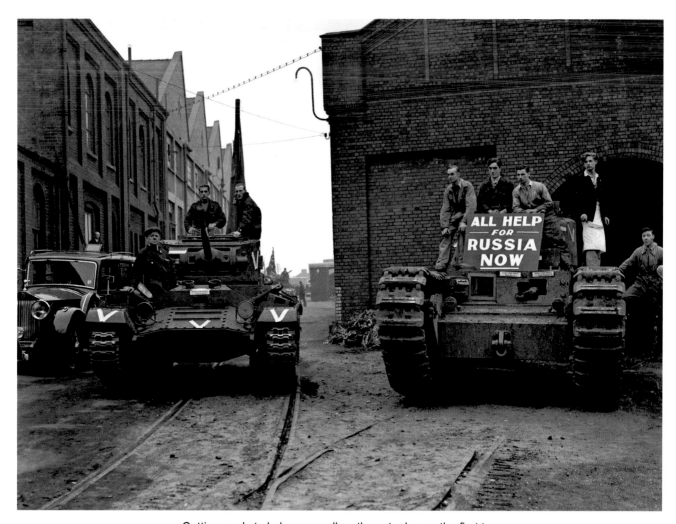

Getting ready to help a new ally – these tanks are the first to be sent from Britain to the battlefields of Leningrad, Moscow and Odessa following Hitler's invasion of Russia in the summer of 1941.

22nd September, 1941

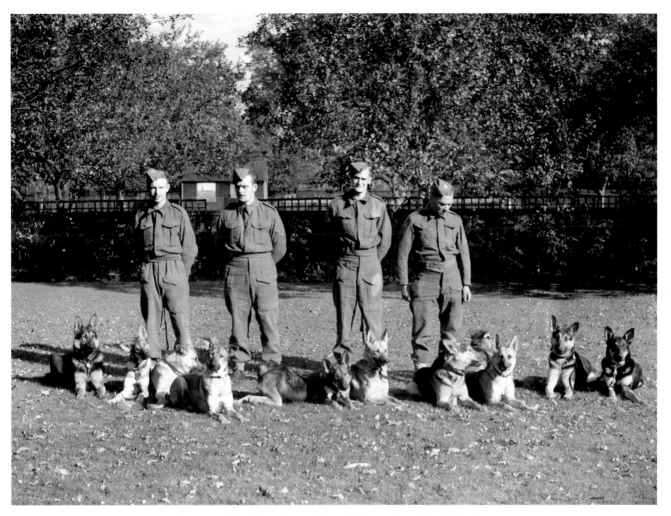

Dogs and their handlers get ready for service at the War Dog Training School. Throughout the war, dogs were used as sentries and messengers and later as Mine Dogs – sniffing out non-metallic landmines, which traditional metal detectors failed to spot.

20th October, 1941

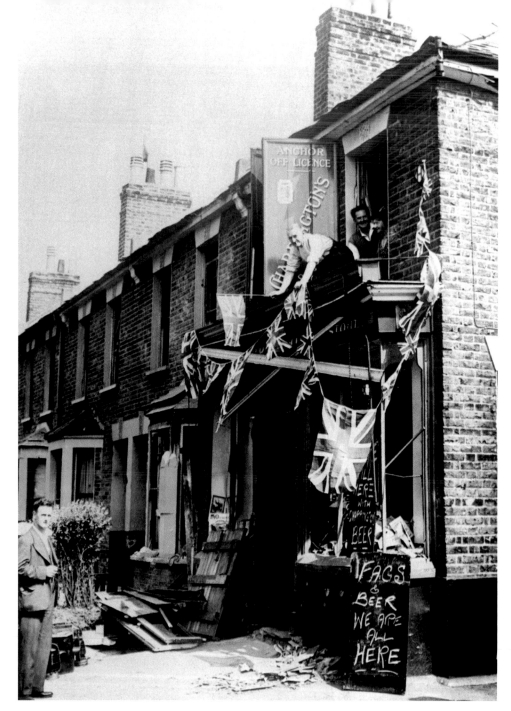

Although this shop has been badly damaged in an air raid, the owner defiantly hangs out the Union Jacks to let customers know that it's business as usual.

28th October, 1941

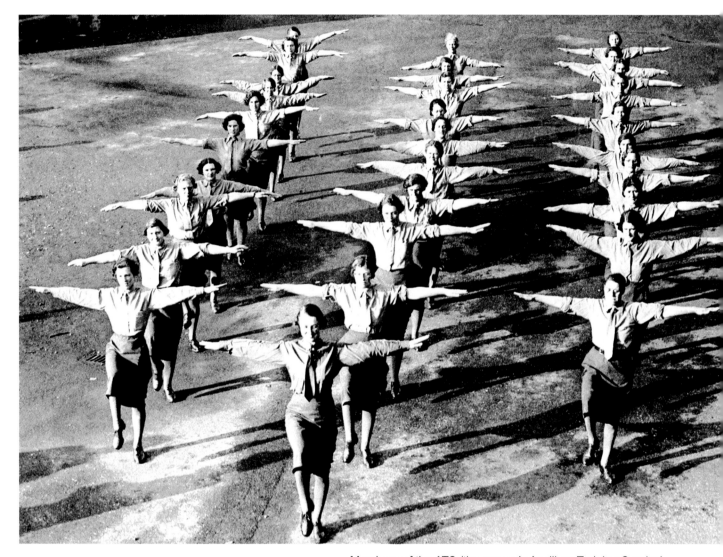

Members of the ATS (the women's Auxiliary Training Service) get in shape during a physical training exercise. Formed in 1938, the first recruits were employed as cooks, telephonists and clerks. By September 1941 the service had more than 65,000 members.

12th November, 1941

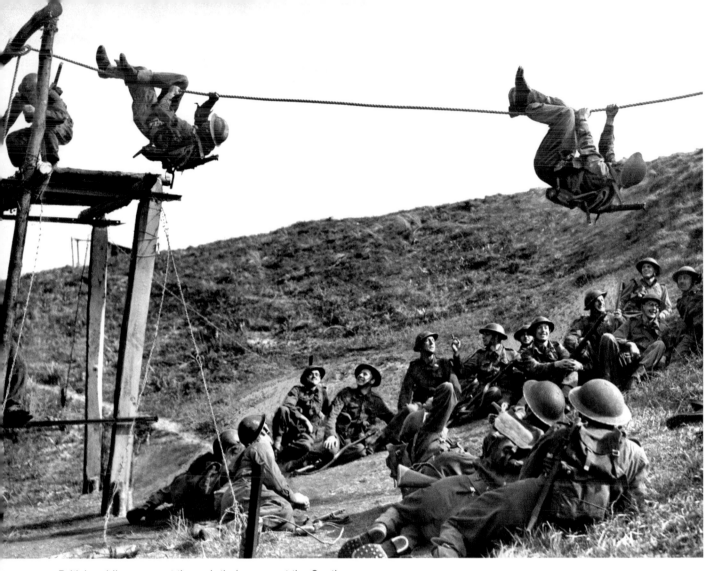

British soldiers are put through their paces at the Southern Command Weapons Training School in Woolacombe, Devon. The exercises, designed to prepare the men for entering enemy territory, include swimming with a full pack, mountaineering and coming under attack.
1942

Facing page: Women hard at work during the construction of Britain's giant bomber, the *Stirling*. The enormous aircraft was the RAF's first four-engined bomber and carried a crew of seven.
1942

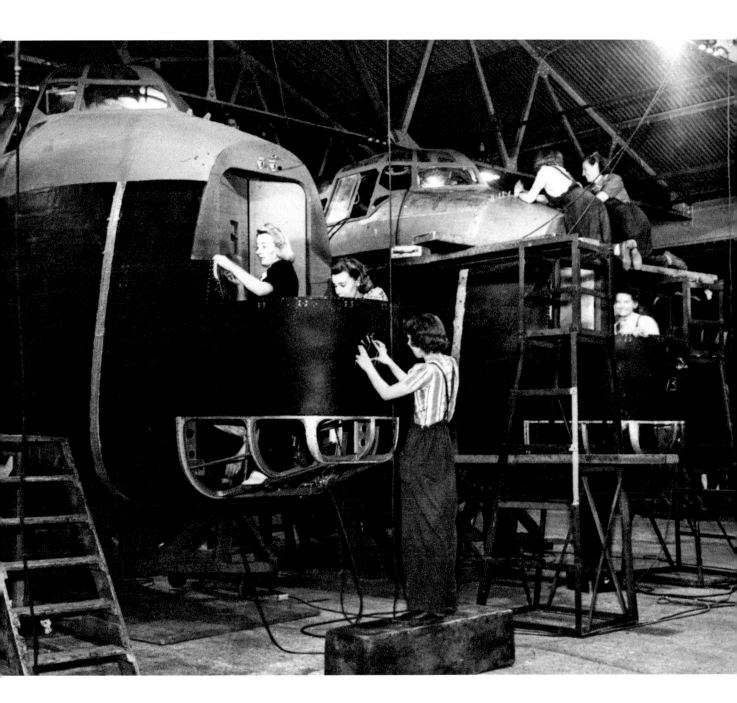

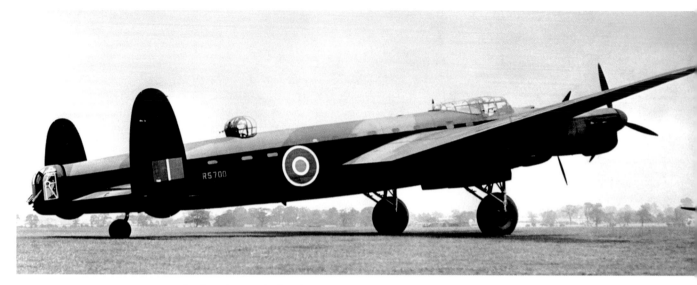

An Avro *Lancaster* bomber awaits its crew at an airfield in 1942. Together with the *Halifax* it was one of the main heavy bombers of the war, being particularly successful on night raids. It is best known for its role in the 'Dam-Busting' raids on Germany's Ruhr Valley in 1943.

1942

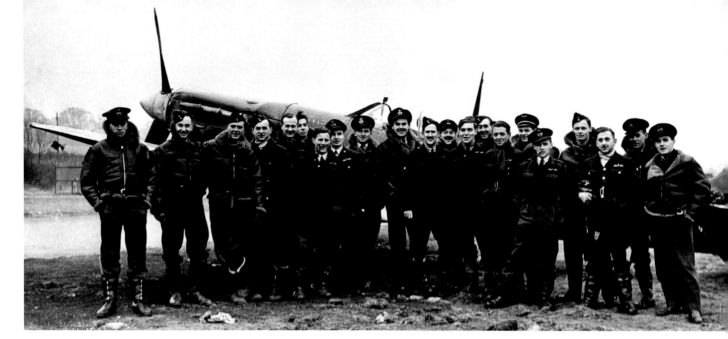

Personnel at an RAF
squadron pose in front of
a *Spitfire*. The single-seat
Spitfire was one of the most
widely used British fighter
aircraft during the conflict,
seeing action in Europe,
South East Asia and the
Pacific.
1942

Two British soldiers give it their all during a lesson in hand-to-hand combat. One soldier attempts to disarm the other, who is holding a bayonet.
1942

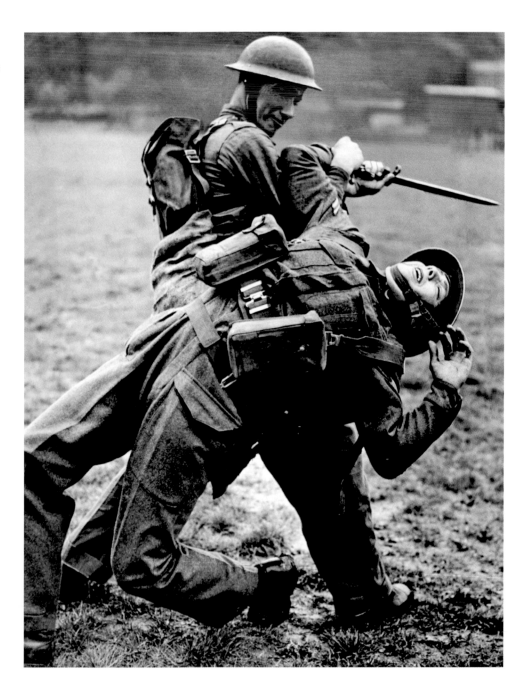

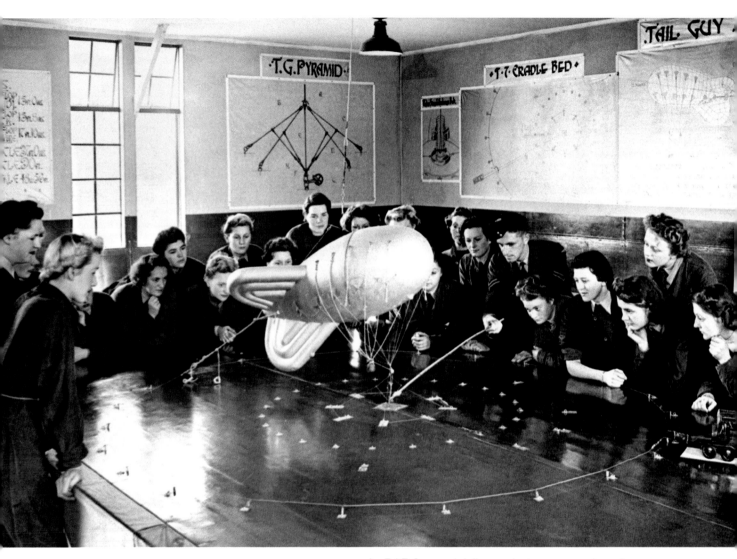

An RAF Corporal delivers a lecture on mooring a barrage balloon, to members of the WAAF. The balloons were designed to defend vulnerable sites against low-level attack by aircraft, either by snaring them in their tether cables, or by forcing them to fly higher into the range of anti-aircraft fire.
1942

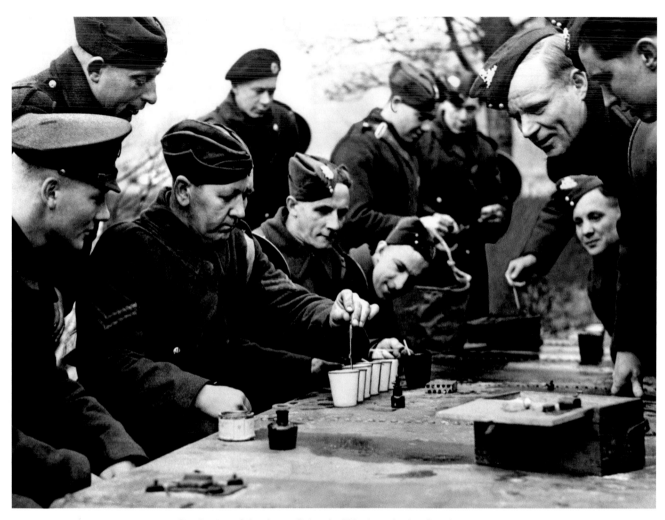

Graduates of the Army School of Hygiene in the South
Eastern Command at Aldershot in Hampshire pore over an
experiment.
1942

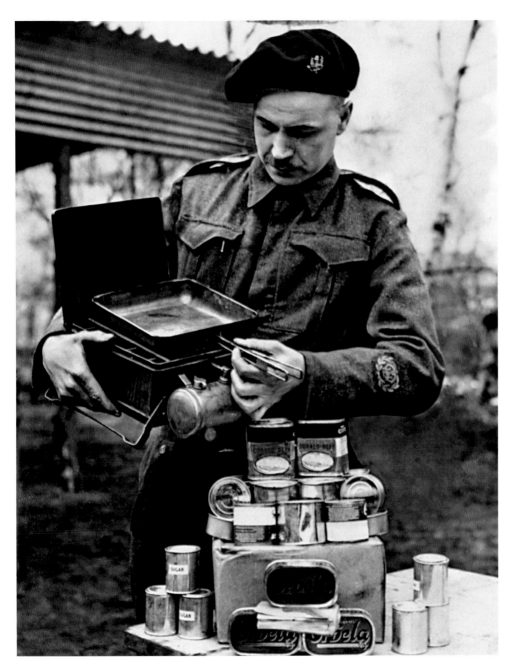

A Warrant Officer of the King's Hussars with cooking equipment and supplies at the Army Catering Corps Training Centre in Aldershot. The school taught Army personnel as well as members of the Voluntary Aid Detachments and the ATS.
1942

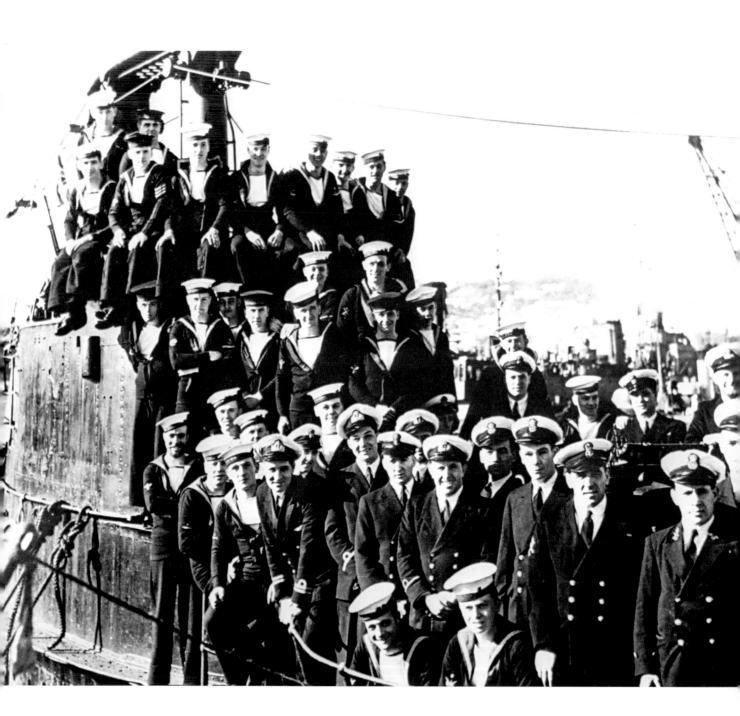

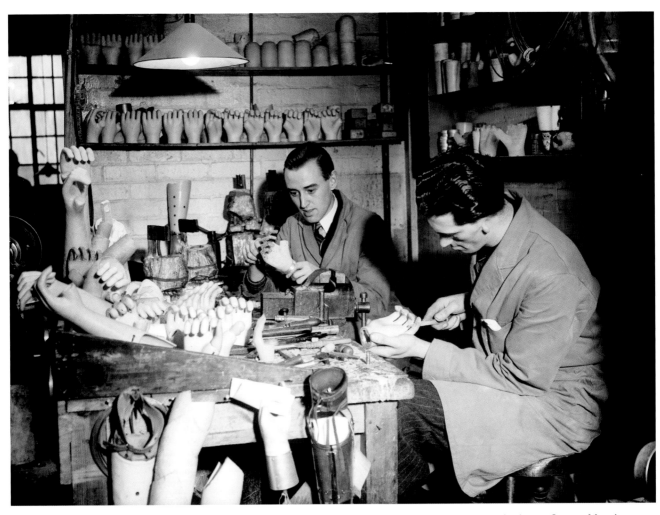

Craftsmen working on the prosthetics at Queen Mary's Hospital, Roehampton. During the Second World War the specialist centre supplied and fitted artificial limbs for 20,000 military personnel and 2,000 civilians.
1st March, 1942

Facing page: The crew of the British S-Class submarine HMS *Splendid* as she prepares to be launched from Chatham Dockyard in Kent. She was sunk by the German destroyer, *Hermes*, on the 17th April of 1943, with the loss of 18 lives. Thirty men including commanding officer Lieutenant Ian McGeoch, survived.
13th January, 1942

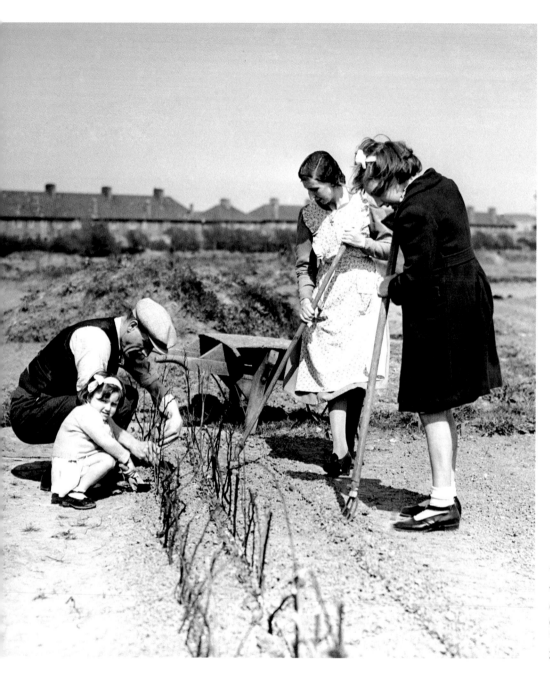

Facing page: London was not the only target for the German bombers. Here, firemen get to work extinguishing flames amid the ruins following a raid on Exeter, Devon.
4th May, 1942

There were jobs for the whole family as Britons were encouraged to grow their own food in the campaign to 'Dig for Victory'.
24th April, 1942

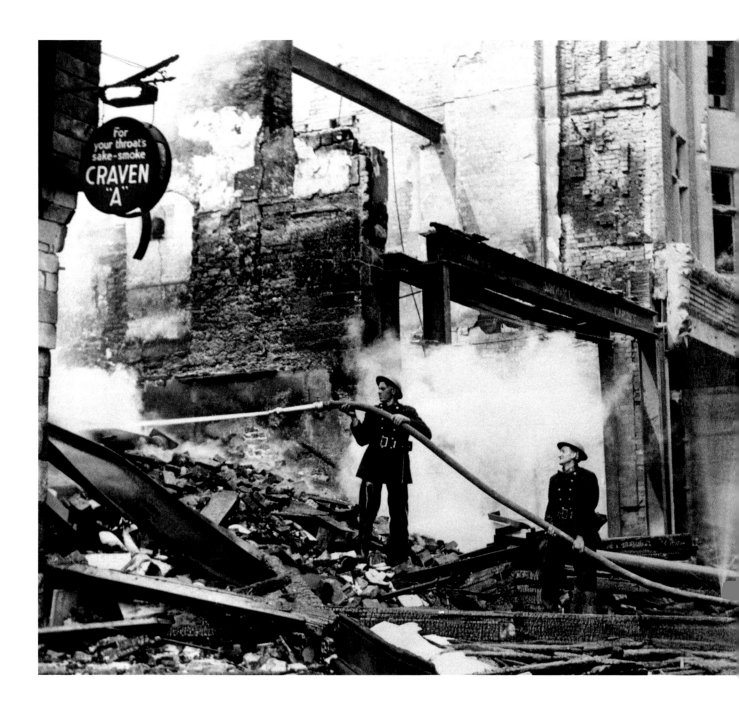

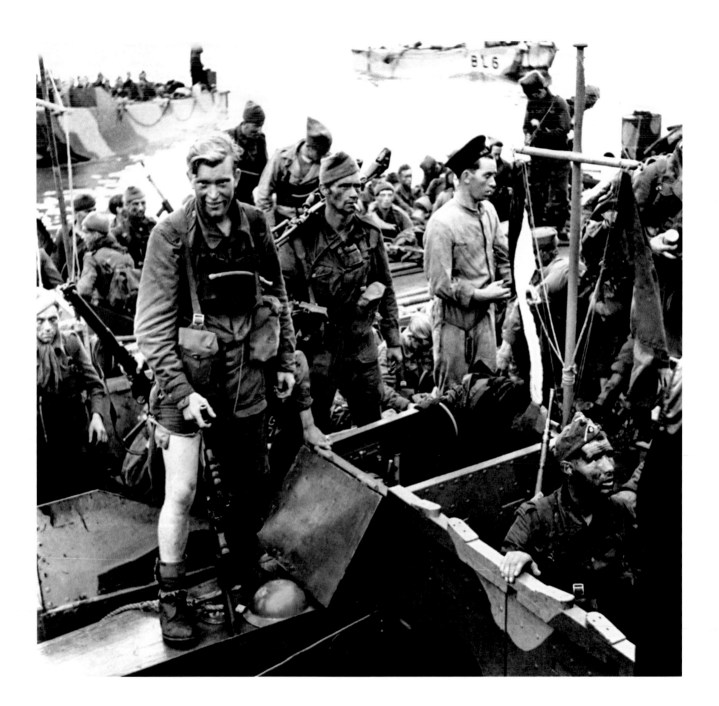

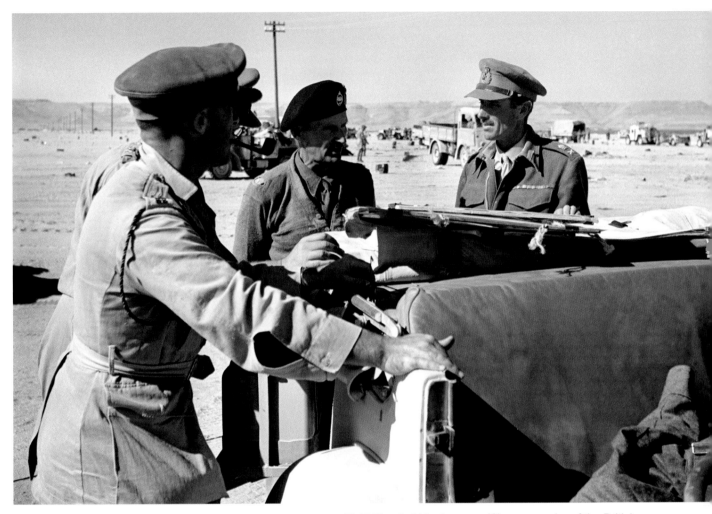

Facing page: Allied troops arrive in Dieppe during Operation Jubilee. More than 6,000 infantrymen set out to capture the German controlled French port but the operation was a disaster – more than half of those involved were killed, captured or wounded.

19th August, 1942

Field Marshal Montgomery (C), commander of the British Army during the Western Desert campaign, briefs officers before the decisive battle of El Alamein. The Allied forces went on to defeat 13 German and Italian divisions.

1st October, 1942

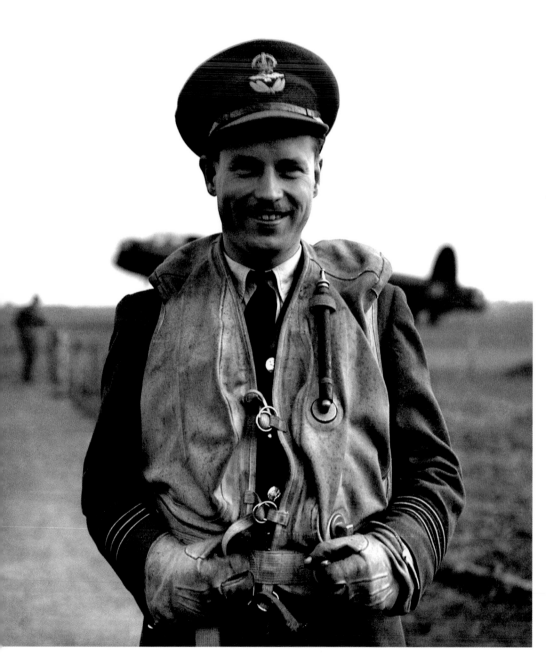

Guy Gibson, 24, who led the *Lancaster* bomber daylight raid on Milan, which involved a round flight of 1,500 miles over the Alps. Gibson later entered the pages of history as leader of the 'Dambusters' raid, which destroyed two of German's most crucial dams with 'bouncing bombs'. He died just two years later when his plane crashed following a bombing mission.

26th October, 1942

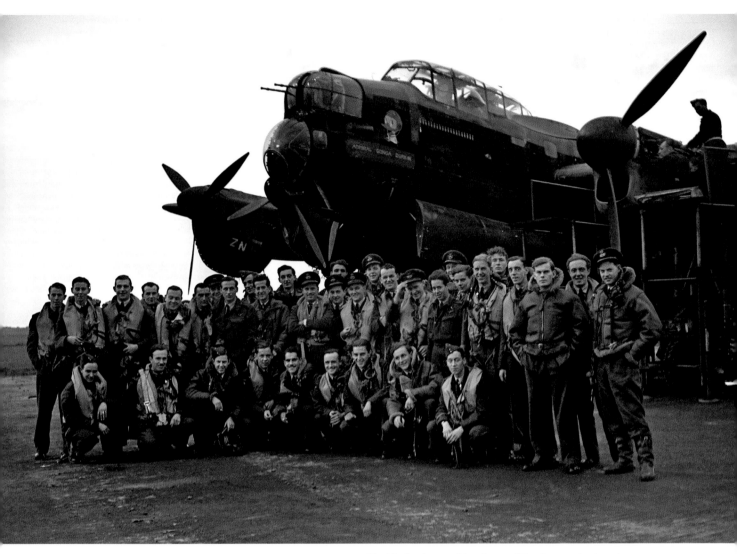

Glad to be home. Members of the *Lancaster* bomber crews
which successfully completed daylight raids on the Italian
city of Milan.
26th October, 1942

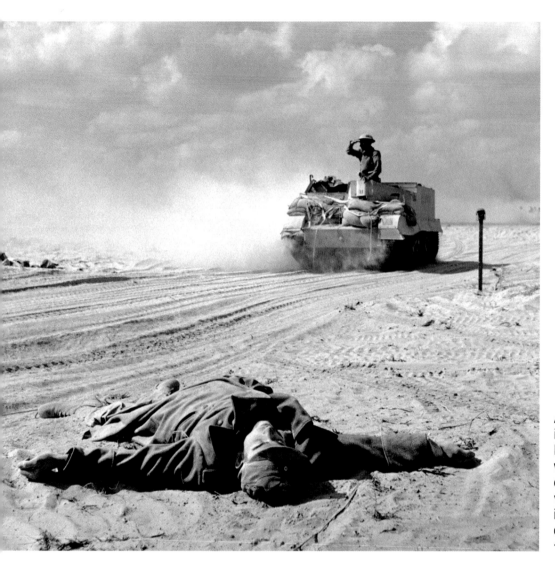

A German soldier lies dead in the path of a British Army Bren Gun carrier, in the wake of the decisive battle of El Alamein. The Allied victory proved a turning point in the fight for the western desert.

15th November, 1942

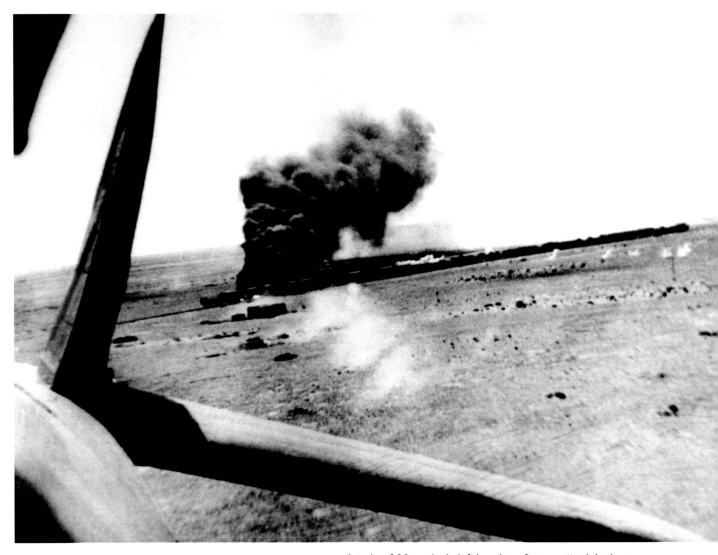

A train of 26 trucks is left burning after an attack by long range RAF fighters, south of Sidi Barrani in Egypt. Allied air supremacy was a vital ingredient in the destruction of the Axis forces in North Africa.
1943

A Royal Army Service Corps sergeant packs a canister with vital supplies. These men were essential to those fighting overseas, delivering food, medical supplies, fuel and weapons. They were specially trained to pack panniers, fly in and drop the load by parachute.
1943

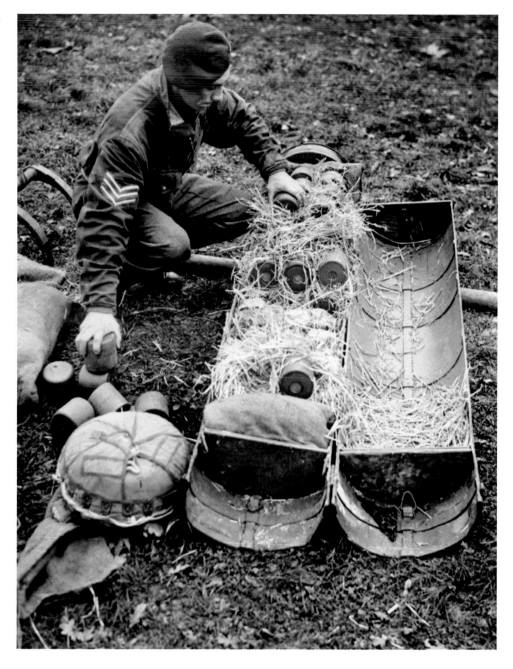

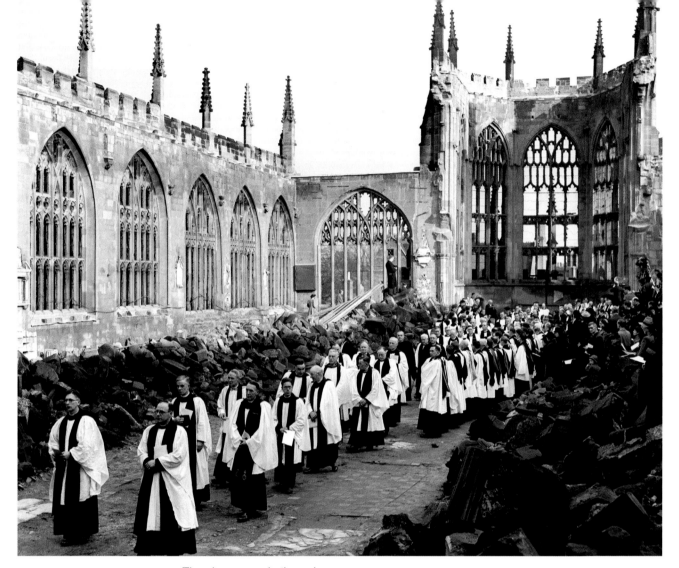

The clergy parade through the ruins of Coventry Cathedral following the enthronement of the Bishop of Coventry, the Right Reverend Neville Vincent Gorton.
20th February, 1943

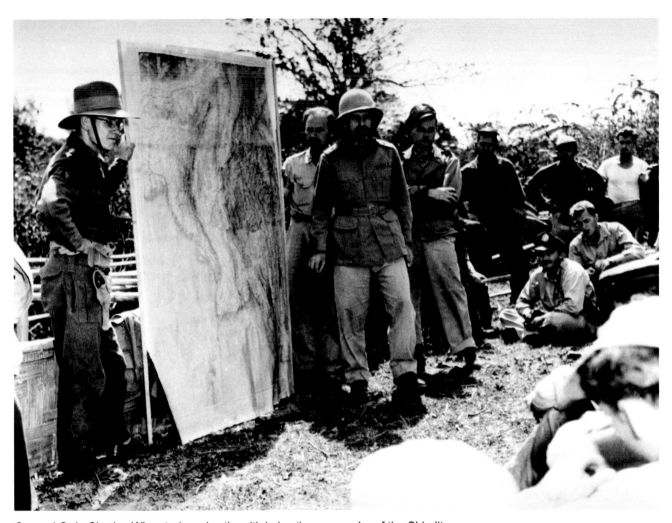

General Orde Charles Wingate (wearing the pith helmet), commander of the Chindits, briefs members of the First Air Commando USAAF in Burma. The Chindits were a British India special force, consisting of long range penetration groups who operated deep behind Japanese lines. Wingate was known for his eccentricities and could often be seen munching on a raw onion, which he wore round his neck in case he needed a snack.
1944

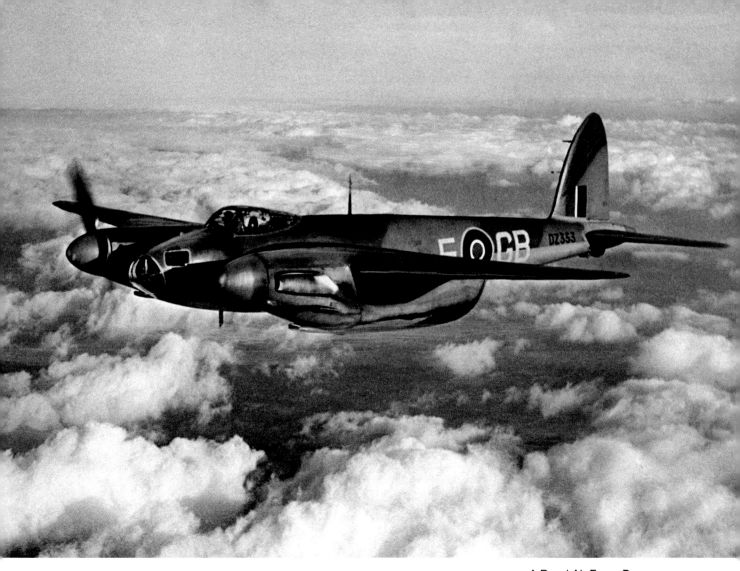

A Royal Air Force De
Havilland *Mosquito* aircraft
in flight. The plane was used
in both a reconnaissance
and bombing role, including
operations over the German
capital, Berlin.
1944

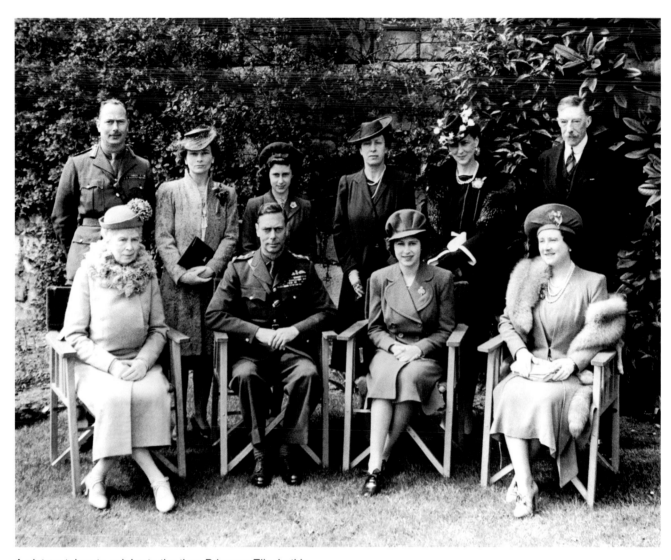

A picture taken to celebrate the then Princess Elizabeth's
18th birthday. She is flanked by her father, King George
VI and her mother, Queen Elizabeth. A young Princess
Margaret is on the back row (third L).
21st April, 1944

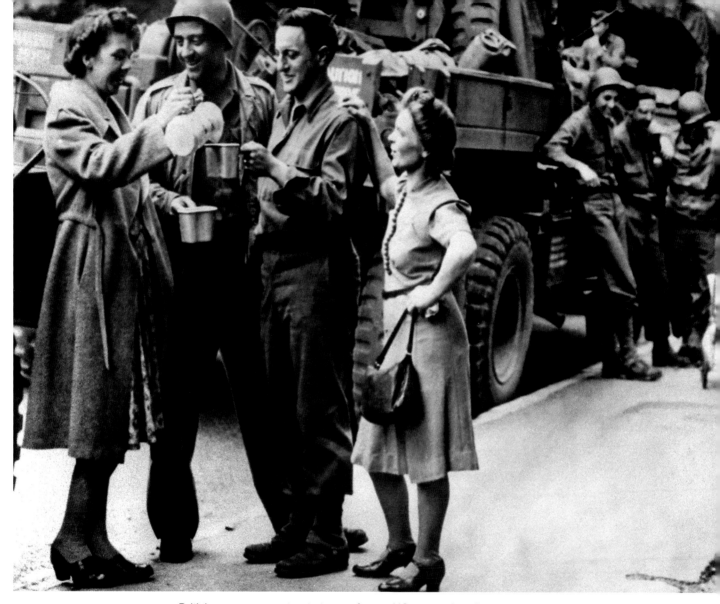

British women serve tea to troops from a US convoy heading
to the south coast of England during the build up to D-Day,
the Normandy Landings.
1st June, 1944

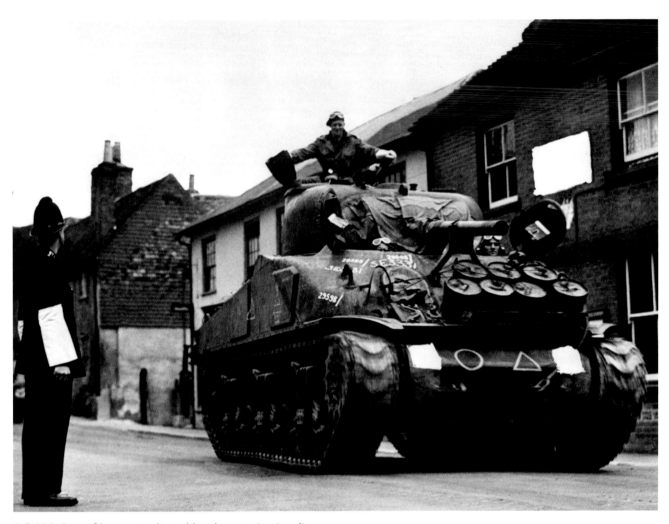

A British Army *Sherman* tank rumbles down a street on its way to a south coast port prior to the Normandy landings of the 6th of June, 1944. The wartime censor has obliterated a sign in the background as well as the tank's unit markings.
1st June, 1944

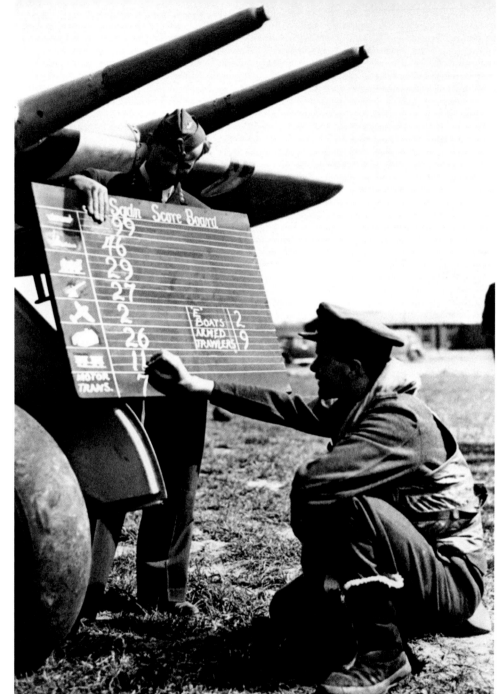

An RAF pilot chalks up the score of his Hawker *Typhoon* Mk1B aircraft on the Squadron board. After several months of operations against the Luftwaffe, the *Typhoon* proved one of the most formidable aircraft in Fighter Command. The pictured aircraft carries Normandy invasion markings (white stripes).

6th June, 1944

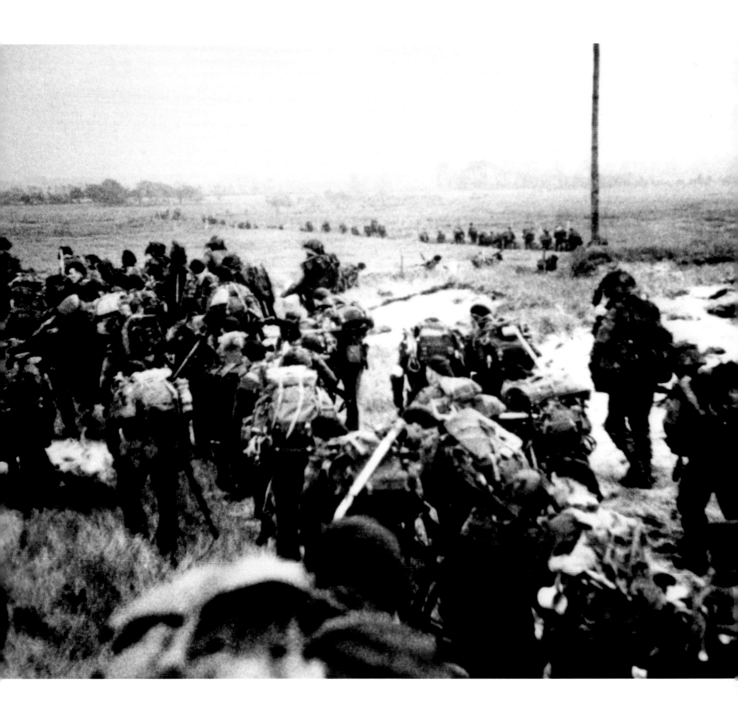

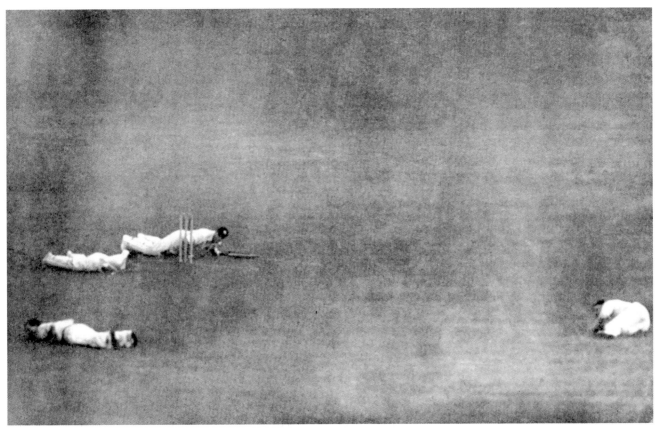

Players in an Army versus RAF cricket match at Lords dive for cover as a *V-1* flying bomb falls nearby. Play resumed almost immediately, with batsman Jack Robertson of the Army hitting the next ball for six runs.
29th July, 1944

Facing page: Royal Marine commandos moving off the Normandy coastline during the advance inland from 'Sword' beach, one of five main landing points during the D-Day landings.
6th June, 1944

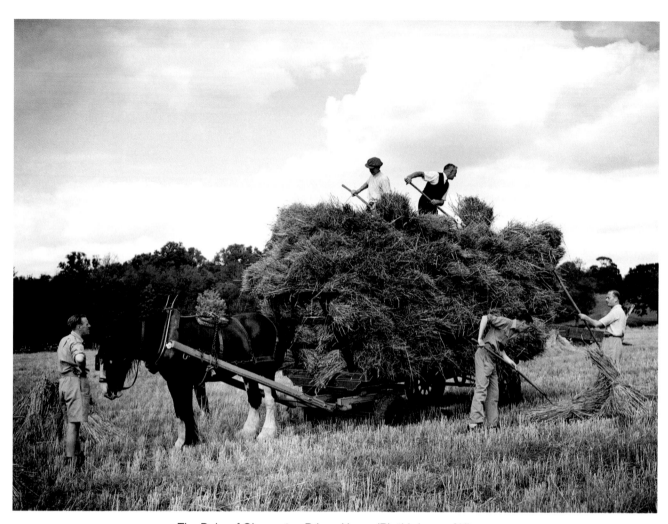

The Duke of Gloucester, Prince Henry (R), third son of King George V, helps gather in the harvest on his farm at Barnwell Manor, near Oundle in Northamptonshire.
29th August, 1944

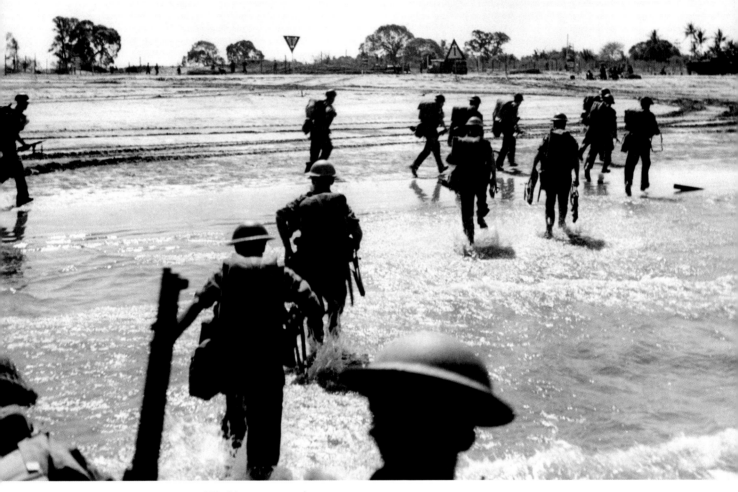

Allied troops run ashore
during the amphibious
assault on Japanese-held
Ramree Island off the coast
of Burma.
21st January, 1945

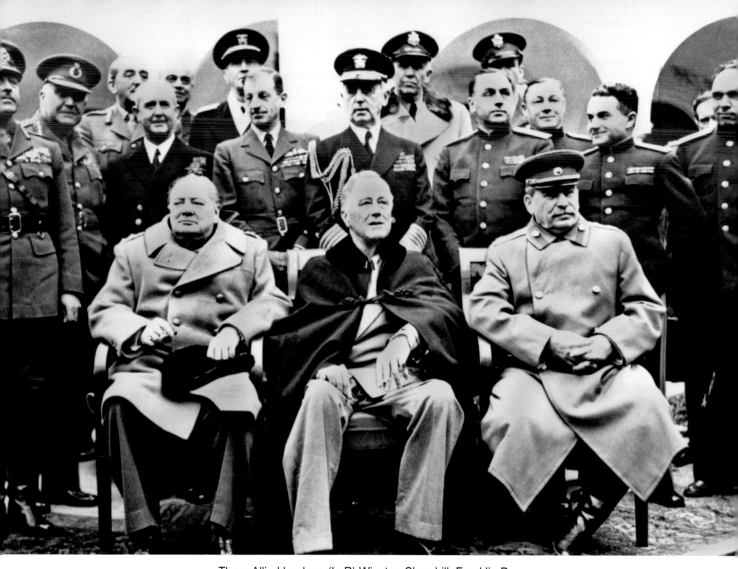

Three Allied leaders, (L–R) Winston Churchill, Franklin D
Roosevelt and Josef Stalin meet at Yalta in the Crimea to
discuss the fate of Germany after the Second World War.
4th February, 1945

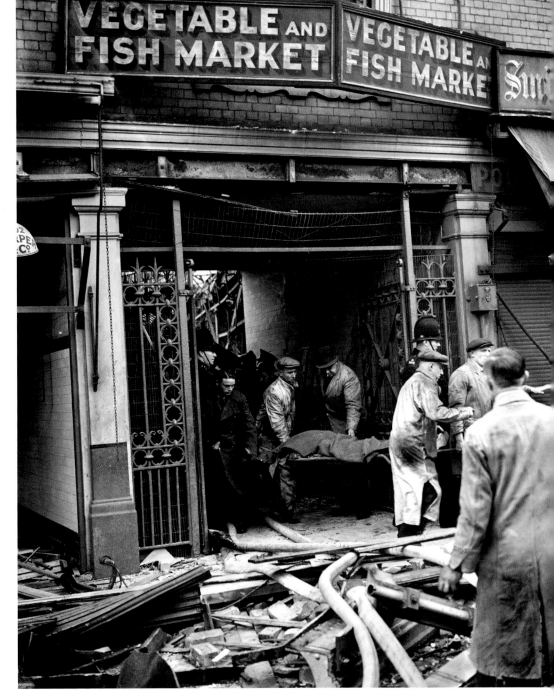

A German *V-2* rocket attack at Smithfield Market in London results in the loss of 110 lives. More than 1,300 *V-2s*, precursors of the modern guided missile were fired at Britain during the closing stages of the Second World War, killing 2,724 people.

8th March, 1945

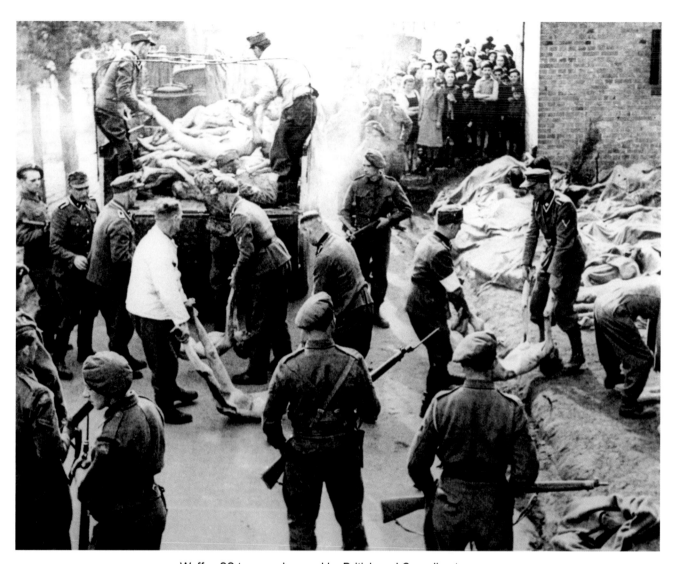

Waffen SS troops, observed by British and Canadian troops,
load trucks with bodies following the liberation of the Bergen-
Belsen concentration camp in north-west Germany.
16th April, 1945

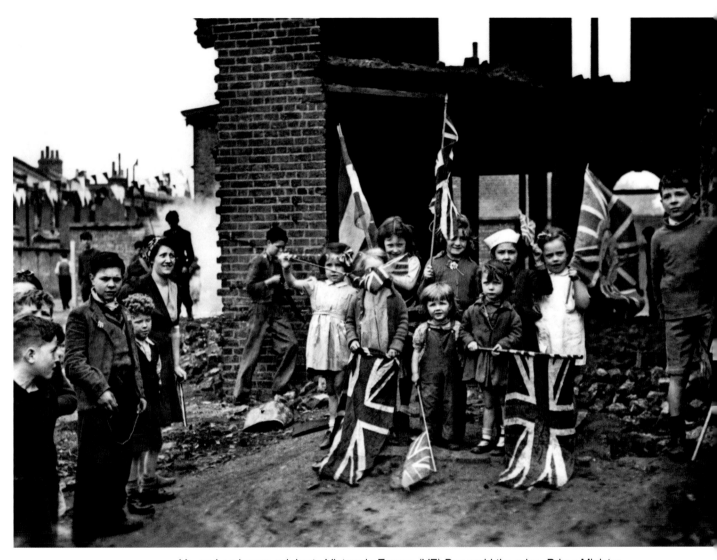

Young Londoners celebrate Victory in Europe (VE) Day amid the ruins. Prime Minister Winston Churchill announced the end of the war with Germany in a broadcast from 10 Downing Street. Yet Churchill stressed that *"Japan... remains unsubdued"* and, *"We must now devote all our strength and resources to the completion of our task, both at home and abroad."* Victory over Japan was sealed four months later.
8th May, 1945

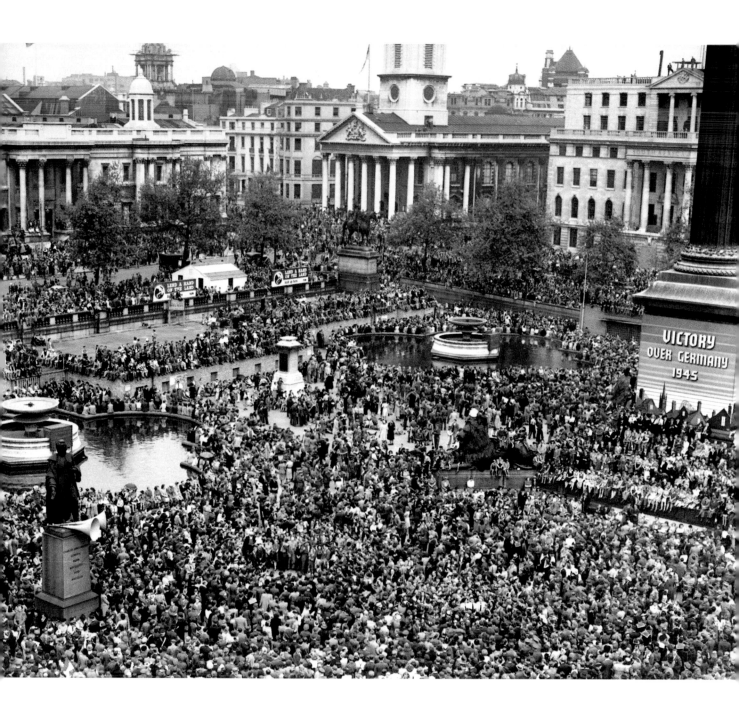

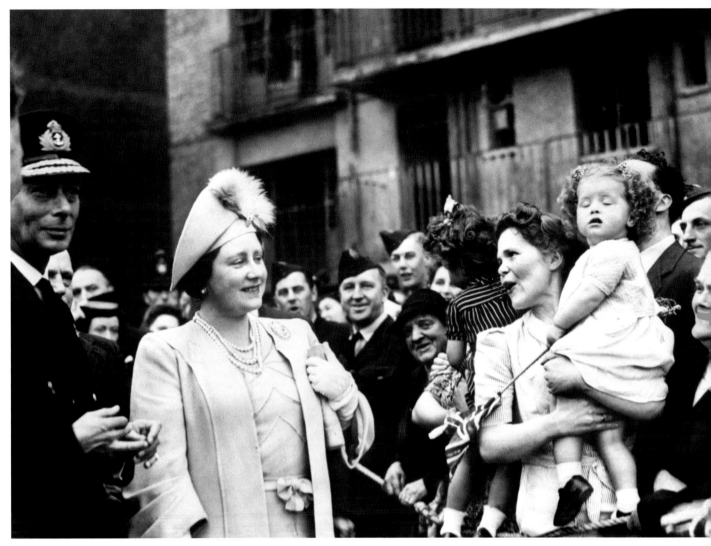

Facing page: Huge crowds descend on Trafalgar Square in London, following the news that the war in Europe had come to an end.
8th May, 1945

King George VI and Queen Elizabeth visit Vallance Road in Stepney, east London to look at damage caused by a *V-2* rocket hit. The attack, on the 27th of March 1945, destroyed a block of flats, killing 134 people. The event is particularly poignant as it was the last *V-2* to land on the capital.
10th May, 1945

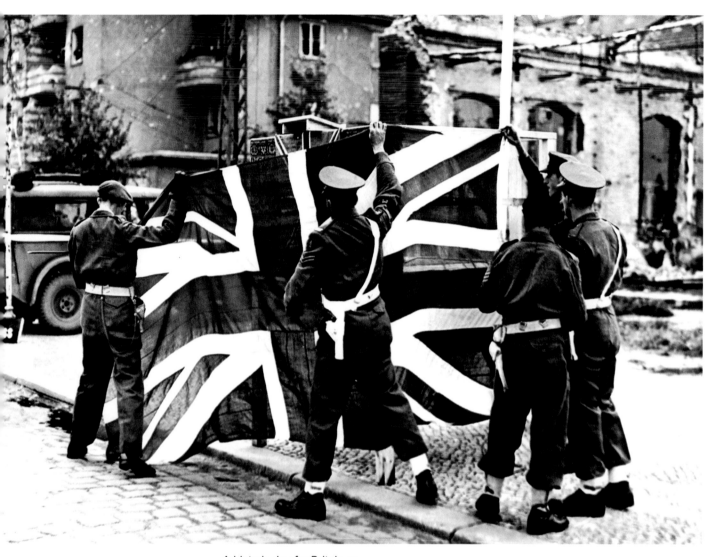

A historic day for Britain as
military policemen prepare
to hoist the Union Jack to
receive the official entry of
the British Army into Berlin.
30th May, 1945

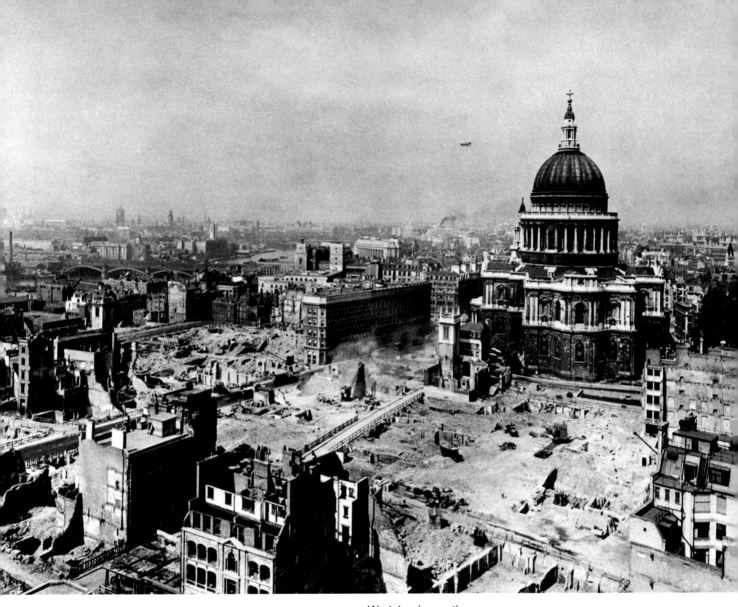

Work begins on the
rebuilding of London, which
has been left devastated by
six years of bombing.
1st June, 1945

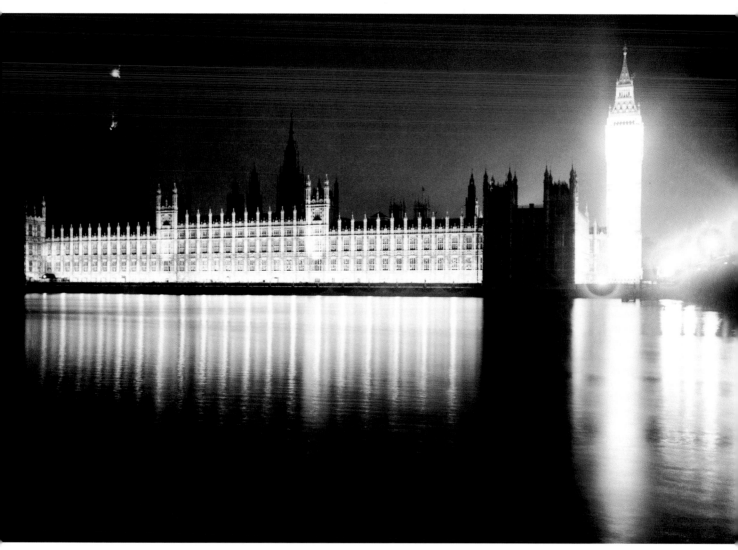

The Houses of Parliament are floodlit to celebrate Victory
in Japan (VJ Day). The announcement of the Japanese
acceptance of the terms of surrender was made by Emperor
Hirohito, although the formal signing of documents took
place on the 2nd of September.

15th August, 1945

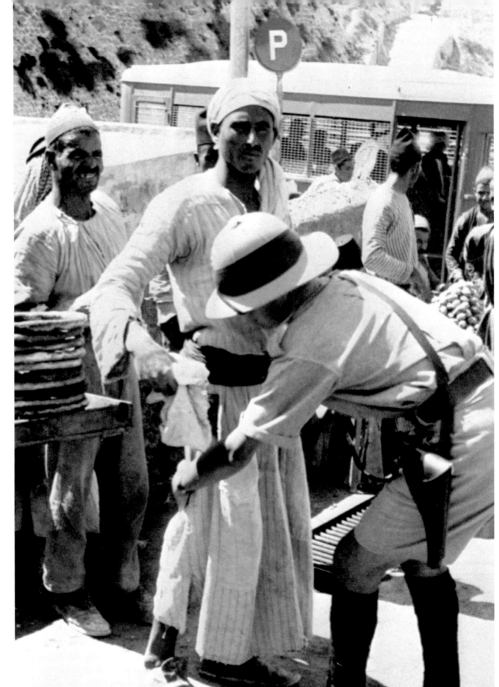

Soldiers of the Black Watch search civilians in Jerusalem, then under the British Mandate of Palestine. Palestine – comprising what is now Israel, the West Bank, Gaza Strip and Jordan – was placed under British administration by the League of Nations in 1920 following the First World War. It was not until 1948 that Israel became an independent state.

1st September, 1945

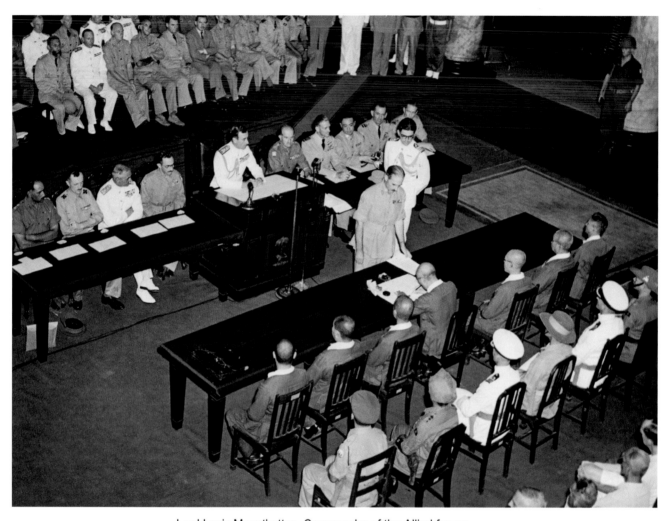

Lord Louis Mountbatten, Commander of the Allied forces
in South East Asia, presides as General Itagaki of the
Japanese Imperial Army signs surrender documents in
Singapore. Although the official terms of Japanese surrender
had been signed on the 2nd of September, 1945, further
ceremonies took place across other Japanese territories
after this date.

12th September, 1945

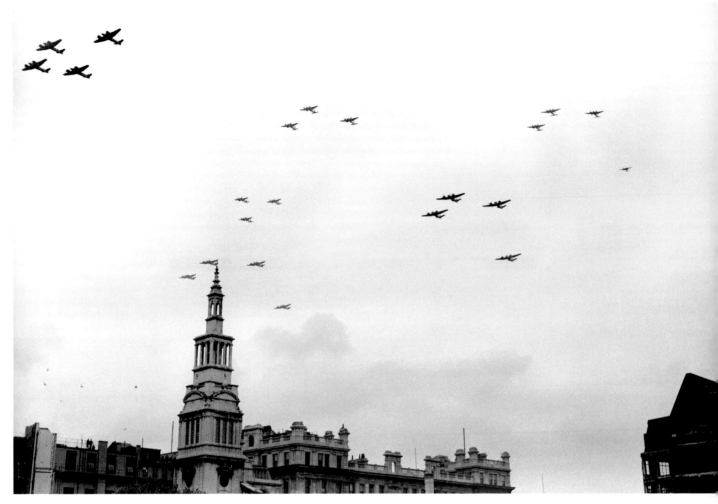

British planes fly over
London during Thanksgiving
Week following the end of
the Second World War.
13th September, 1945

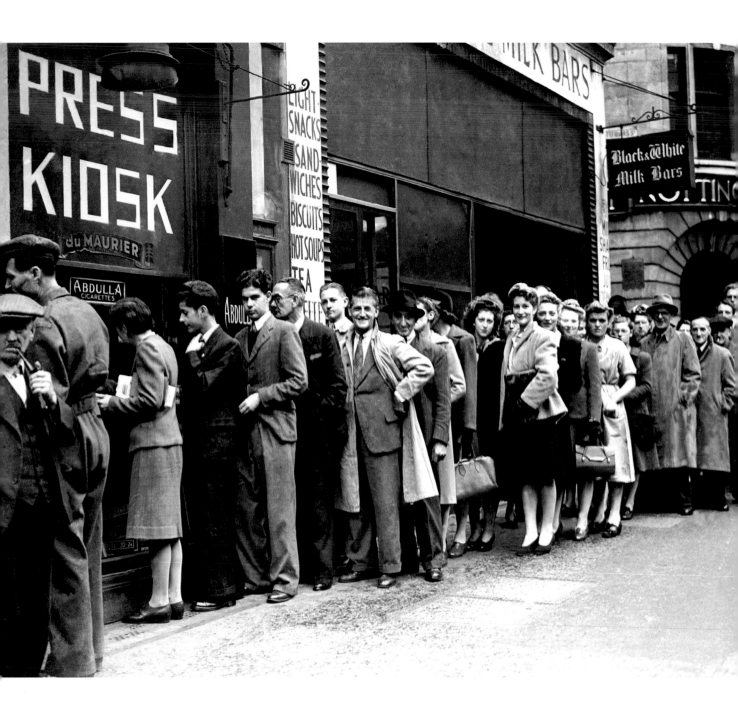

Survivors of the cruiser, *Exeter*, sunk by the Japanese in 1942, celebrate their return to England from prisoner of war camps. They contribute to a complement of 400 PoWs carried back to Portsmouth by HMS *Maidstone*.
11th December, 1945

Facing page: Queues wait in Fleet Street during a cigarette shortage. Rationing of products such as petrol and clothing remained in Britain for several years after the end of the Second World War, with food rationing continuing until as late as 1954.
15th September, 1945

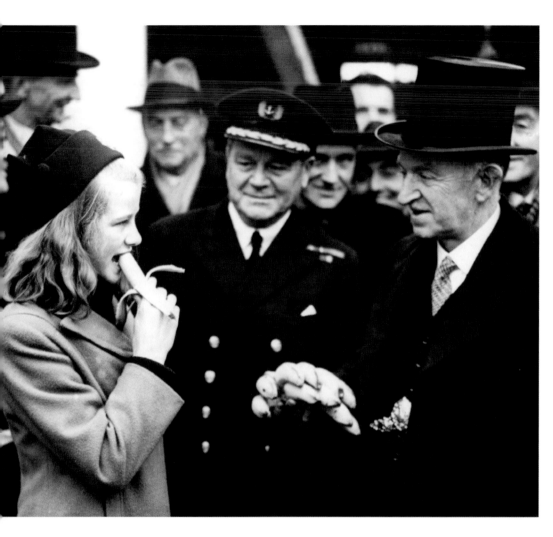

Daphne Philips is given the honour of tasting the first banana to arrive in Britain after the Second World War. It is given to her by Alderman James Owen JP, Lord Mayor of Bristol, on the quayside in Portsmouth, Hampshire.

30th December, 1945

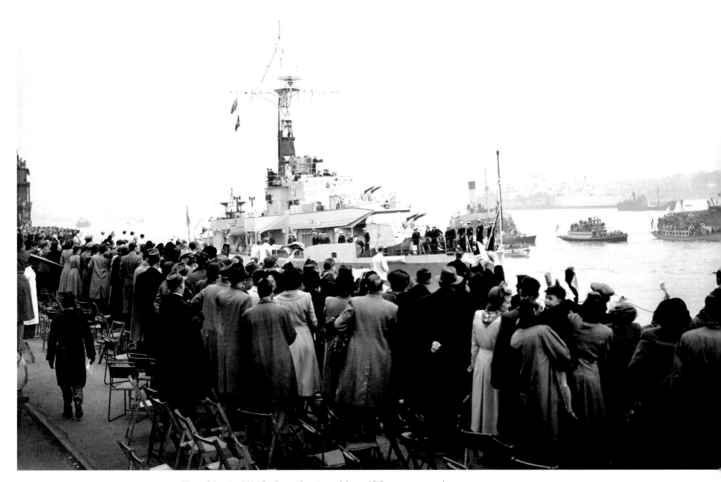

The frigate HMS *Amethyst* and her 150 crew members
are given a rousing welcome as they return to Devonport
following a dramatic escape from the Yangtse River in China,
where she came under heavy fire from Communist forces
during the country's Civil War.
1st November, 1949

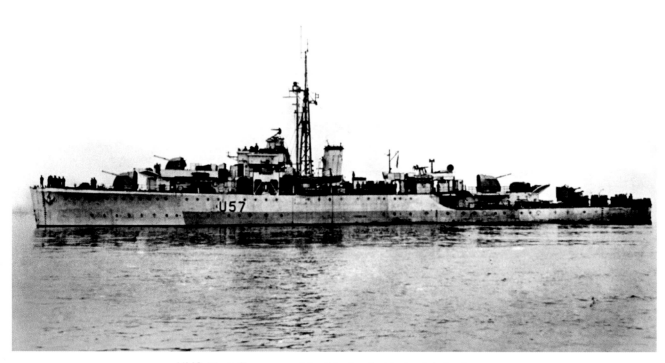

HMS *Black Swan*, one of the frigates that helped defend
Allied shipping from U-Boats during the Second World War
and which went to the aid of the HMS *Amethyst* during the
Yangtse Incident of 1949, is seen here in Korean waters.
4th July, 1950

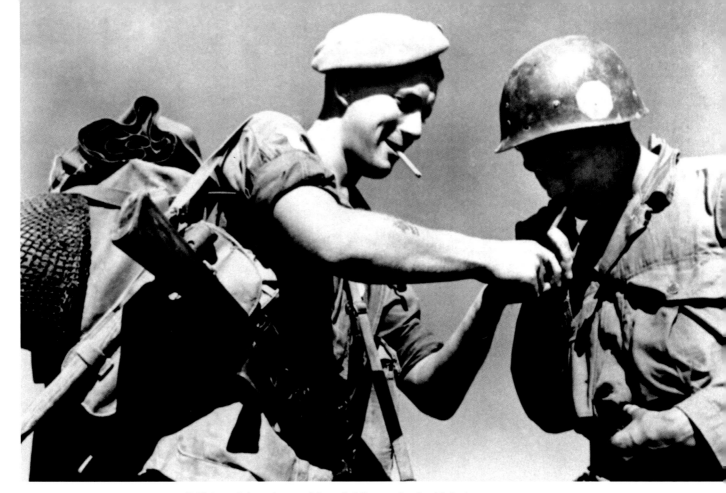

British and American soldiers fighting under the United Nations flag in Korea meet for a cigarette. The United States-backed Republic of Korea was invaded on the 25th of June, 1950, by the North Korean People's Army. The US would call on the United Nations Security Council to take action and troops from several nations, including the United Kingdom, were sent to the region to resist the North Koreans.

30th August, 1950

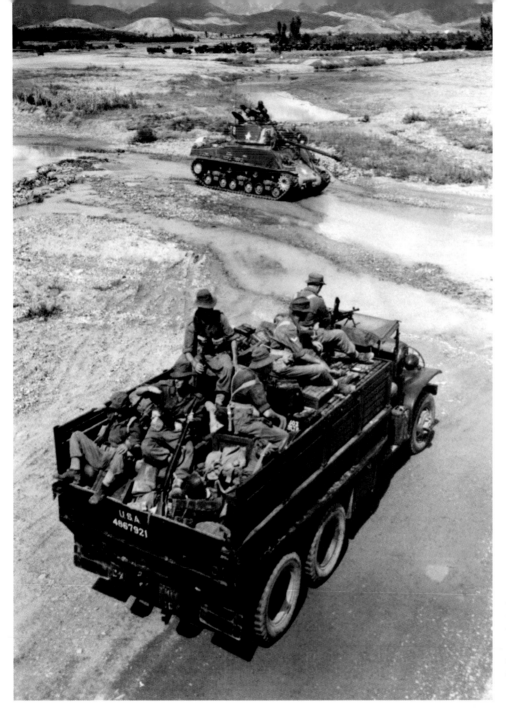

An American tank stands guard as a lorry full of troops from the 1st Middlesex Regiment prepare to push forward during the Korean War.

3rd September, 1950

A woman waves goodbye as a plane, carrying soldiers of the Argyll and Sutherland Highlanders, takes off from RAF Lyneham, bound for Korea.
11th September, 1950

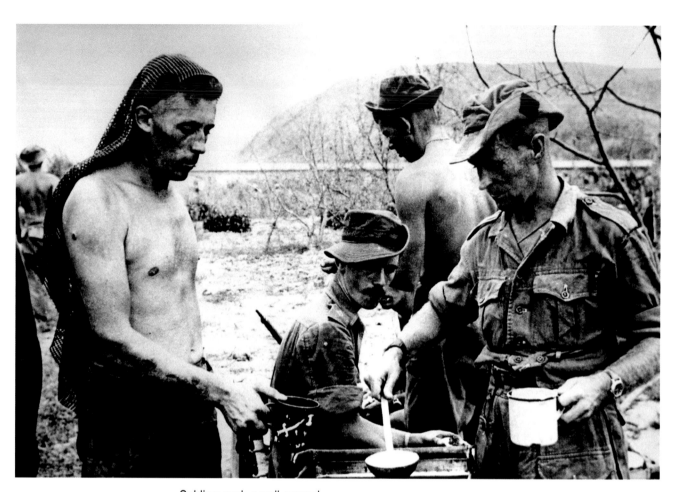

Soldiers grab a well-earned
cup of soup at a British
Forces field kitchen in Korea.
20th September, 1950

The 1st Battalion Royal
Northumberland Fusiliers
raise a cheer as they set
sail for Korea aboard the
RMS *Empire Halladale* from
Southampton.
11th October, 1950

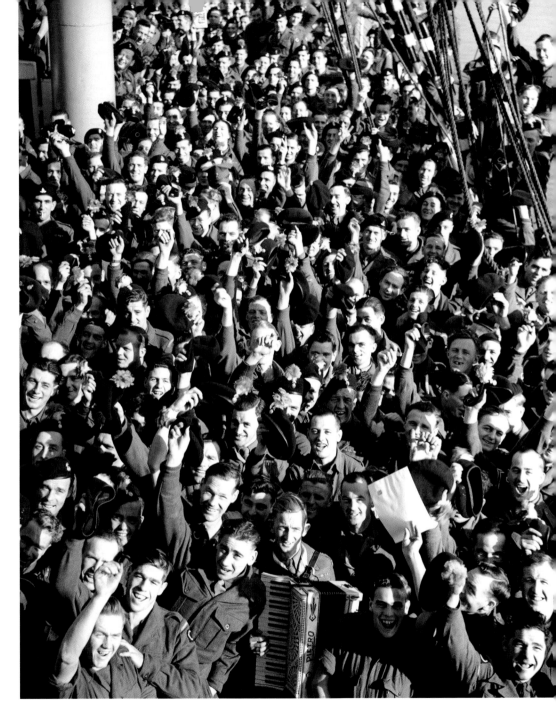

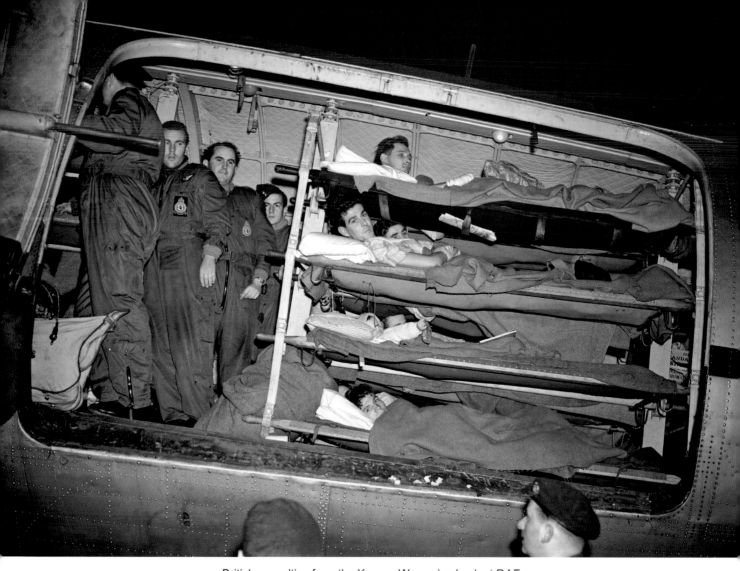

British casualties from the Korean War arrive back at RAF Lyneham, Wiltshire, aboard a *Hastings* aircraft. A total of 2,674 British service personnel were injured during the conflict, while 1,078 were killed in action. American deaths numbered nearly 40,000.

22nd November, 1950

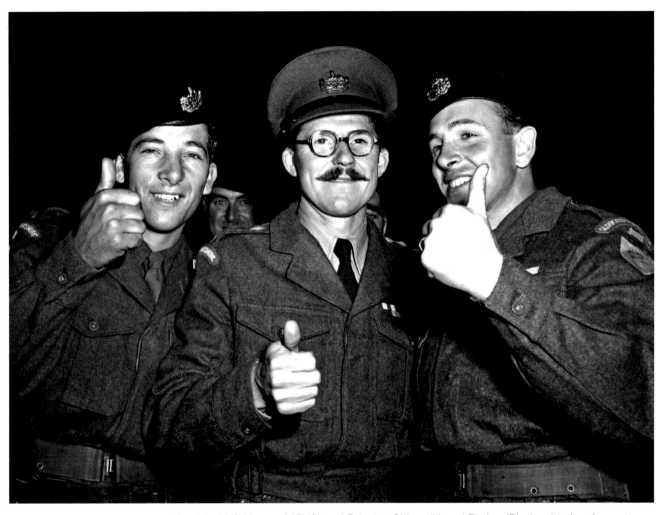

Captain M G Harvey MC (C) and Privates Shiers (L) and Rudge (R) give the thumbs up to photographers on arrival at Southampton with 1st Battalion, the Gloucestershire Regiment 'the Glorious Glosters'. During the Korean War, Chinese forces isolated the battalion from the rest of its brigade on the infamous 'Hill 235' during the Battle of the Imjin River. The majority were captured, but some, under Harvey, escaped to friendly lines.
21st December, 1951

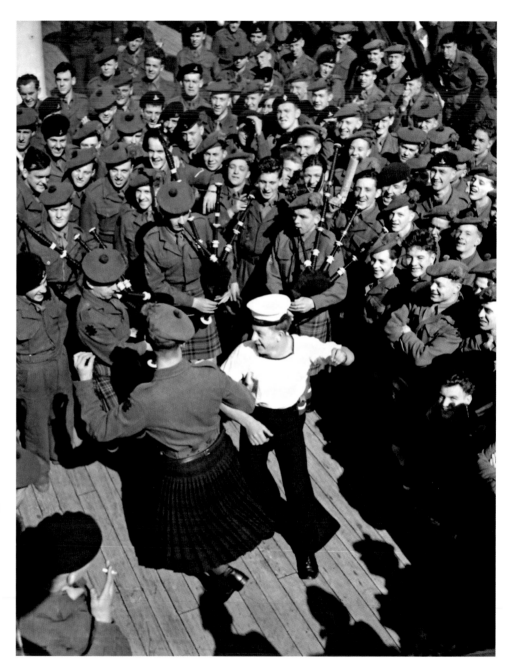

Troops are entertained by pipers and dancers as the *Empire Orwell* sets sail for the Far East from Southampton. The 'Empire' series of ships in the service of the British Government all bore the same prefix. They were used during the Second World War by the Ministry of War Transport (MoWT), who contracted them out to various shipping lines.

21st May, 1952

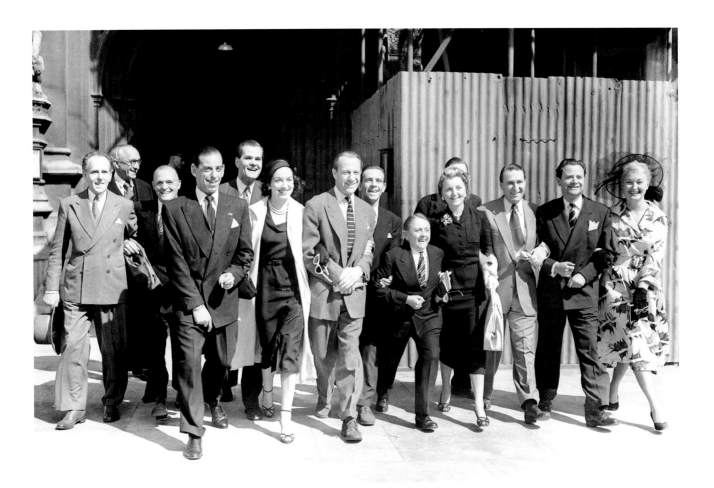

British variety artists including: (L–R) Ben Warriss, Pat Kirkwood, Jimmy Jewel, Norman Wisdom, Wee Georgie Wood, Avril Angers, Charlie Chester, Derek Roy and Christine Norden, leaving the House of Commons after volunteering to entertain troops in Korea.
22nd May, 1952

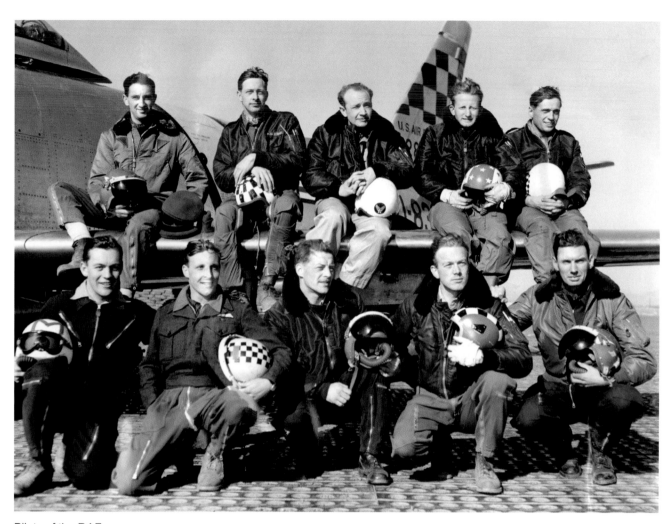

Pilots of the RAF on
temporary duty flying *F-86
Sabre* jets with the 51st
Fighter-Interceptor Wing of
the United States Air Force
in Korea.
4th May, 1953

Facing page: The 1st Battalion, Royal Warwickshire Regiment,
salute the camera on board their troopship at Southampton.
Heading for Korea around the time of the armistice, the
majority of the soldiers are on National Service.
31st July, 1953

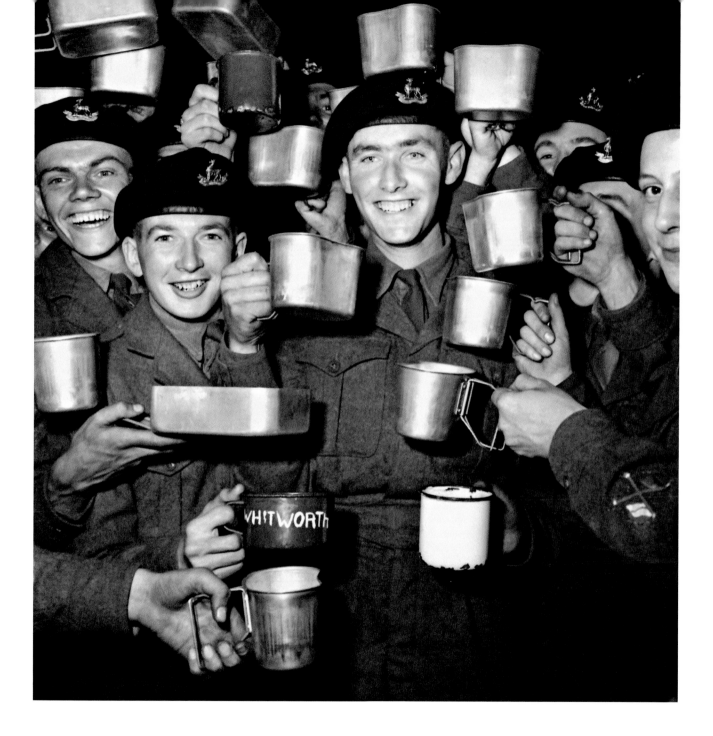

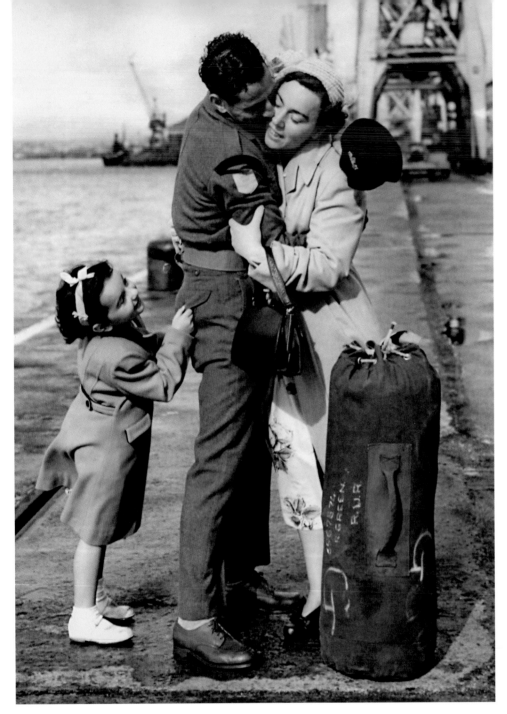

Rifleman Ronald Green, repatriated after being a prisoner of war in Korea, is reunited with his wife Kathleen and his daughter, also Kathleen, at Southampton docks.
16th July, 1953

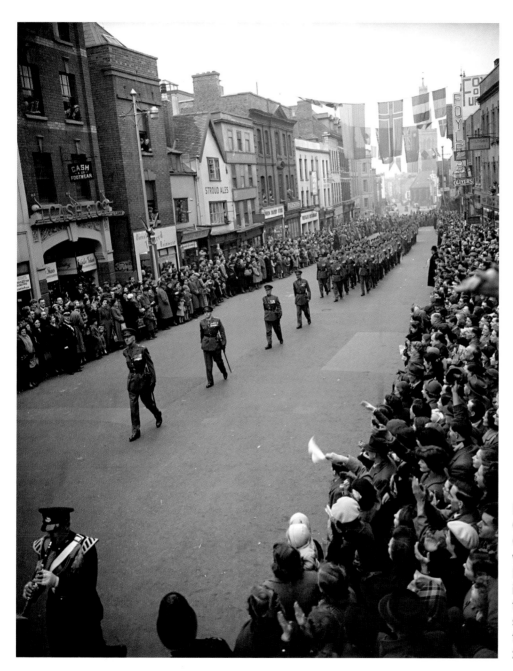

Lieutenant-Colonel James Carne VC DSO of the Gloucestershire Regiment, who commanded at the Battle of the Imjin River in Korea, leads a parade through Gloucester after a service of thanksgiving for the survivors' safe return.
22nd November, 1953

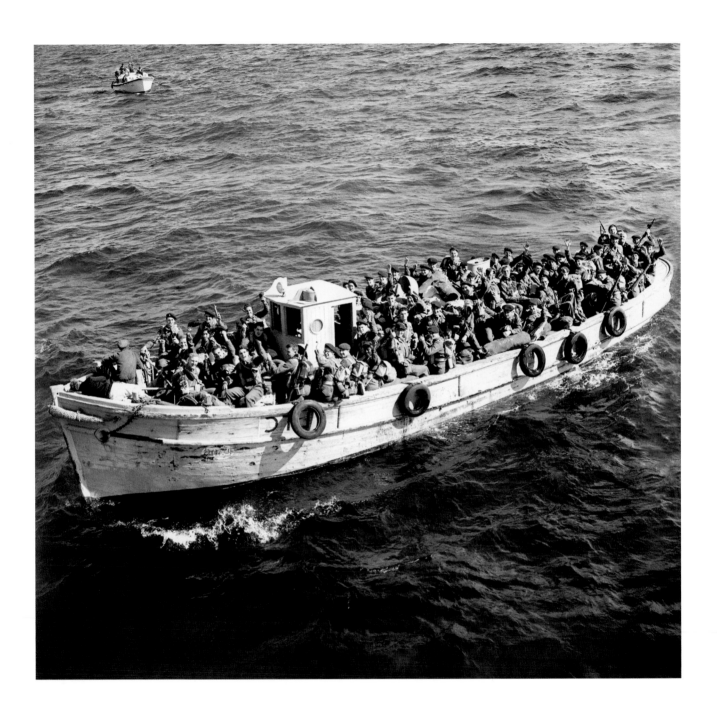

Facing page: A barge of cheering troops leaves Limassol in Cyprus for Egypt as the crisis over the control of the Suez Canal escalates.
1st October, 1956

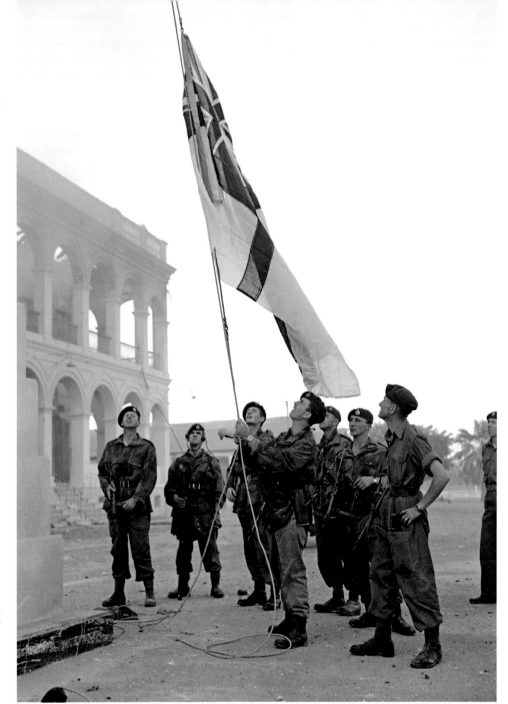

British Commandos raise the White Ensign over Navy House, Port Said, Egypt, just 10 minutes after capturing the building in heavy fighting with Egyptian forces during the Suez Crisis.
8th November, 1956

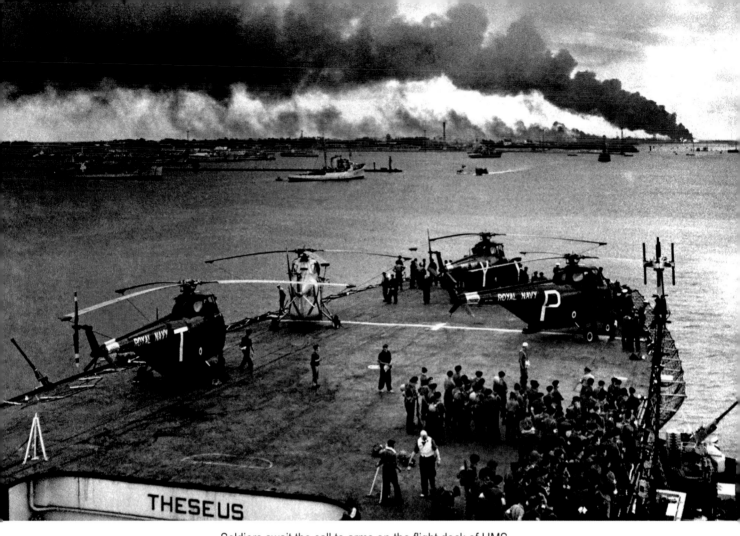

Soldiers await the call to arms on the flight deck of HMS
Theseus, a Colossus-class light carrier, just outside Port
Said in Egypt. In the distance smoke bellows from blazing
oil tanks. The assault on Port Said marked the biggest
helicopter operation in the history of the British services.
12th November, 1956

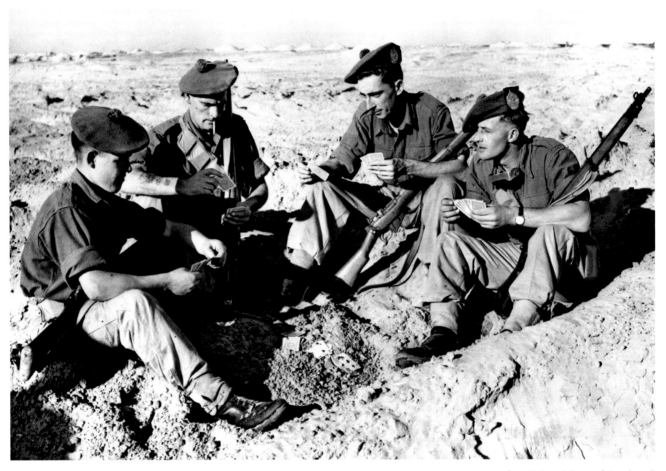

Scottish soldiers of the Argyll
and Sutherland Highlanders
serving with the Anglo-
French police force in Egypt,
relax and play cards just
outside Port Said.
21st November, 1956

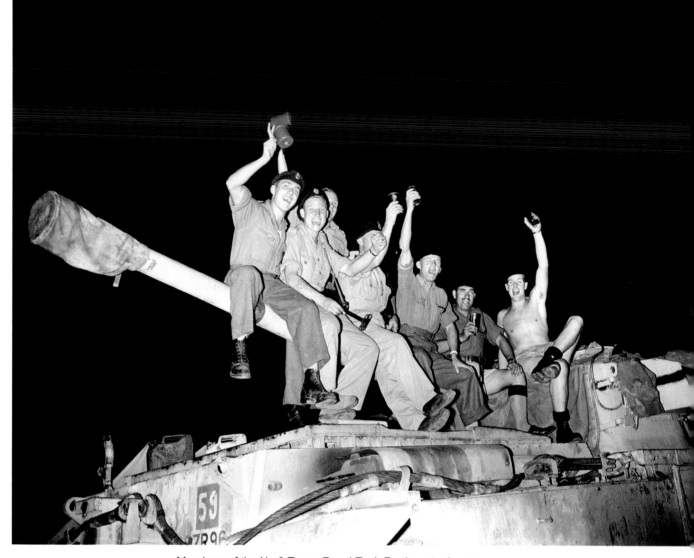

Members of the No 6 Troop, Royal Tank Regiment raise
their glasses as they sit on the gun barrel of a tank in Port
Said. British troops had begun to withdraw from the region
following the ceasefire in November.
1st December, 1956

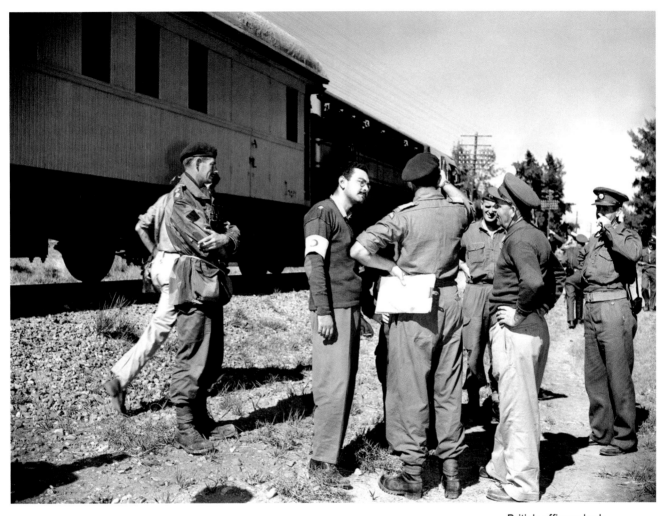

British officers look relaxed as they talk to a major in the Egyptian Medical Corps beside a hospital train at El Gap, Egypt, following an end to the hostilities.
1st December, 1956

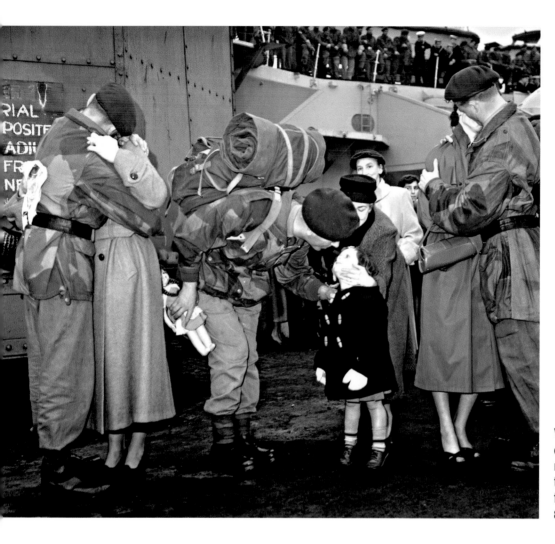

Welcome home – members of the Royal Marines are reunited with loved ones as they returned to Plymouth from Port Said in Egypt.
8th December, 1956

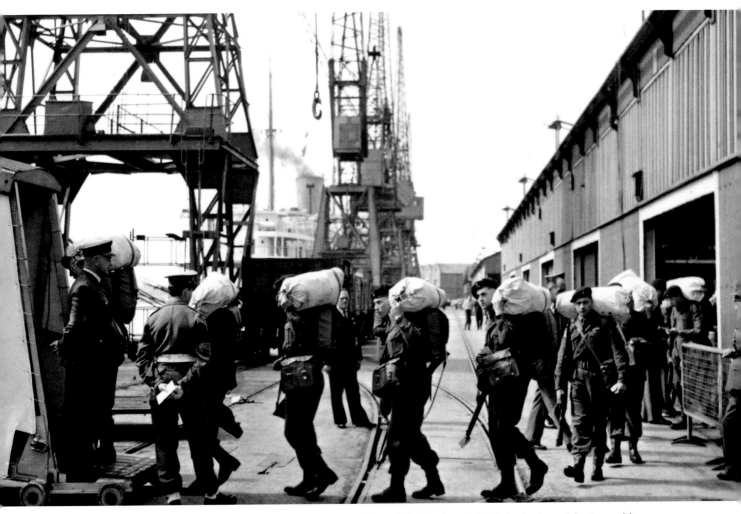

Men of the Durham Light Infantry board the troopship, *Devonshire*, at Southampton en route for Cyprus. Troops were sent to the island to bolster Britain's presence following the EOKA uprising and subsequent guerrilla war, which sought the "*Liberation of Cyprus from the British yoke*". **17th July, 1958**

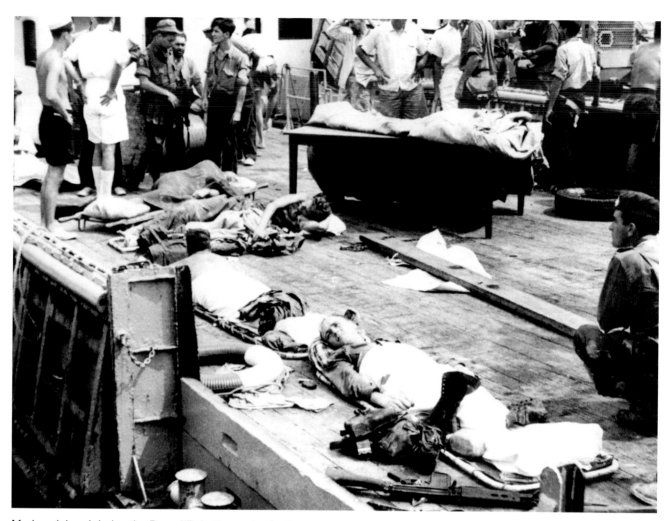

Marines injured during the Brunei Rebellion arrive back at
Labuan, off the coast of Malaysia, on board the minesweeper
HMS *Chawton*. The revolt was led by Yassin Affandi and was
in protest at proposals to form a new Malaysian Federation.
18th December, 1962

Facing page: A convoy of
Land Rovers from the 1st
Battalion Yorks and Lancs
pause in a Cypriot village
to allow a flock of the local
brown-faced sheep to pass.
1st February, 1967

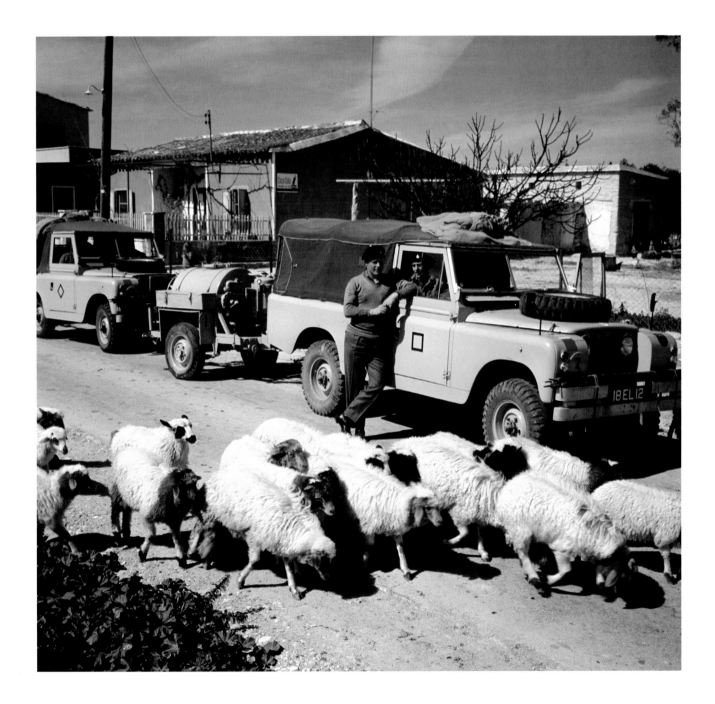

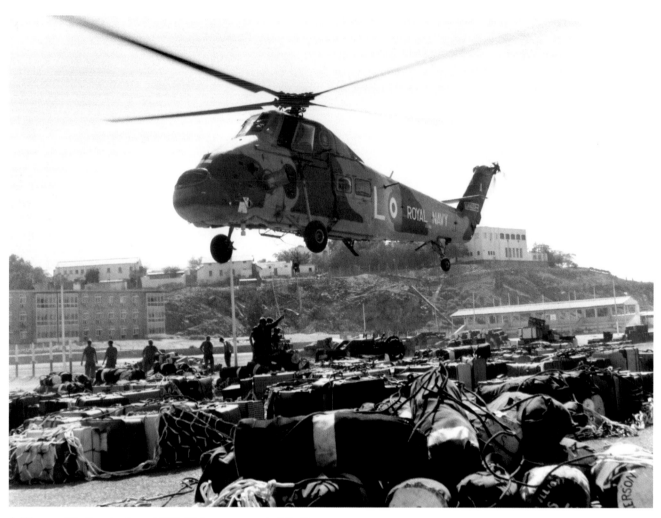

A *Wessex 5* helicopter from HMS *Albion* prepares to lift off stores from Steamer Point in Aden during the conflict in the region. The Aden Emergency, as it is known, was an insurgency against British forces that lasted for four years until the British pulled out in 1967.
29th November, 1967

Facing page: A Fleet Air Arm *Buccaneer* aircraft from HMS *Eagle* flies over Aden in the Middle East as British troops withdraw from the area.
29th November, 1967

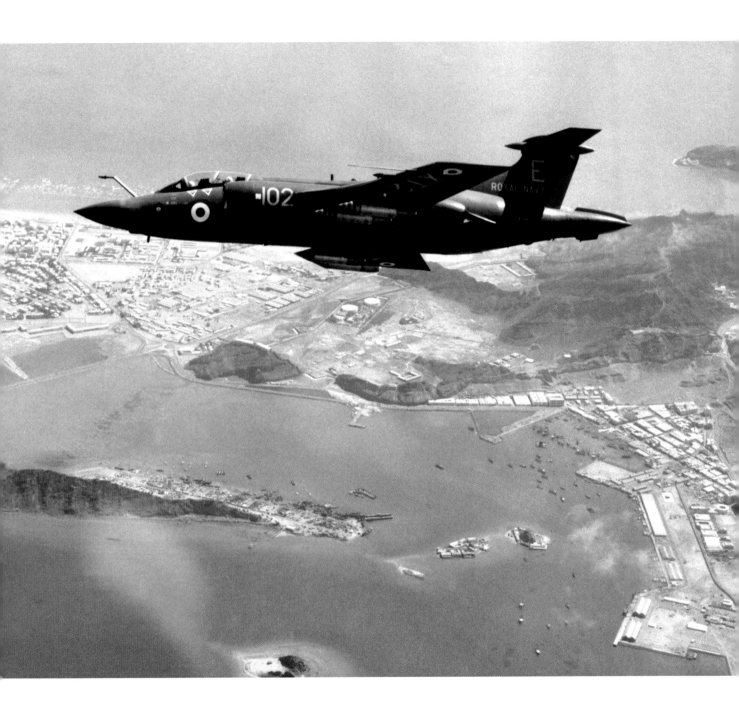

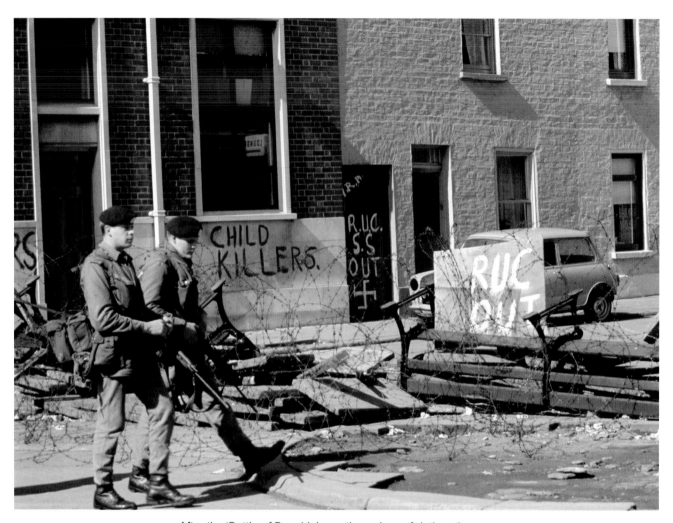

After the 'Battle of Bogside' saw three days of rioting, the British Army was called in to separate the RUC and the Bogsiders. This was the first direct intervention in Northern Ireland by the London government, and the British Army, since partition in 1921.

August, 1969

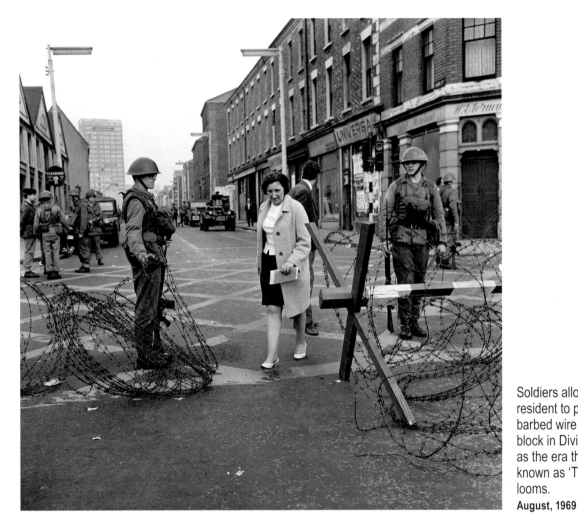

Soldiers allow a woman resident to pass through the barbed wire at a military road block in Divis Street, Belfast, as the era that became known as 'The Troubles' looms.
August, 1969

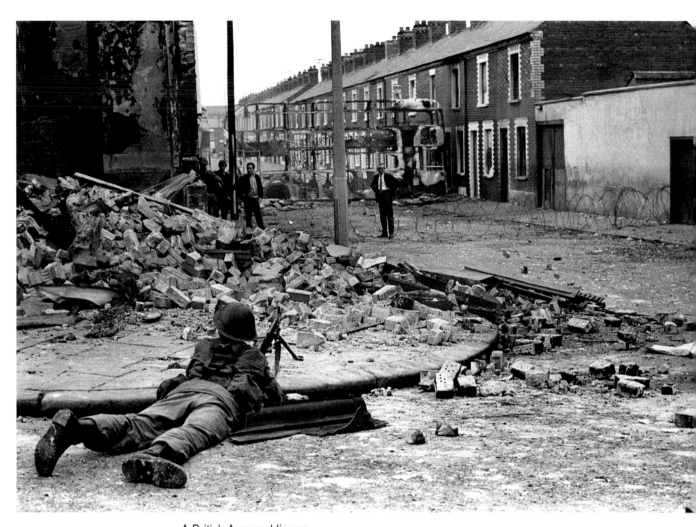

A British Army soldier on
lookout in Belfast, where
the city was in the grip of
violence and civil unrest.
15th August, 1969

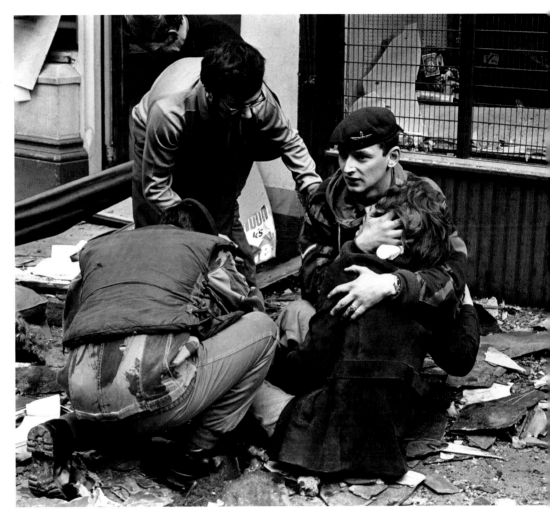

A British paratrooper cradles
a young woman in his arms
after she had been hurt in
a bomb blast in Donegal
Street, Belfast.
20th March, 1972

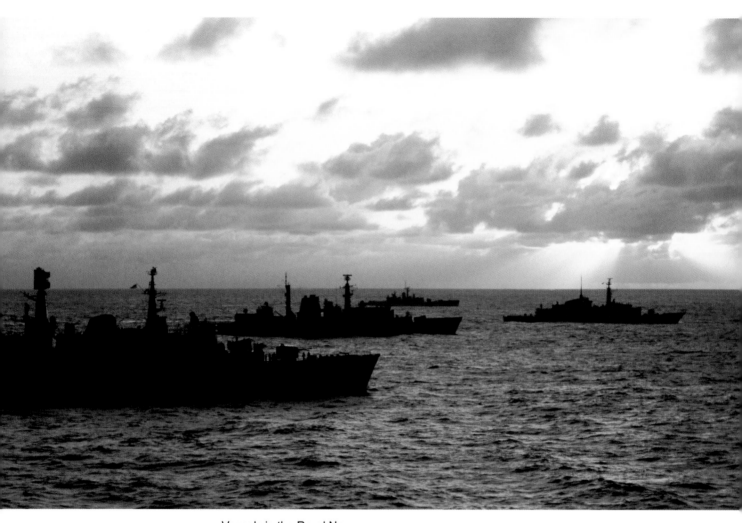

Vessels in the Royal Navy
Task Force steaming south
across the Atlantic Ocean at
the outset of hostilities with
Argentina.
April, 1982

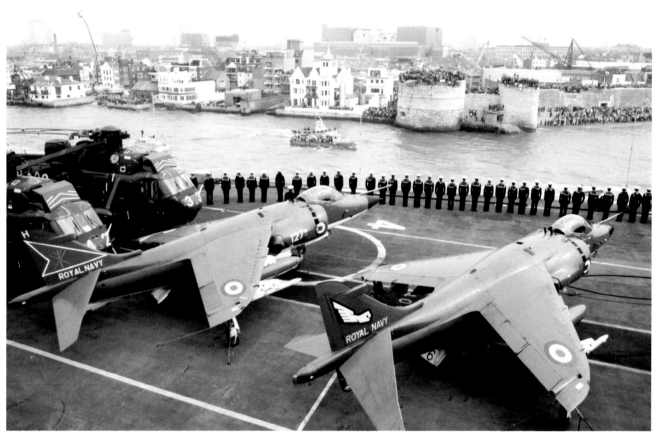

Well wishers line the
wall of the Round Tower
in Portsmouth, as HMS
Hermes, the flagship of the
British fleet, sets sail for the
Falkland Islands.
5th April, 1982

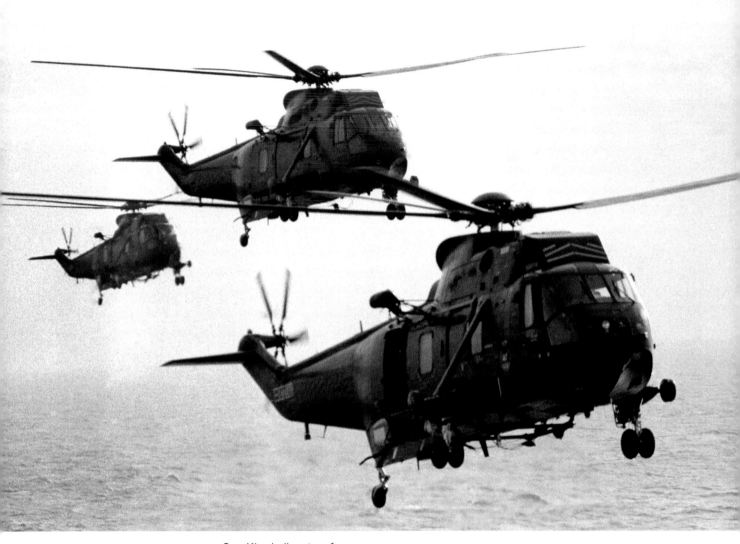

Sea King helicopters from
the carrier HMS *Hermes* fly
in formation during a practice
sortie from the vessel as she
makes her way across the
Atlantic.
7th April, 1982

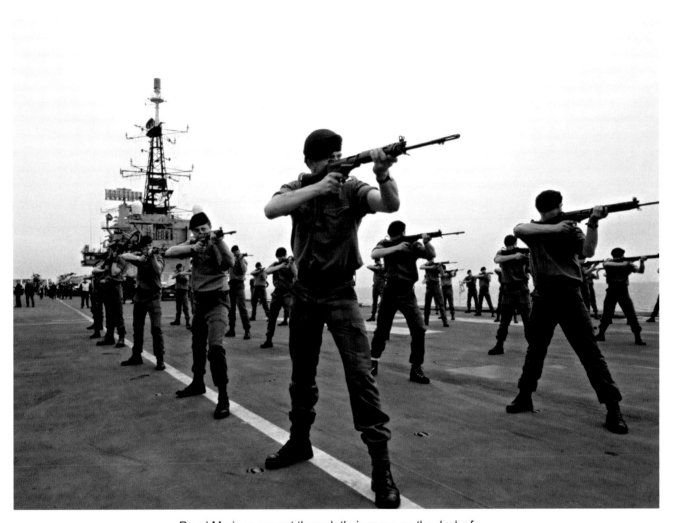

Royal Marines are put through their paces on the deck of
HMS *Hermes*. The *Hermes*, a Centaur-class aircraft carrier
could carry up to 28 *Sea Harriers* capable of Vertical Take-
Off and Landing (VTOL). Prior to the conflict the ship had
been earmarked for scrapping.
7th April, 1982

A serviceman aboard the HMS *Hermes* takes the chance to unwind as the vessel heads south towards the Falklands.
18th April, 1982

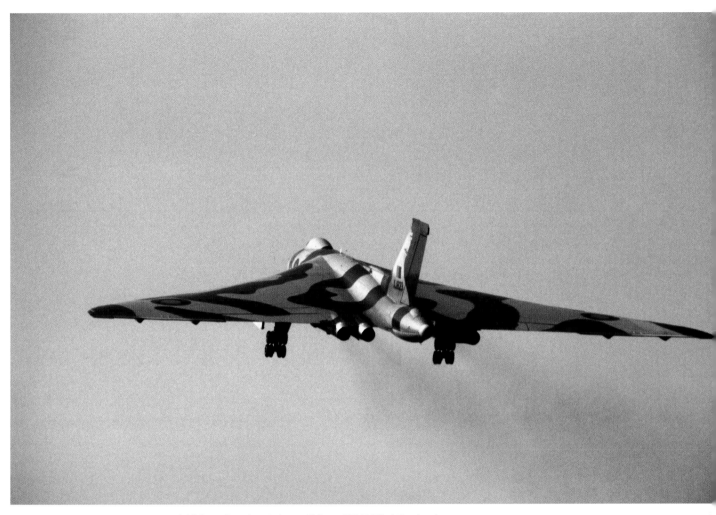

A Vulcan bomber takes off from RAF Waddington in Lincolnshire during the Falklands Crisis. Although the process of decommissioning the bombers had begun, three were deployed for service in the South Atlantic: each sortie from their base in the Ascension Islands to the Falklands required 10 mid-air refuellings – five on the way out, five on the way back – per aircraft. The *Vulcan* was finally retired in 1984.

19th April, 1982

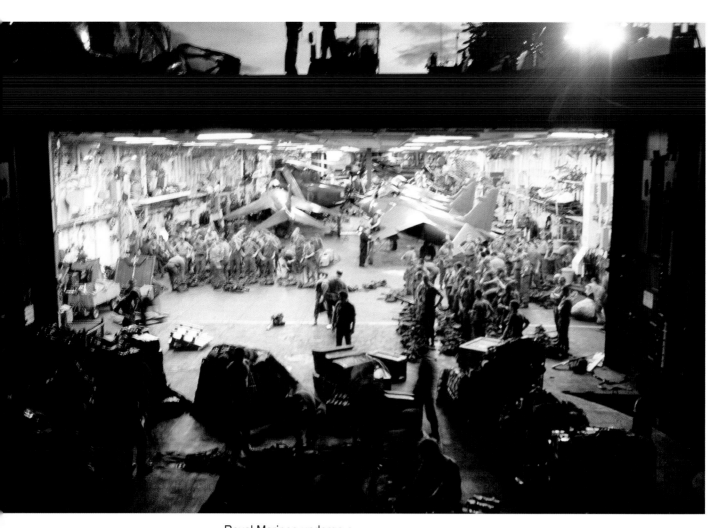

Royal Marines undergo a
weapons inspection beside
their aircraft within one of
the hangars aboard HMS
Hermes.
20th April, 1982

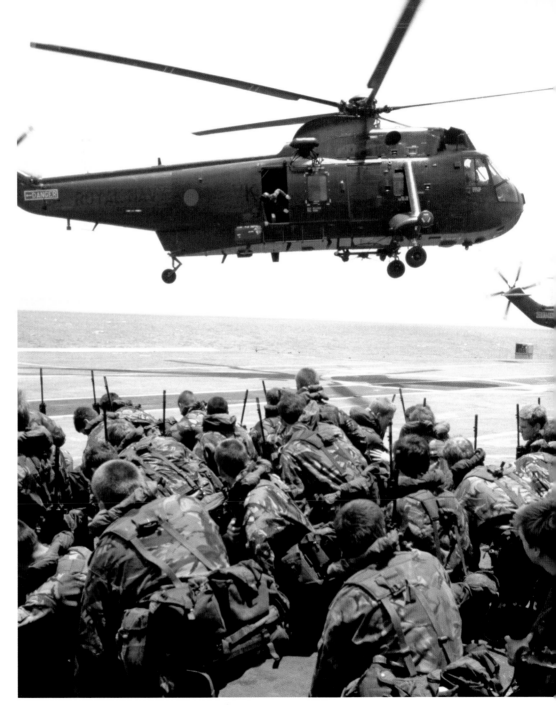

Marines crouch down on the deck of their aircraft carrier as a *Sea King* helicopter lands on board during the Falklands Conflict.
20th April, 1982

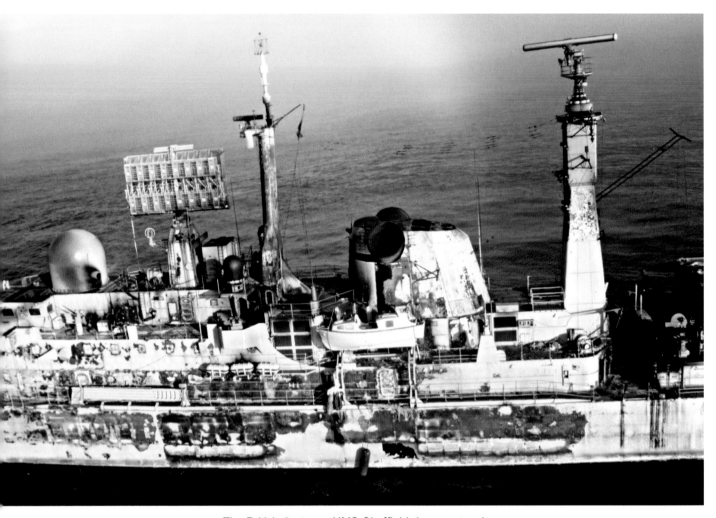

The British destroyer HMS *Sheffield* shows extensive
damage after being attacked by Argentine planes on the 4th
of May. The ship, on which 20 men were killed, sank while
being towed to safe water.
10th May, 1982

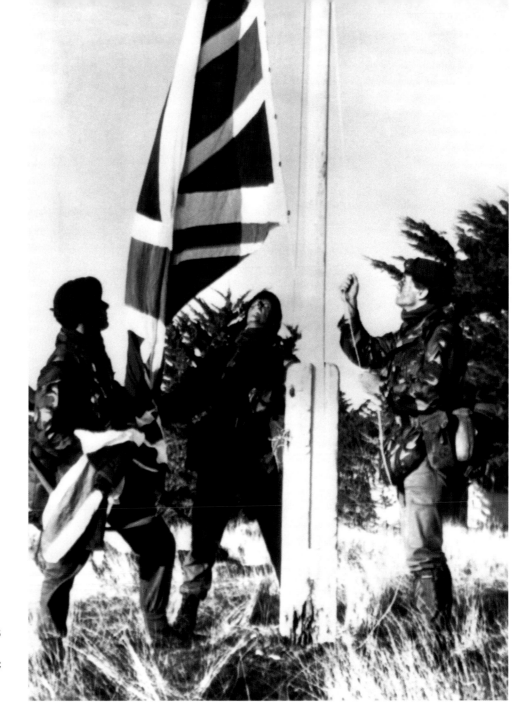

Royal Marine Commandos
hoist the Union Jack after
securing a critical strategic
position.
22nd May, 1982

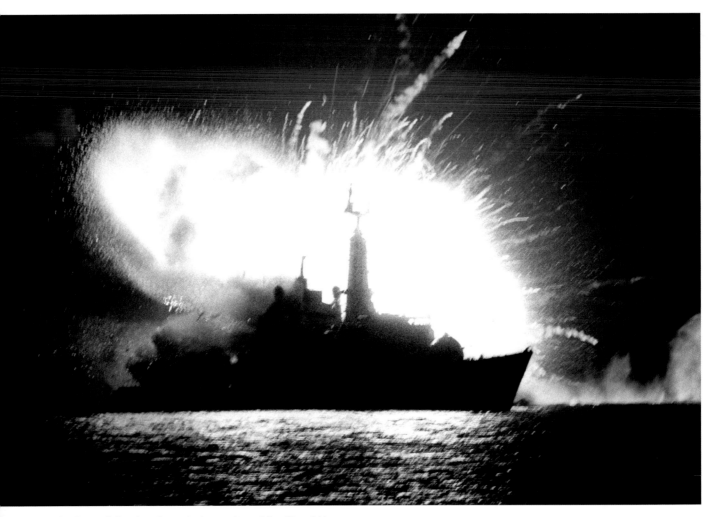

An Argentinian bomb explodes on board the Royal Navy frigate HMS *Antelope* killing the bomb disposal engineer who was trying to defuse it. The ship was part of the British Task Force engaged in the recapture of the Falkland Islands following the invasion by Argentina in April 1982.
23rd May, 1982

Facing page: A *Wessex* helicopter hovers overhead as HMS *Antelope*, still burning fiercely, slips beneath the water.
23rd May, 1982

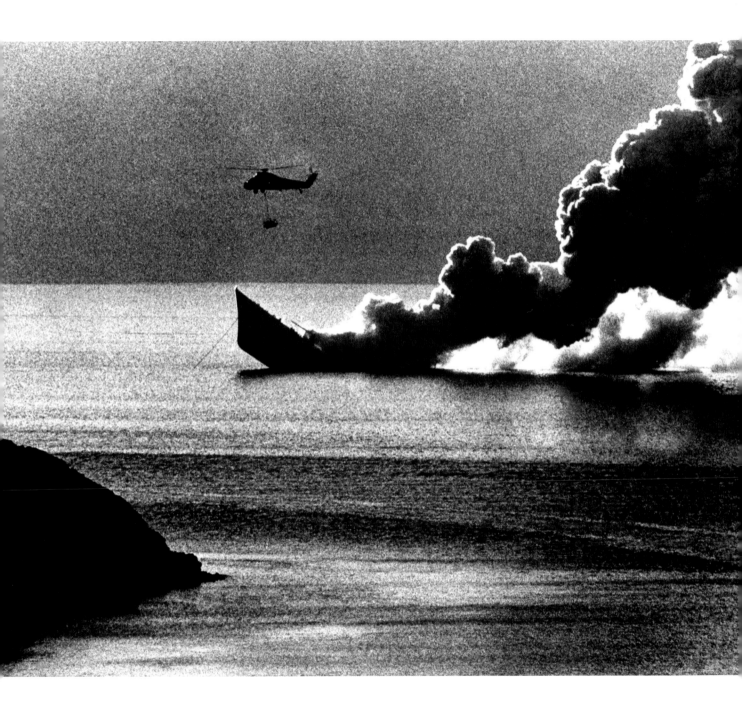

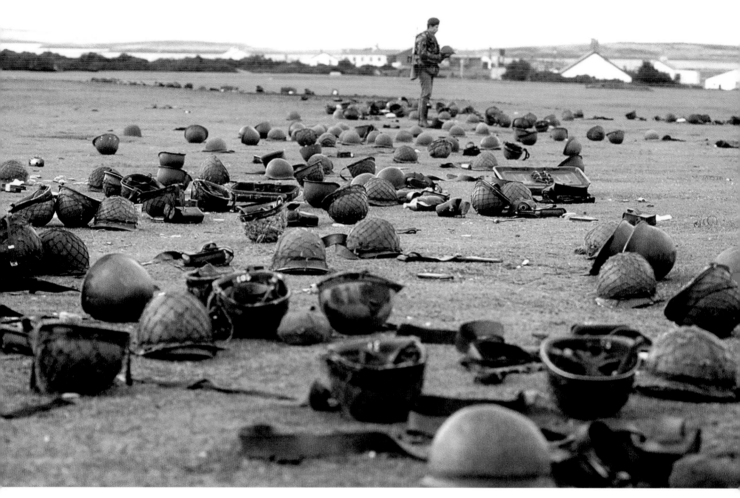

Steel helmets abandoned by Argentine armed forces
following their surrender to British troops at Goose Green. It
became known as an epic victory for the British as they were
outnumbered by more than two-to-one. Seventeen Para's
were killed during the battle and more than 200 Argentinians
lost their lives, with at least another 1,000 captured.
28th May, 1982

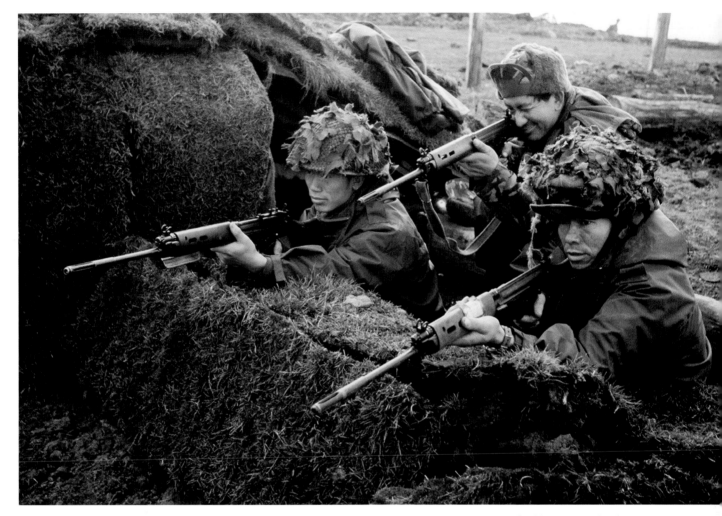

Gurkha troops, dug in on a
hillside at San Carlos Bay,
during the final stages of the
Falklands Conflict.
1st June, 1982

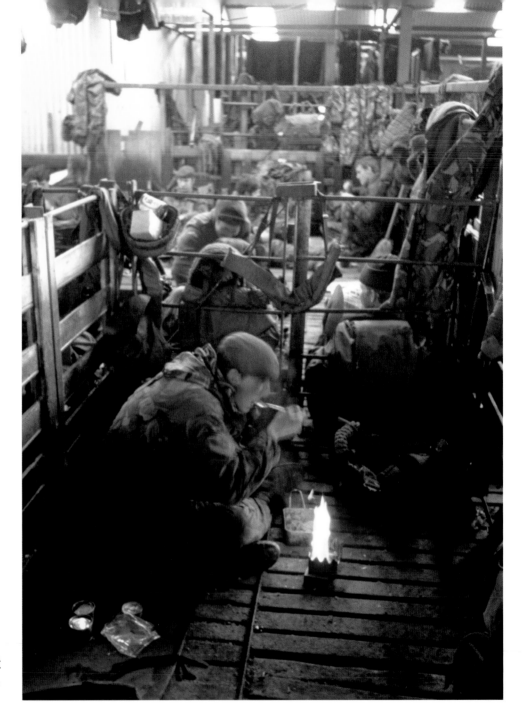

The men of the 2nd
Battalion, the Parachute
Regiment tuck into their
rations after settling down
for the night in a sheep pen
on a farm at Fitzroy on East
Falkland during the conflict.
1st June, 1982

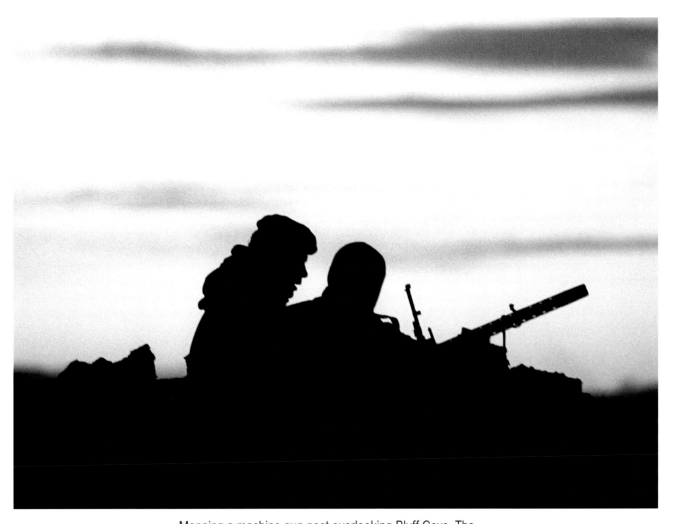

Manning a machine gun post overlooking Bluff Cove. The area was later the scene of great British loss when both the RFA *Sir Galahad* and its companion ship *Sir Tristram* were attacked by Argentinian *Skyhawk* fighters.

1st June, 1982

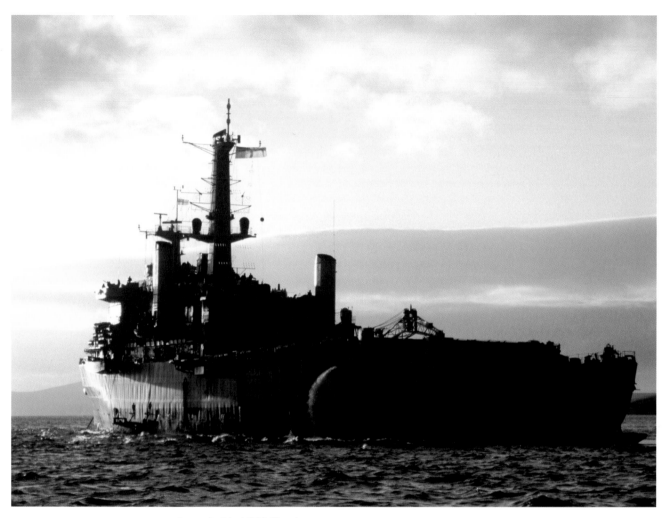

Assault ship HMS *Fearless,*
silhouetted at dusk, comes
to San Carlos Water
after the bridgehead was
established by the Task
Force on East Falkland in
the South Atlantic.
1st June, 1982

Brigadier Tony Wilson (L) and Major General Jeremy Moore consider their position in the San Carlos Bay area. Moore would later become the most famous commander in Britain after he accepted the Argentinian surrender that brought the conflict to a close.

1st June, 1982

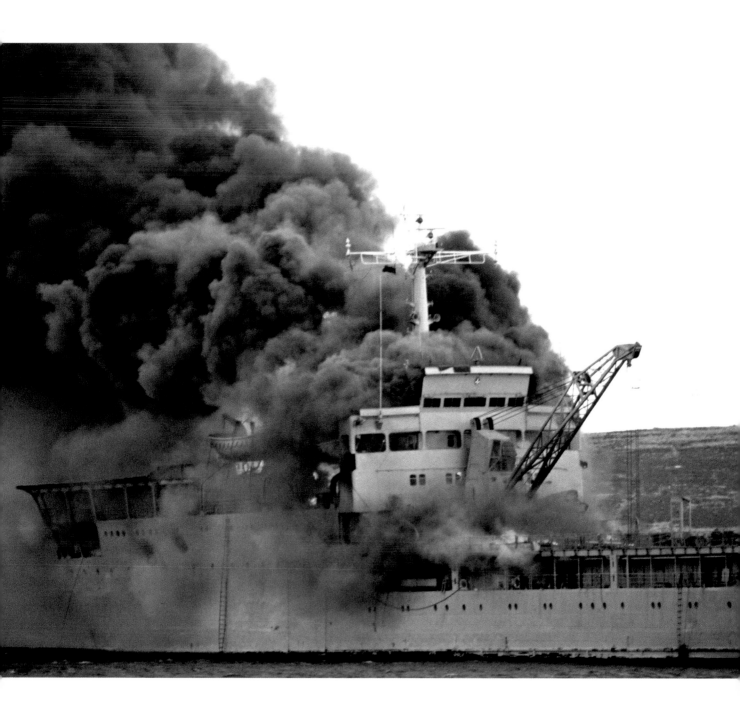

Facing page: The *Sir Galahad* is set ablaze during an Argentine air raid off Fitzroy near Bluff Cove. Many British soldiers, most of them Welsh Guards, lost their lives during the attack and the wreck is now an official war grave. The bombing accounted for approximately one fifth of the 255 British fatalities during the Falklands War.
8th June, 1982

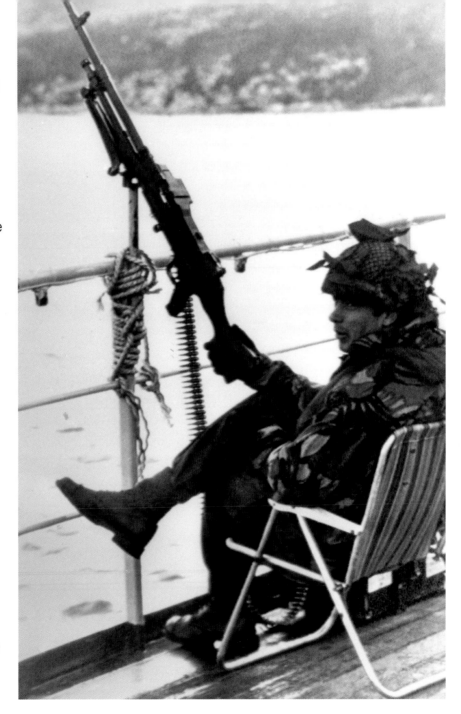

A Royal Marine finds a more comfortable chair beside a machine gun on board ship.
8th June, 1982

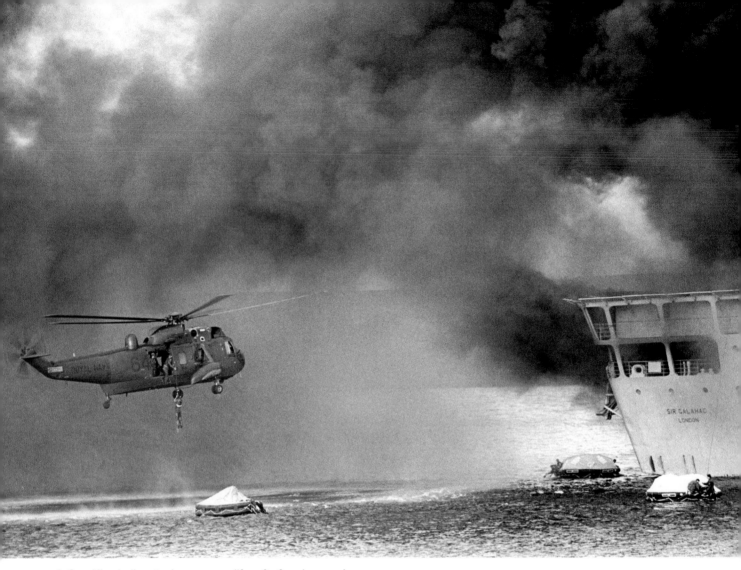

A *Sea King* helicopter hovers over life rafts ferrying survivors
from the blazing British landing ship, RFA *Sir Galahad*, which
had been attacked by Argentine fighters.
8th June, 1982

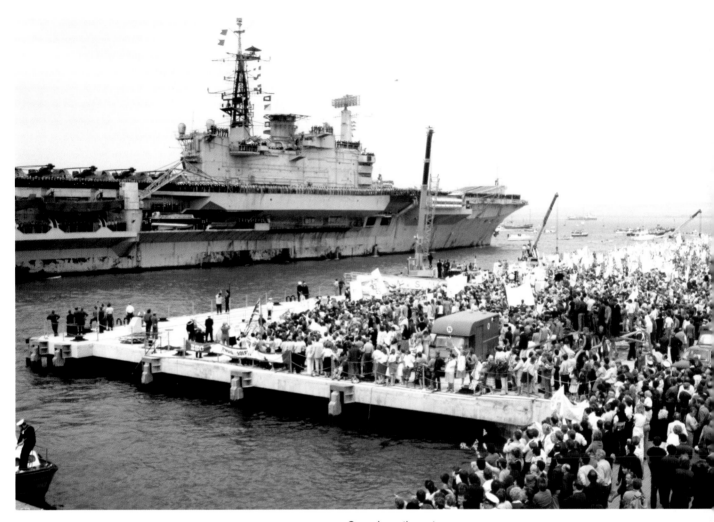

Crowds gather at
Portsmouth to greet the
Falklands Task Force
flagship HMS *Hermes* on
her return from the South
Atlantic.
1st July, 1982

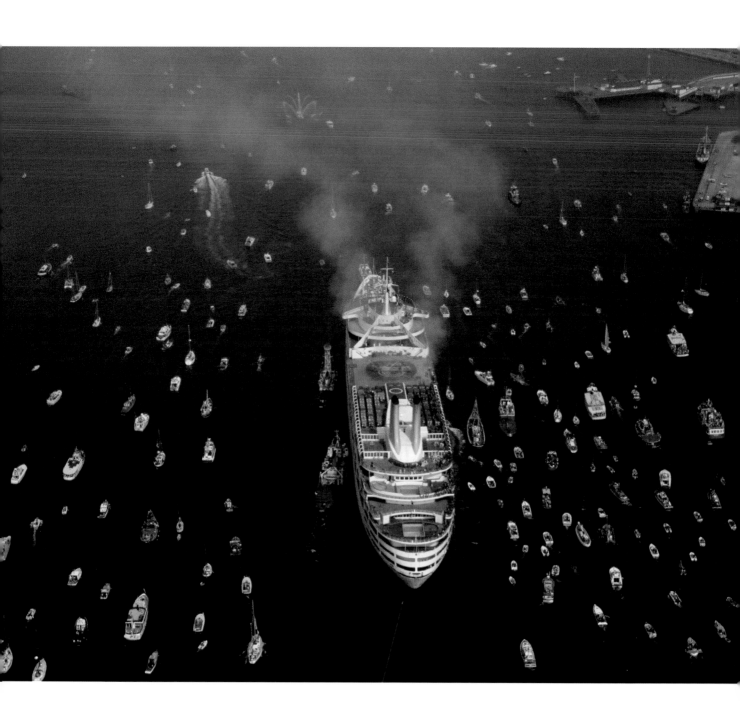

Facing page: The P&O
liner SS *Canberra* and her
complement of troops, are
escorted up Southampton
Water by scores of smaller
vessels on their return from
the Falklands.
11th July, 1982

British *Tornado* fighters return to RAF Brize Norton from
Dahran Military Air Base after six weeks in Saudi Arabia, the
prelude to the First Gulf War. On the 2nd of August, 1990,
Iraqi troops under Saddam Hussein invaded Kuwait. The UN
Security Council authorised *"all necessary means"* to force
Iraq to withdraw should it not do so by the 15th of January,
1991. Iraq ignored the ultimatum. On the 17th of January,
1991 the coalition force, headed by the US, began an air
offensive on Iraq and Kuwait.
17th September, 1990

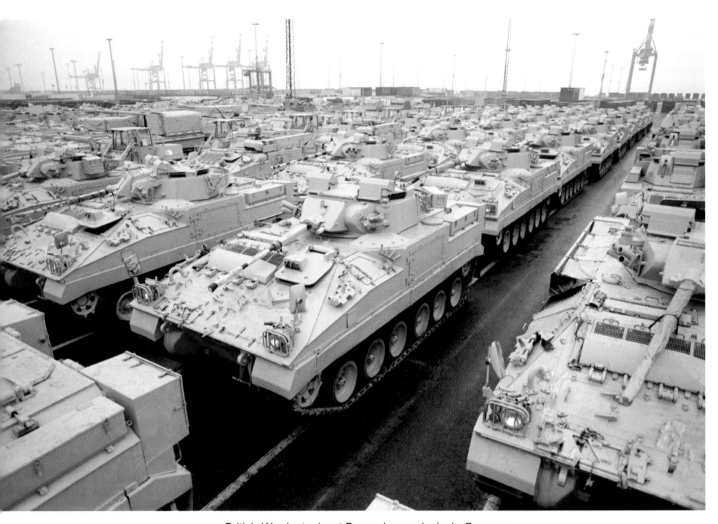

British *Warrior* tanks at Bremerhaven docks in Germany
await deployment to the Gulf as Western forces begin to
assemble following the Iraqi invasion of Kuwait. By mid
October there were 15,000 British troops in the Gulf.
30th September, 1990

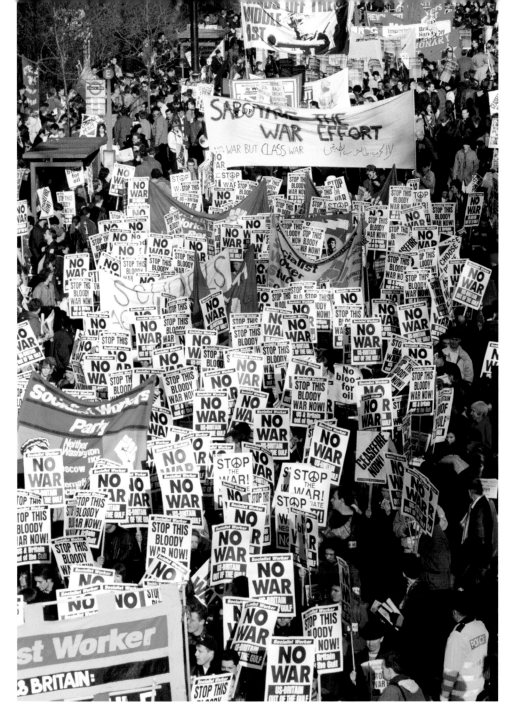

As hostilities heighten during the First Gulf War, protesters stage a 'stop the war' demonstration in central London.
19th January, 1991

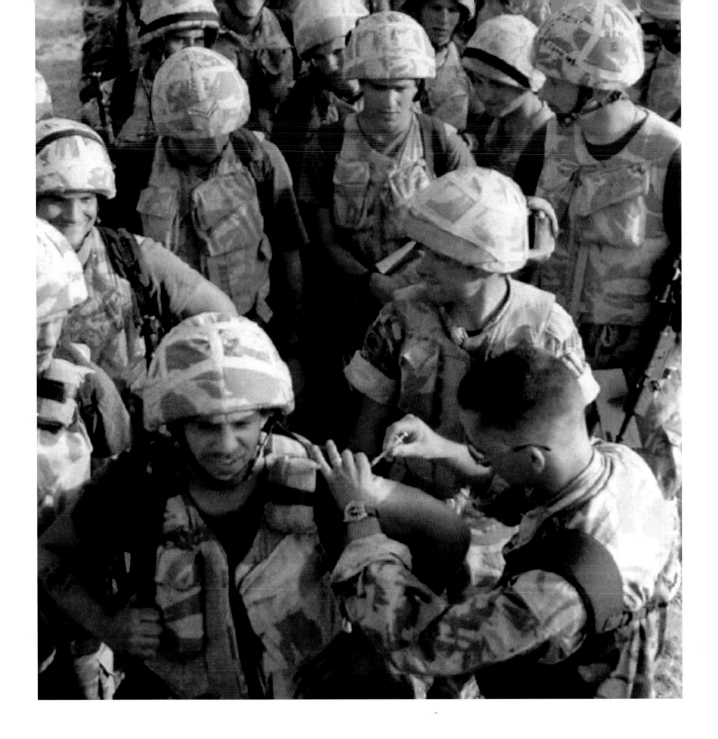

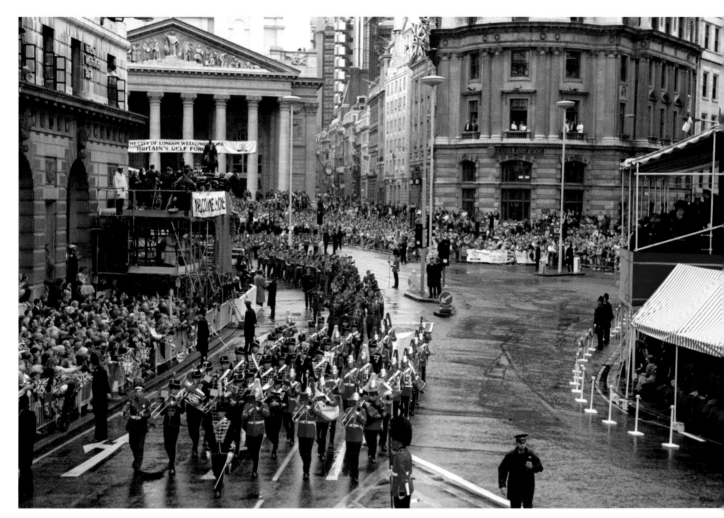

Facing page: B Company of the Royal Scots receive injections designed to offer protection should chemical weapons be used against them.
21st February, 1991

A cavalry band leads troops through London during the Gulf War victory parade. On the 28th of February, 1991 Iraq accepted all UN resolutions and its troops withdrew from Kuwait.
21st June, 1991

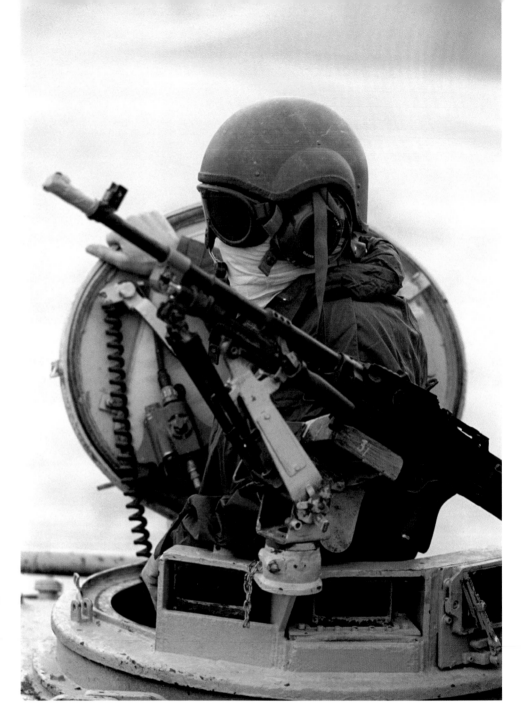

A soldier from the British 7th Armoured Brigade – the 'Desert Rats' – wears a facemask and goggles to protect himself from the dust and sand of the Saudi Arabian desert.
2nd October, 1991

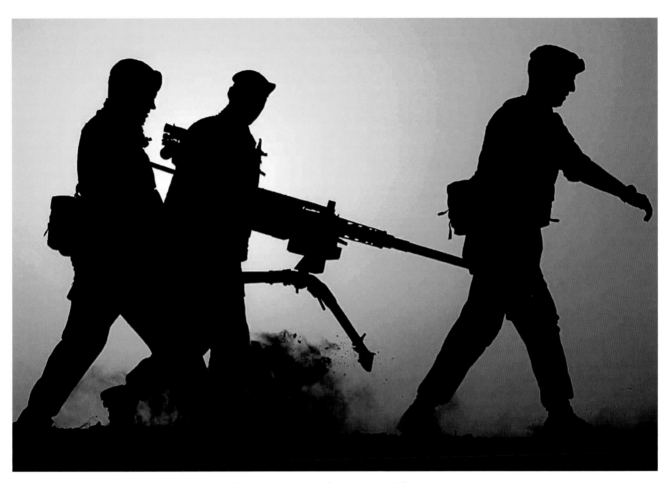

Soldiers of Royal Marine 45 Commando X Company carry
a heavy machine gun at Camp Fairburn during an exercise
in the desert of Oman.
17th October, 2001

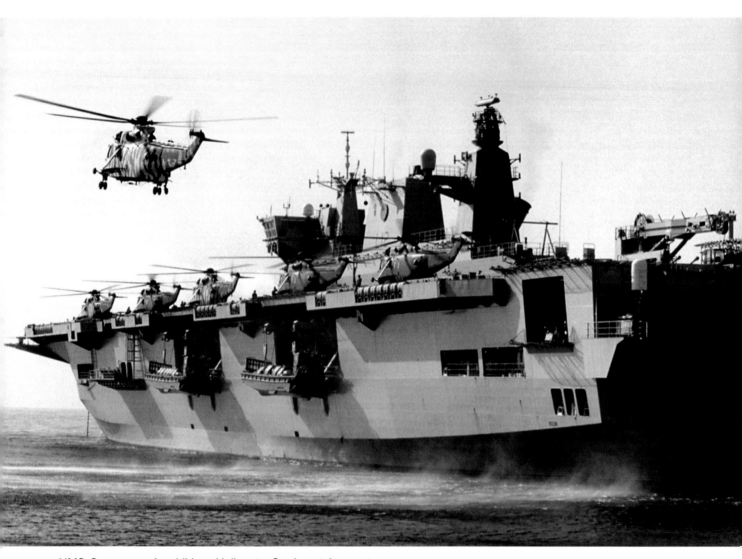

HMS *Ocean* – an Amphibious Helicopter Carrier – takes part
in an exercise. She was part of the Royal Navy task force
deployed in Operation Telic during the Second Gulf War.
The ship can carry up to 800 Royal Marine commandos,
18 helicopters and four landing craft.
15th January, 2003

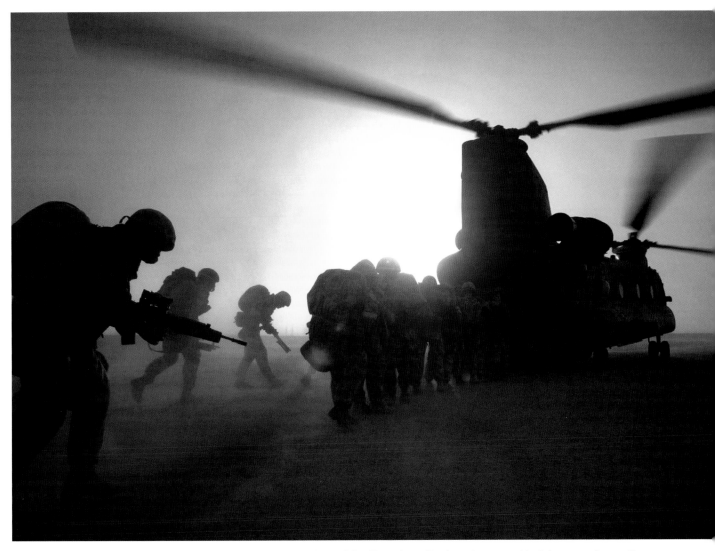

Soldiers from the 1st Battalion of the Parachute Regiment carry out training exercises with a *Chinook* helicopter in the Kuwaiti desert as tensions mount in the Gulf region. On the 20th of March, 2003, American missiles hit targets in the Iraqi capital of Baghdad at the beginning of a US-led campaign to remove Saddam Hussein from power.
17th March, 2003

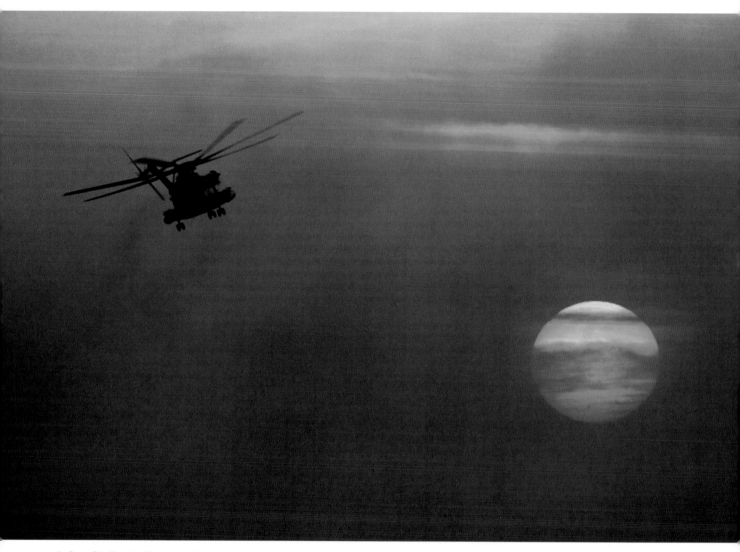

A *Sea Stallion* helicopter of
the Royal Navy carries out
low-level training exercises
in the Kuwaiti desert.
19th March, 2003

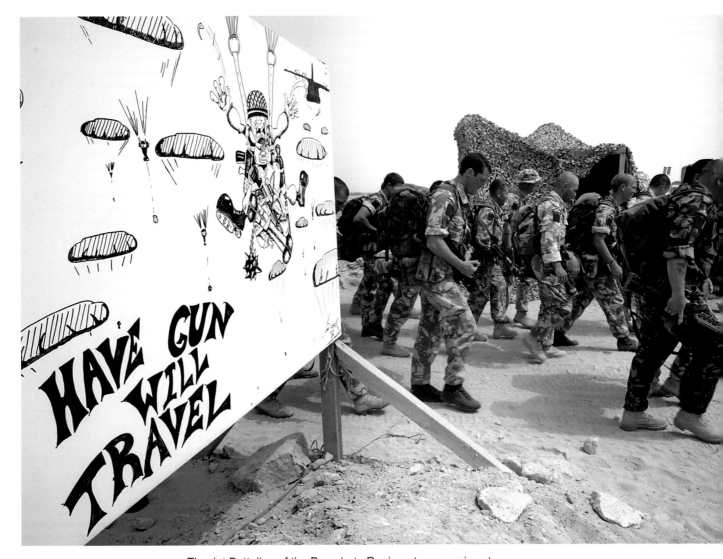

The 1st Battalion of the Parachute Regiment on exercise at
its camp, Eagle 2, in the Kuwaiti desert, as it prepares for
possible military action in Iraq.
20th March, 2003

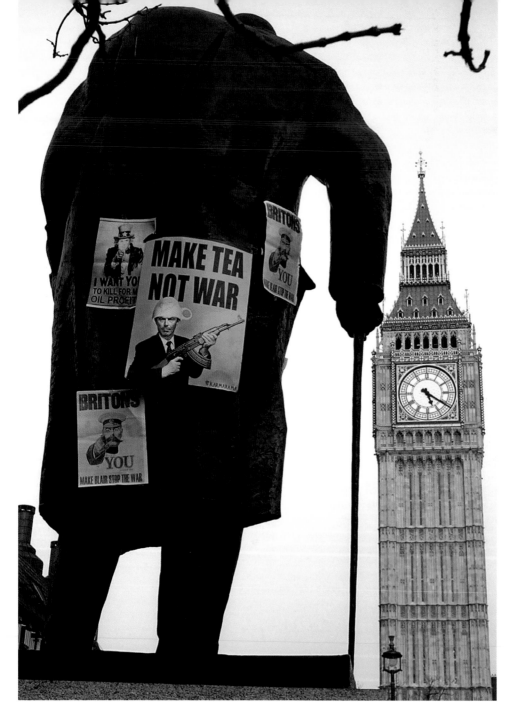

Sir Winston Churchill's statue in London is plastered with anti-war posters as young people in Parliament Square protest against actions in the Middle East.

20th March, 2003

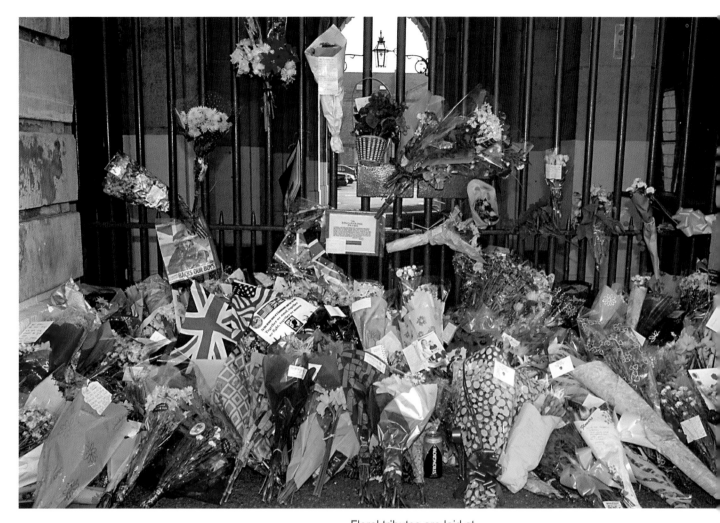

Floral tributes are laid at
Stonehouse Barracks,
Plymouth, in tribute to
Marines killed in the Gulf.
23rd March, 2003

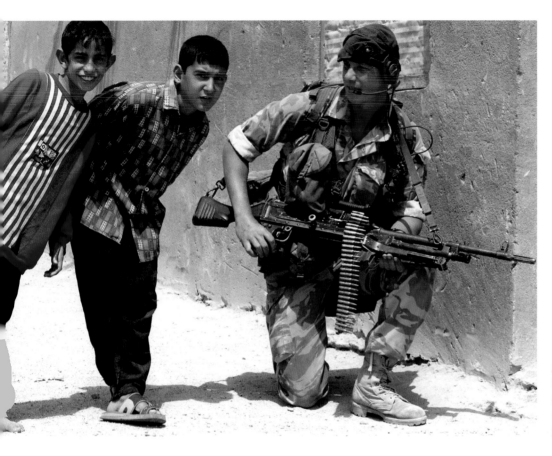

A Royal Marine patrolling in Umm Qasr, southern Iraq, draws attention from local children.
29th March, 2003

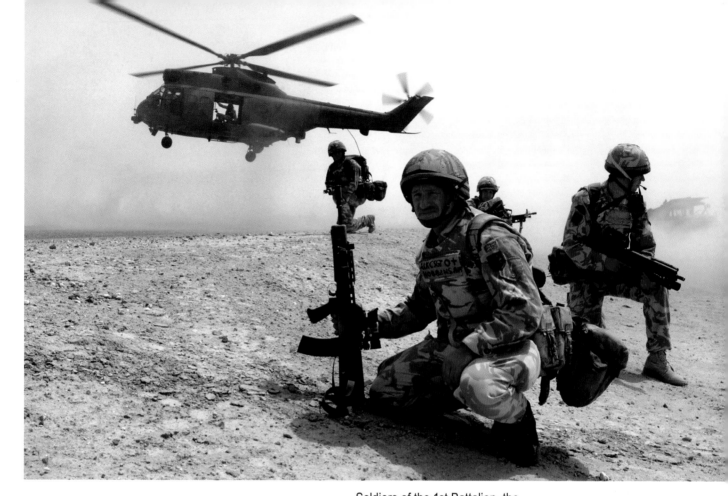

Soldiers of the 1st Battalion, the
Parachute Regiment prepare to
search vehicles for weapons in
southern Iraq.
30th March, 2003

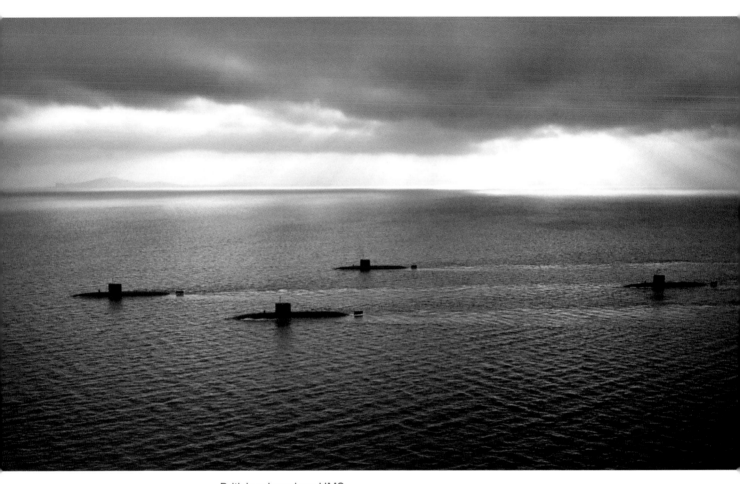

British submarines HMS
Splendid, HMS *Sovereign*,
HMS *Sceptre* and HMS
Spartan travel in convoy
near Arran on the west coast
of Scotland. *Splendid* fired
Tomahawk missiles during
the coalition attack on Iraq.
17th July, 2003

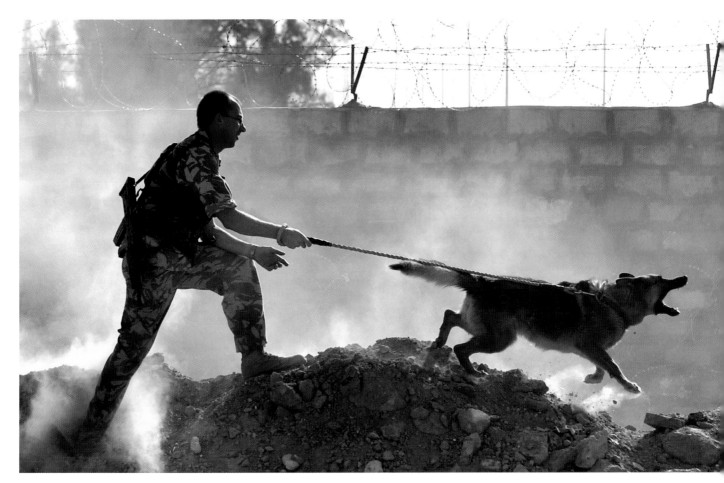

A Gunner from 168 Pioneer
Regiment patrols near the
Iraqi port of Umm Qsar.
By this time the capital of
Baghdad had been taken by
coalition forces but Saddam
Hussein was still at large.
26th September, 2003

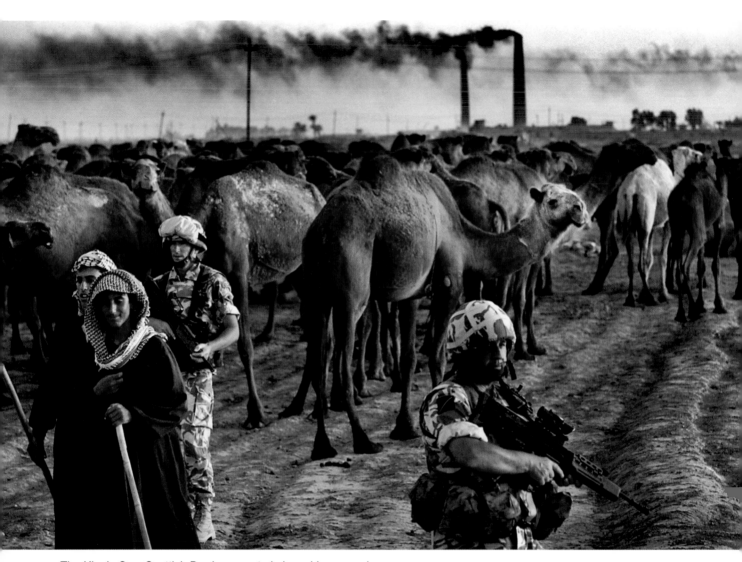

The King's Own Scottish Borderers patrol alongside a camel
train outside Al Amara in Northern Iraq.
27th September, 2003

British Prime Minister Tony Blair addresses troops in the Iraqi port of Basra. Saddam Hussein had been captured in December, 2003, but insurgency continued. Mr Blair tells the soldiers: *"It's a great honour for me to be here today. The first thing I want to say is a huge thank you for the work you're doing here."*

4th January, 2004

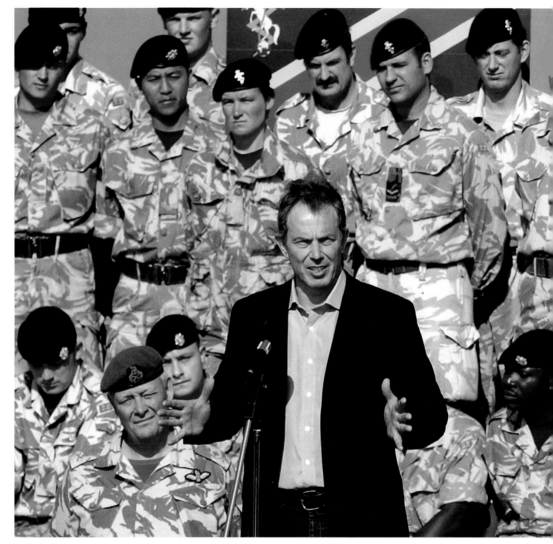

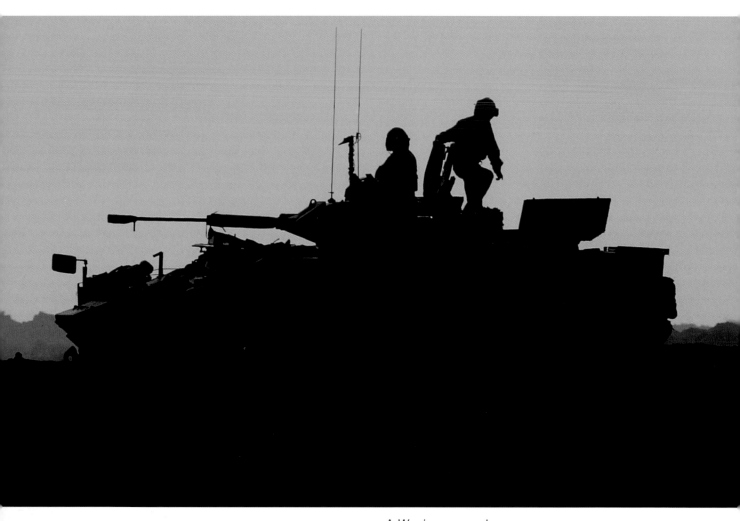

A *Warrior* armoured vehicle from A Company, the 1st Battalion Black Watch, prepares to patrol Ahmed Al Ahamadi near Camp Dogwood as dawn approaches.
4th November, 2004

Autumnal foliage forms a stunning backdrop to the war memorial at Shildon, as Britain prepares to remember those killed in conflict, including casualties from the ongoing operations in Iraq, on Remembrance Day.
9th November, 2004

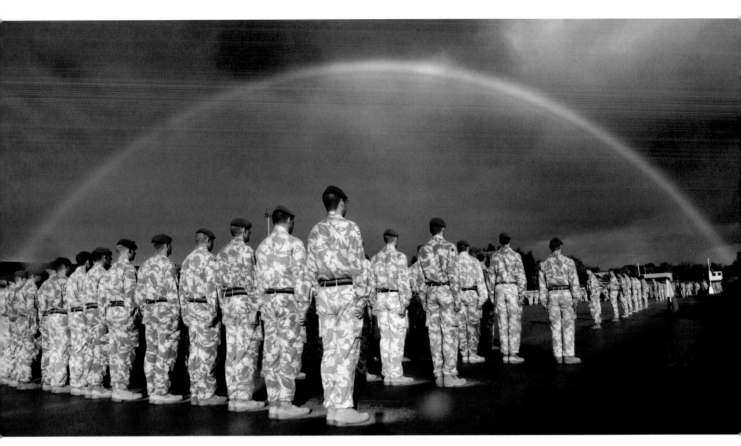

Framed by a spectacular
rainbow, members of the 1st
Battalion, Royal Anglians,
are presented with their
medals at Pirbright in Surrey
following a six-month tour
in Iraq.
4th November, 2005

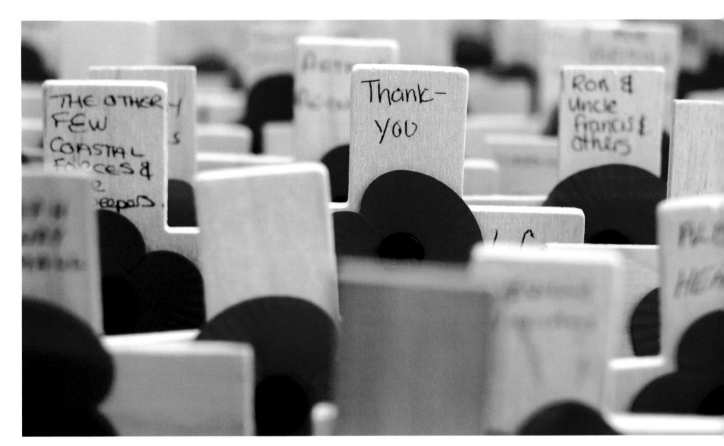

Lines of poppies on simple wooden crosses bear personal and heartfelt messages in a Field of Remembrance outside Westminster Abbey in central London.
9th November, 2005

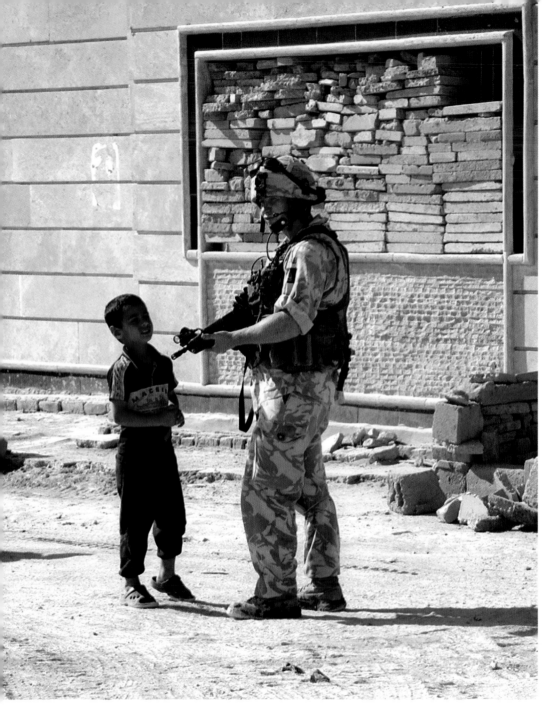

A small boy approaches a
soldier on patrol in Basra,
southern Iraq, as British
troops launch a crackdown
on illegal weapons.
7th March, 2006

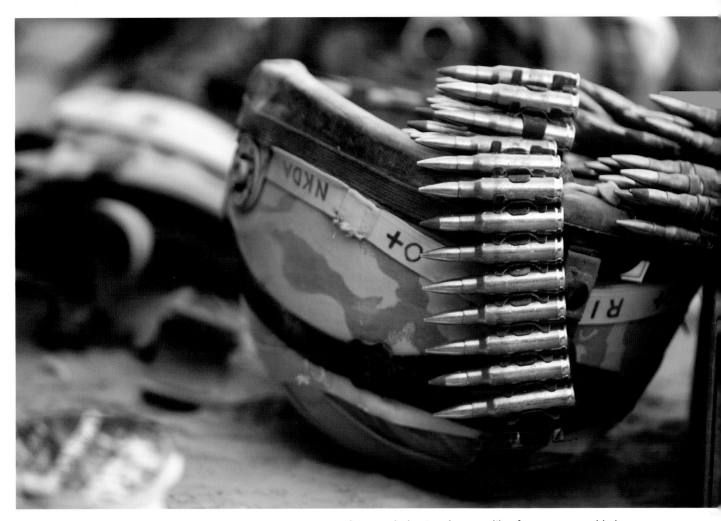

An army helmet and ammunition form a memorable image as soldiers from B Company, Worcester and Sherwood Forest Regiment, prepare for duty in Helmand province, southern Afghanistan. The UK first became involved in Afghanistan in 2001 as coalition forces led by the US undertook operations against Al Qaida and the Taleban. The red-tipped bullets are tracer rounds.

14th August, 2007

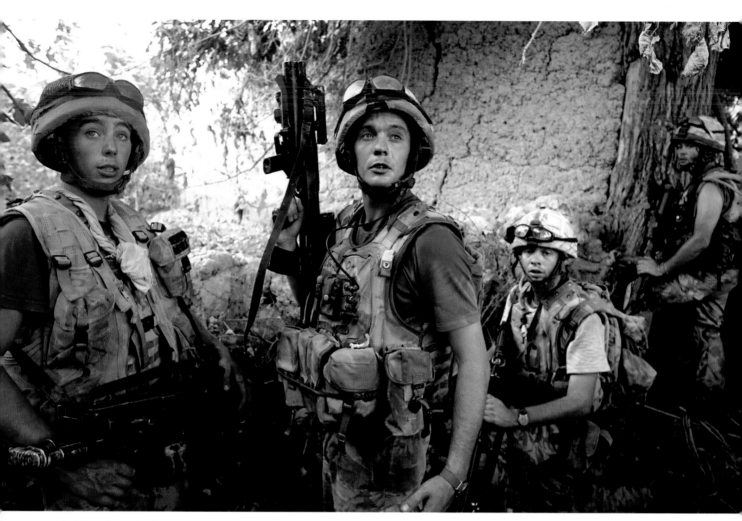

Soldiers from the Sherwood
Forest Regiment in action
in Helmand Province,
Afghanistan.
14th August, 2007

Facing page: Welsh Guards
soldiers fire a mortar
on Taleban positions
in Helmand Province,
Afghanistan.
16th August, 2007

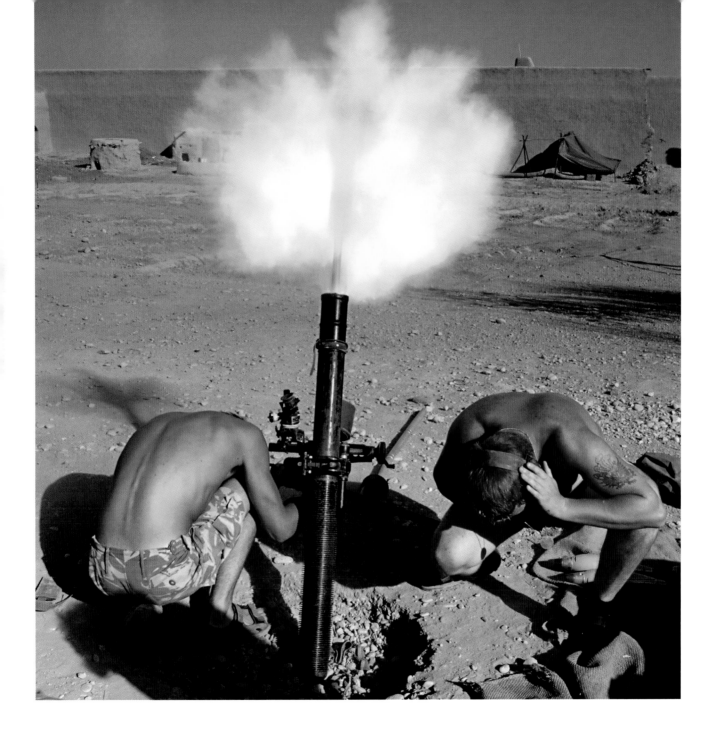

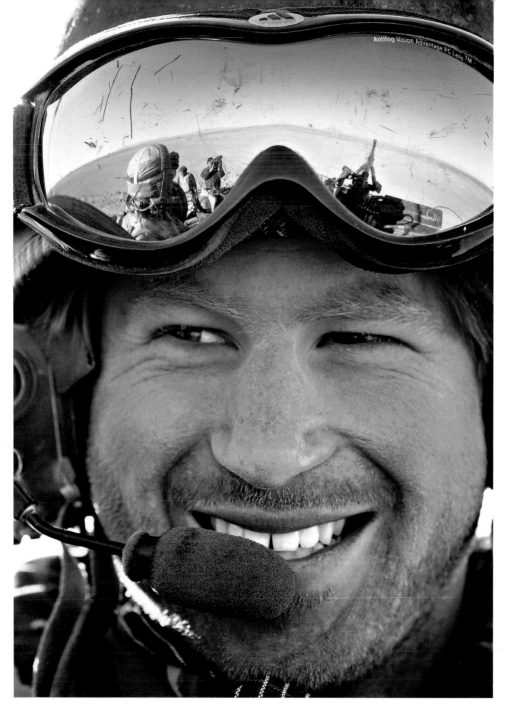

Prince Harry sits in his *Spartan* armoured vehicle in Helmand Province during his tour of duty in southern Afghanistan with the 'Blues and Royals' of the Household Cavalry Regiment. The Prince returned to Britain 10 weeks into a 14-week deployment after a news blackout broke, leading to fears he would be targeted by the Taleban.
10th January, 2009